FOREWORD

by Kate Macfarlane, curator/co-director, The Drawing Room, London

This book is the product of a passion for drawing as a mode of discovery and creativity. The brain child of two artists; it is their enthusiasm for the medium of drawing and all that it has to offer that distinguishes *Drawing Projects*. Jack Southern and Mick Maslen bring to the project their years of experience of teaching drawing at foundation and degree level. The book engulfs the reader in a world of artistic production with glimpses into the studios and minds of some of the most interesting contemporary practitioners. It has been conceived to encourage practical experimentation and invention within a set of carefully conceived parameters. In this fertile and stimulating context *Drawing Projects* provides practical guidance for those wishing to explore new approaches to drawing. John Ruskin wrote *The Elements of Drawing*, 1857, to replace drawing manuals that "propose to give the student the power of dexterous sketching with pencil or water-colour, so as to emulate... the slighter work of our second-rate artists".

Life Drawing Drawings, an ongoing series of artworks by contemporary artist Fiona Banner, provides evidence that Ruskin failed to stamp out such drawing manuals and testifies to their continued production. Banner collects examples of such manuals, makes a drawn copy of the cover in the manner advocated within the pages of the manual, and leaves the inside blank, transforming them into sketchbooks. *Drawing Projects* represents another refreshingly inspirational update to such manuals. Its unique format, which combines practice and theory, encourages readers to develop their own artwork and to arm them with the means to do so. We witness how an economy of means can lead to highly ambitious and successful art works. The project conveys the message that drawing underlies divergent artistic practices. Approaches that are driven by subjective interests and radical ideas are embraced as essential for the production of effective and compelling works of art. In contrast to Ruskin's *The Elements of Drawing*, for example, which adopted a highly prescriptive tone

(not withstanding some extremely good teaching and advice to look at the art of Turner, Dürer, Rembrandt, Leonardo da Vinci and others) this book presents what could be described as a contemporary approach to contemporary drawing. The featured artists punctuate projects, and in some cases parallels can be drawn between elements of the suggested approaches and techniques. The artists are carefully chosen to enrich the readers understanding of the breadth of contemporary drawing practice.

Drawing Projects, begins by discussing the importance of observation and drawing, from childhood, through to methodologies and philosophies of drawing in an educational environment. The reader is gradually drawn into the world of creation, as the content includes practical exercises that subtly encourage a wide readership to engage in the business of making drawings. These practical lessons orientate around small scale studio environments, limited materials, and around objects and subjects which are accessible in the everyday world. This approach removes psychological and practical obstacles and enables readers to develop their own work with limited facilities. The workshops also demonstrate how a consideration of the fundamental basis of drawing enables the students to explore and develop their understanding in relation to the wider activities, materials and processes which contemporary drawing incorporates.

Drawing Projects is revelatory in its exposure of the most intimate thoughts and of drawings by key practitioners. The practice of most artists is underpinned by the production of drawings that remain largely hidden; even those collected by museums are more likely to be relegated to archive boxes and drawers than exhibited in the galleries. Presented in the context of this book, many of the drawings disclose sensibilities and concerns that we may not normally attribute to their authors. Revelatory too are the interviews with the artists. These were conducted on the basis of informal discussion, rather than set questions. Reading the interviews we are privy to the most intimate and critical ideas that drive artistic production. Incidental events and actions that occurred during formative years are exposed through the refreshingly honest exchanges. Seemingly mundane activities—such as Cornelia Parker's childhood duty of laying

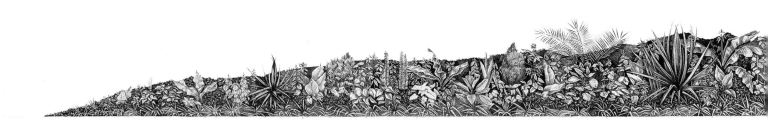

the fire—are revealed to be fundamental to subsequent artistic developments. We discover that there are multiple ways to learn or to employ drawing, and that keeping options open and experimenting with quite simple procedures can lead to the production of substantial and powerful works of art. The project demonstrates the primary role that drawing plays in contemporary practice and refutes its position as a medium that is secondary and marginal. The cliché that drawing is a window to the soul of the artist is exposed as a one-dimensional and restrictive interpretation of drawing as practiced by contemporary artists. In this book we find that Cornelia Parker, who uses a range of 'altered' materials as her drawn line which is manifest in actual space, categorises much of her output, whether in two or three-dimensions, as drawing.

Jeff Koons employs drawing in a more traditional sense, to plan his sculptural work. Such is the reproductive drama of his sculptures and tableaux, it is not surprising that we rarely witness sketches that reveal how his mind works. We discover that whilst a number of the artists share an interest in figuration, their approaches to drawing differ radically. Dryden Goodwin's portraits display multiple lines that trace and retrace the contours and features of his subjects. This obsessive observation, that could be compared to that of Alberto Giacometti, seems to simultaneously build and deconstruct the face. Charles Avery's drawings are narratives driven by characters drawn entirely from his imagination; his method is to adopt a close relationship with his invented characters which the act of observation would interrupt. Kate Atkin uses photographs as the starting point of her drawings but these constitute a limited number, by her own admission, of poor quality snapshots. Franziska Furter's starting point is also secondary sources, from Manga to illustrations from a wide range of publications, which are subjected to radical changes in scale to produce works that hover between representation and abstraction. Conversely, Martin Wilner and Keith Tyson make work that embraces our image-obsessed culture and the information overload to which we are subjected daily. Julie Mehretu makes layered abstract works that bring together different modes of representation including mapping and axonometric drawing.

William Kentridge's politically driven narratives unfold through multiply-corrected charcoal drawings that are usually animated. Jake & Dinos Chapman subvert cultural and political icons and language to challenge complacency and compliance. During the High Renaissance drawing was considered to be the most important discipline to learn. The notion of drawing was tied intimately to that of thought and knowledge, and thus the act of drawing was a highly revered skill. A recent exhibition of Renaissance drawings at the British Museum demonstrated that drawing was the product of highly intelligent and enquiring minds and revealed more links than dissonances to our own sensibilities and perception. Piero de Cosimo's drawing of 1461/2 combines

TOP Franziska Furter, *Draft V*, 2009, pencil on paper, 140 x 110 cm. Courtesy galerie schleicher+lange, Paris.

BOTTOM Kate Atkin,, *Island: Flowerbed*, 2006, pencil on paper, 119 x 220 cm. Courtesy the artist.

real and fantastic landscape elements; Antonio Pisanello's Hanged Men of c 1433 describes six corpses in varying stages of decay; and Leonardo da Vinci's head studies detail the disfigurement of old men. These artists understood the importance of *pentimenti* (corrected, changed areas) to convey life-like poses and to suggest contingency. *The Last Supper* by Leonardo, in particular, demonstrates the effectiveness of this methodology, which is also employed in the contemporary practice of Charles Avery. With the development of art academies in the eighteenth century there was a move away from observation from life and an emphasis on learning techniques that reduced the variety of nature to abstract ideas. Students copied from plaster models and from engravings to create ideal forms that conformed to Neo-Classical propriety. William Blake raged against such 'lies' and 'follies' claiming that "Every Eye sees differently". In the course of each individual's perception, all things renew their particularity. Half a century later, John Ruskin championed an empirical approach, establishing a system whereby students of all disciplines learnt to draw as a means to discover and learn, to know. The 1960s and 1970s represent a particularly fertile period in the history of drawing. Tendencies that began in the 1940s gathered force and the medium of drawing broke free of its association with figuration and with its role as a fundamental but overlooked stepping stone to painting and sculpture. The motivation to produce singular and definitive outcomes to artistic production was questioned and established boundaries between different disciplines were tested, providing opportunities for the medium of drawing to be reassessed. As *Drawing Projects* clearly demonstrates, much of the magic and power of drawing is in the act, the process of its unfolding. During the 1960s and 1970s the procedures of a works production were appreciated as being critical to its nature. Richard Serra famously said "There is no way to make a drawing—there is only drawing" which describes this tendency most succinctly. The activity—the making of the drawing is of significance, not what that activity produces, summed up by Serra's statement that "Drawing is a verb". This tendency reaches back to the practice of artists such as Robert Rauschenberg who, in a life drawing class in 1949, turned his back on the model and produced a cryptic meander of lines and numbers scratched into the paint which he titled *White Painting with Numbers*, 1949. At the same time, artists working in figuration at this time, such as Edward Ruscha, incorporated the techniques and effects of the graphic designer. A life into art impulse penetrated 'fine arts' perimeter fence and all modes of drawing—diagrams, sketches and cartography—were considered to be equally valid and particularly suitable for reproduction. The association of drawing and connoisseurship was challenged as elitist and the medium of drawing became associated with radical views and behaviour. Mel Bochner's *Working Drawings and Other Visible Things on Paper Not Necessarily Meant To Be Viewed as Art*, 1966, included receipts, notes and sketches by his colleagues that he photocopied and presented in folders on plinths. This work represents the ultimate affront to the conception that the act of drawing is bound to the artists' touch.

The radicalisation of artistic practice in the 1960s led to the implementation of the Coldstream Report, named after Professor William Coldstream of the Slade School of Fine Art. Art education in the UK underwent radical change. A shift from the life room began and a compulsory core component of complementary studies was introduced—a range of courses embracing the 'new art history' formed by Marxist, feminist, semiotic, structuralist and psychoanalytic perspectives. During the 1980s and 1990s theory was considered equally as important, if not more important than, practice, and attention to artistic materials and processes was often neglected. Whilst liberating, the cross-fertilisation of disciplines that has characterised art since the 1960s can also render the practitioner rudderless. Denied the language and rules that were traditionally associated with each particular medium leads to an 'anything goes' approach. Avant-garde practices have developed in opposition to conformity; perhaps it is time to bring back some rules to chafe against?

Drawing Projects reinvigorates drawing terminology that was largely abandoned in art schools and studios in the 1950s. We learn about tone, about line, about contour as well as the idiosyncratic terminology that Jack Southern and Mick Maslen have developed over their years of teaching drawing. We vicariously experience the trial workshop sessions to witness the processes and outcomes of their suggested methodologies. It could be argued that the resurrection of this terminology and such exercises can provide the artist with the tools necessary to exploit fully the nuances of the medium. Rather than being considered according to its physicality, drawing can be seen as presenting the artist with a clear set of rules within which highly complex ideas can be explored. The Authors suggest that "The draughtsman must learn to tell the truth with lies". This instruction acknowledges one of the essential features of drawing that makes it so popular for contemporary practitioners. A drawing by its nature acknowledges its own deceit; it can never purport to be other than itself—graphite or some other material applied to a two-dimensional surface. To make a drawing, in whatever mode, is to acknowledge this fact. Charles Avery in conversation with Jack Southern says "I see drawing as a very earnest medium". Drawing lends itself to investigation and analysis and is therefore inextricably linked with authenticity and intelligence. The general trend away from glamour and hyperbole and towards truth and honesty accounts for a resurgence of interest in the practice and appreciation of drawing. Whilst the past seemed to be distinguished by phases of polar opposites, today there are signs that almost any approach to drawing, and indeed artistic practice, is valid. Ruskin's empirical approach to drawing is enjoying a revival as artists once again embrace the pleasure of observation and of acquiring traditional drawing skills. Craft and toil are values to be revered rather than criticised; the intensive and detailed procedures of artists such as Gemma Anderson, and of Shahzia Sikander, for example, expose the labour involved in the production process. *Drawing Projects* demonstrates that effective and lasting artworks are built on practices that combine a carefully conceived conception with close attention to process and materials.

© Kate Macfarlane, curator and Co-Director, Drawing Room, London.

ABOVE Martin Wilner, *Making History:
April 2009*, ink on paper,
29.2 x 29.2 cm. Courtesy the artist.

INTRODUCTIONS

Jack Southern

This book has been one big project, one big conversation. An extensive and evolving dialogue, which we have shaped and formed into the format in which you find it. Over the past two years we have worked with tutors, artists, curators, researchers and students. Throughout, the ongoing discussion and exchange has reaffirmed our curiosity to develop our own understanding of the possibilities of drawing.

In working with such a diversity of people, we have put an emphasis on understanding the process of what drawing represents and means to each individual. An interesting communality to emerge, is how the medium of drawing is used as a primary means of expression, but also as a quiet, intimate, hidden, introspective activity. A means to access and process thoughts, work through ideas and understandings, and release intuitive gestures and feelings.

Throughout, the value of the process of making drawings has been seen as a profound and significant one by the majority of people involved. A range which has been as broad as to encompass students who have had very little experience of drawing, through to internationally, established practitioners, and experts in their field.

In the context of this inclusive approach, this book is a wander through a series of linked thoughts about drawing. It is not an attempt to define drawing in fixed, material terms. On the contrary, this book represents our shared and collective exploration of the thinking process, and activity, of making drawings. In part, this book's conception and realisation has been driven by other people's ability to mirror our excitement for drawing.

This multifaceted and rich range of input has materialised into a complex and varied book, encompassing our collated experiences. It represents both the period Mick and I have been working together, as well as our collective 45 years as practicing artists and lecturers. That experience accumulates in this book to form three main parts, a core text, drawing projects and features on contemporary artists work.

Mick is largely responsible for the original content of the core text. Much of it has origins in teaching notes Mick made while teaching drawing and painting to students on the Foundation Course at the University of Gloucestershire, and has been evolving for more than 20 years. Over the past four years we have worked together; thoughts have been shared, issues examined and clarified, and as a result the core text for this book has evolved. On first meeting Mick our ideas and methods seemed to amalgamate effortlessly. My energy and drive for this project has been fuelled by the inherent knowledge of how rare it is to find a creative partner with whom you can work so fluidly, and share such meaningful time, thoughts and experiences.

Our working dynamic led to Mick and I writing projects together which original featured in the *Guardian Guide to Drawing* in 2009. These were then re-written and presented as workshops which we organised and taught specifically for this publication. The workshops took place at Pittville studios, at the University of Gloucestershire, over two two-week periods in April and July of 2010.

The works that accompany the projects in this book were made by invited participants who are current and former students from a range of UK art schools including, Slade, Goldsmiths, and University College Falmouth; all of whom had previously been students on the foundation course at the University of Gloucestershire, Cheltenham. As well as working through the projects, students were encouraged to integrate the methodologies into their own personal and individual ideas. They were motivated to be ambitious and to embrace and address wider activities, materials and processes incorporated in contemporary drawing practice.

This enabled the workshops to reflect and articulate a broad definition of drawing. We are excited by the idea that the evidence and energy of the workshops will now be disseminated through this book, and be used by tutors and students as a pedagogical tool, as well as by individuals with limited facilities, and an economy of means.

In part, the motivation for *Drawing Projects* is an attempt to allow significant issues of the teaching and learning of drawing practice, commonly associated with 'traditional approaches', to emerge with a revitalised significance and renewed currency within contemporary teaching. We seek to ask the fundamental question of what is relevant to students now, while facilitating the answer to remain allusive.

In writing the projects we attempt to address issues intrinsic to exploring the medium of drawing, such as observational skills and mark-making, and encourage a felt and emotional response to the visual world through a philosophical framework. The Projects initially introduce the notion of drawing as being a 'descriptive visual language' and encourage the student to see drawings as hand-made objects that are an autographic record of the experience of responding in mark. Fundamental is acknowledging learning how to see the world by drawing, as the primary means by which greater visual awareness can develop.

We hope the projects encourage an open-minded sense of discovery, as from our experience of teaching drawing; we recognise that becoming familiar with the unfamiliar, and being able to value and acknowledge the struggle of the journey, is an essential aspect of learning. In doing so, we make the activity and process of drawing less formidable, and one in which elements of difficulty and 'failure' can be incorporated into the solution of a drawing, to be a valued aspect of its character.

The contributions of contemporary artists include images of their works as well as texts written from primary source interviews. These contributions punctuate the projects, and assume a dialogue and relationship with the content of the projects. However as Dryden Goodwin pointed out in the early stages of the book, "the relationship between the project and the artists' work won't be explicit, but will be demanding and challenging the reader to develop a deeper understanding of links and relationships of different aspects of drawing practice".

The artists have been extremely generous with their time, as the process of working from informal conversations

is a very lengthy and evolving one. In spending time with the artist in their studios I have had an increasing insight into their practices. The conversations that emerged through that process have been a deeply profound experience for me.

Many discussions have presented the opportunity to talk about works that are less commonly seen than those we might associate with the artist through exhibitions and publications. Works that are revealing and have a personal significance, perhaps anchor points in the process of developing ideas and ways of working. In many of the conversations, communalities, thread's and predominate thoughts have emerged, as well as insight into when they may have been established, and how they reoccur in the work in different ways.

At the back of this book we have a section in which we acknowledge the invaluable support and advice from a range of individuals. We would also like to give special mention to the people who have contributed directly to the content of the book. These include, Kate Macfarlane for writing the foreword. Bill Prosser for writing the section on doodles. Jennifer Whiskerd for writing one of the projects which she also presented as a day-long taught session during the workshops.

Tom Lomax and Sam Belinfante, for contributing a day's teaching during the workshops. Ruth Chambers for general administration for the book, including transcribing all the artist's interviews. And a special thanks to Dale Berning, for her support throughout, having worked with us on the project which proceeded this one, with the *Guardian* newspaper.

It is important to note that this introduction is the distillation of both my-own and Mick's shared thoughts and feeling about the development of this book over the past two years. It is also very important to me, to point out that I feel honoured to have worked with Mick and cherish the friendship we have developed. The evolution of my understanding of the possibilities of drawing has been accelerated by Mick's generosity to share his extensive knowledge with me. Mick is, and will always continue to be, a true inspiration to me.

Mick Maslen

It has been my privilege to teach the subjects of drawing and painting to Art and Design Foundation students for more than 30 years, and much of what has become the text of this book started out as a set of evolving notes, which were made whilst both teaching students, and learning from students 'how to make drawings'. They say that, "You teach best what you most need to know", and for me this has been true.

When I started out as a young art lecturer, with not much teaching experience, and limited drawing skills, it was very important for me to establish an art school studio environment in which the activity of drawing could be explored, discovered and in some ways defined by both my students and myself. My needs were the student's needs, and their needs were mine. I had everything to learn.

This environment was one in which the students were encouraged to have and share opinions, and recognise and value difference. It was an 'open' space whose content shape was always flexible enough to accommodate the question 'what if?'—a space in which they could feel encouraged and supported, and could dismantle their pre-conceptions, take risks, fail, make 'bad' drawings, and allay their fears and inhibitions. It was all new and exciting, and as they learnt, I learnt with them. My role was to recognise, value, and reflect back, any possible options for the further development of what we were learning. We openly taught each other, and together, we continually re-defined our purpose and intent whilst we drew.

We can all draw in our own way, but what we sometimes fail to do is recognise the things that are particular and special about our way of drawing. We can never quite be sure what our drawings look like to other people, or even ourselves, and are often deceived into thinking that they are better than, or not as good as we think.

To some extent, they are always inconclusive, and as we change, the way we see our drawings changes. It has always been my thought that I can 'look' with ease at the drawings of other people, but have to self-consciously 'watch' my own. They seem to live and change through time—sometimes for the better and sometimes for the worse. I understand of course that it is not them changing, but me. However, I accept this, and I am pleased to be able to say that as I am changing I am still learning. Drawing is an act of faith.

In 2009 the co-author of this book Jack Southern was asked if he would write some Drawing Projects for what was to become the *Guardian* newspaper's 'Guide to Drawing'—he agreed and invited me to write them with him as a joint venture. We thoroughly enjoyed the creative process of writing the projects together. My teaching notes continued to evolve whilst working with Jack. They, with some of the projects we wrote, form the base from which this book has developed.

My hope for this book is that some of what I learnt from my students whilst teaching them can be passed on, and that by doing the projects which we have written for this book, you will embrace drawing as an activity that encourages you to see and describe the world in which you live with reverent interest.

DRAWING

THE EYE THAT THINKS

The activity of drawing usually precedes that of writing in the development of small children, although much depends on the label the parents use to describe it. Children have no language to describe this 'motor scribble', mark-making activity, and are likely to agree with whatever the parents suggest when they ask "would you like to do some drawing?" or, "are you writing?". If drawing is encouraged, repeated, and thereby re-affirmed, it is likely that children will become accustomed to the activity and its label, and want to draw more.

The pleasure for them is in the action, and the resultant mark, and at this stage in their development [aged two to three], it does not really matter what it is called. They will associate the activity with the materials, the marks, the label, and with the encouragement or discouragement they receive for their efforts. They have no concern for what it is that might be called drawing, and the outcome is most often scribbles and scrawls.

To children, a surface of black or coloured marks made by them on a piece of paper, or any surface, in pencil, crayon, or felt-pen is a mirror to the 'motor mark-making' movement of their hand and arm, and a visible and external affirmation of their existence: it is a gestural self-portrait.

At this point in their development, this purposeful action and the resultant kinesthetic marks are to a large extent the content of the drawing, and it is only later, [aged three–five] after being introduced by parents to the idea that a drawing should be of something, that they start to draw things—a horse, a whale, mummy, daddy, etc..

FIRST I THINK, AND THEN I DRAW MY THINK. Anon (child)
Mark-making soon becomes picture-making and begins to carry a narrative. They are taught to write their name on the drawing, and if they are lucky, a parent, or teacher, will stick it on a suitable wall for everyone to see and admire. With such positive encouragement, it is likely that they will want to repeat the activity and continue to make other drawings.

As children get older, [aged five-seven] and the relationship between the visual, tactile, and spatial elements of their world become more integrated, their perceptions gradually become conceptualised, and more fixed as labelled ideas. Drawing becomes more coherent image-making, and they begin to make symbols and somewhat pre-conceived but recognisable images that stand for and represent their ideas.

TO PERCEIVE IS TO CONSTRUCT INTELLECTUALLY, AND IF THE CHILD DRAWS THINGS AS HE CONCEIVES THEM, IT IS CERTAINLY BECAUSE HE CANNOT PERCEIVE THEM WITHOUT CONCEIVING THEM.
Jean Piaget

Drawings by children often become a concrete realisation of what the subject matter they are drawing feels like, as a 'whole' sensory experience. A drawing of a pond might show how it is possible to walk around the shape of the pond—how a fence and trees enclose it—how the surface of the pond has ripples on it,

how there are fish under the surface, and that there is a blue sky and yellow sun above.

At this stage the drawing incorporates the child's knowledge and experience of the pond as a whole body experience perceived through all of their senses, and not just through their eyes, or from a single point of view. In some ways, this is children's drawing at its best, and perhaps it exemplifies something of what Picasso was searching for when he is reputed to have said that he had spent 80 years learning to draw like a child.

Unfortunately this way of seeing does not last for most children, and as adult artists, we can spend a lifetime trying to re-discover qualities of naive expression, and resurrect moments of lost innocence. The wonderful qualities of an innocently expressed child's drawing are greatly admired by many artists.

MY LINE IS CHILD-LIKE, BUT NOT CHILDISH. IT IS VERY DIFFICULT TO FAKE: TO GET THAT QUALITY, YOU NEED TO PROJECT YOURSELF INTO THE CHILD'S LINE. IT HAS TO BE FELT. Cy Twombly

Sometimes the images we make as children, are our own, and particular to us—'my house', 'my dog', 'my mum', etc., and we draw them in our own unique way, and sometimes we are unconsciously influenced by our educational environment and peer group.

This environment helps to influence and shape our shared understanding of the world in which we live, by what it stimulates, discourages and enables. We conceptualise the collective consciousness of our peer group and teacher, into an acceptable 'schema', and make drawings in which—the sky is always blue, the sun is yellow, tree trunks are brown, and most things sit on the base line.

ALL THIS SHOWS THAT A CHILD'S EYE AT A SURPRISINGLY EARLY PERIOD LOSES ITS PRIMAL INNOCENCE, AND GROWS SOPHISTICATED IN THE SENSE THAT INSTEAD OF SEEING WHAT IS REALLY PRESENTED, IT SEES, OR PRETENDS TO SEE WHAT KNOWLEDGE AND LOGIC TELL IT IS THERE. IN OTHER WORDS, HIS SENSE-PERCEPTIONS HAVE FOR ARTISTIC PURPOSES BECOME CORRUPTED BY TOO LARGE AN ADMIXTURE OF INTELLIGENCE.
James Sully

Nursery and Primary school teachers tend to encourage children to draw or paint mainly 'from their head' as a means of self-expression, and for most children this is entirely appropriate, and they produce original and exciting drawings. But as the educational environment continues to place emphasis on the development of memory, intellect, literacy, and numeracy, a child's ability to make visual equivalents of their perceived mental images often remains neglected, and their visual instincts remain undeveloped.

It is very rare that children will be asked to draw the world outside of themselves and for example, examine the perceived colour of a tree trunk as they experience it through their eyes. They begin to inhabit a world whose consciousness is predominantly verbal.

By the time the child can draw more than scribble—by the age of three or four years, an already well formed body of

conceptual knowledge formulated in language dominates his/her memory and controls his/her graphic work.

Drawings are graphic accounts of essentially verbal processes. As a verbal education gains control, the child abandons his/her graphic efforts, and relies almost entirely on words.

LANGUAGE HAS FIRST SPOILT HIS/HER DRAWING, AND THEN SWALLOWED IT UP COMPLETELY. Karl Buhler

As they get older [between the ages of ten and 15] they continue to draw from their imagination but become more consciously aware of what the world around them looks like. Their focus is now on how successful the drawing is as an end product as they strive to produce more 'adult-like' mature drawings. They recognise that in order to be able to draw this more grown-up three dimensional world, they will have to work hard and change the immature child-like way that they have previously drawn.

Making these adjustments can be difficult, and what seems to happen to some students is that if the drawings they make do not match their 'mental picture' of what the world they see looks like, they become very self-conscious and embarrassed by what they perceive their visible lack of ability—their confidence wanes and they decide that drawing is not for them. Because drawing is generally seen as a talent, and not a learned skill, they readily accept that they have no talent for it. Once they recognise that the world they are attempting to draw looks a bit like a photograph, their rational brain tends to only value a drawing whose likeness to what they see is photographic, and if they continue to draw, they are likely to start copying information from flat, two dimensional photographs because it is easier than drawing a 'real' object that exists in three dimensional space. Students of this age [14 to 17] often spend endless periods of time in their bedroom listening to music, and rigorously copying photographs in order to satisfy their creative needs and gain credence with their peer group.

Examining the three dimensional world of space and objects in a purposeful way, and learning how to see and describe it through the process of drawing is largely undervalued in school, and it is assumed that as the students' intellect develops, so will their ability to see and draw.

Unfortunately most adults' drawing skills do not develop beyond those of the young adolescents who gave up drawing. The world is full of educated people who, it is assumed, see the world as sophisticated adults, but draw like adolescents.

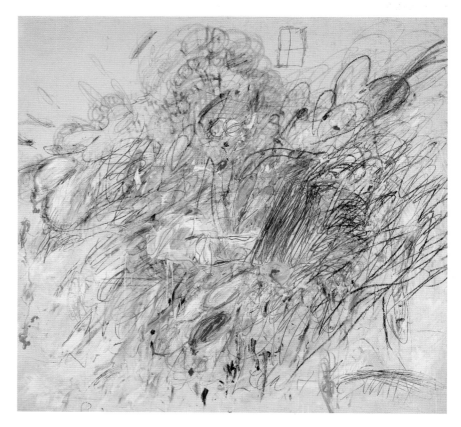

PREVIOUS PAGES Mick Maslen and Jack Southern introduce the workshops on the first day of Workshop 1, April 2010.

LEFT Daniel Magellan Maslen (aged five), *Dad*.

RIGHT Cy Twombly, *Leda and the Swan*, 1962, oil, pencil, and crayon on canvas, 190.5 x 200 cm. Acquired through the Lillie P Bliss Bequest (by exchange). Courtesy the Museum of Modern Art, New York. © 2011. Digital image, The Museum of Modern Art, New York/Scala, Florence.

THE HEMISPHERES OF THE BRAIN

In popular psychology, broad generalisations are often made about the lateralisation of certain functions occurring in either the left or the right hemispheres of the brain. These lateralisation's need to be carefully considered because the evidence is not entirely conclusive. However, it is generally accepted that the two hemispheres work together and share information through the *Corpus Callosum*, but that at the same time, they do retain aspects of difference. The main concerns of the left hemisphere are the verbal, numerical and rational processing of information, and it tends to have a preference for linear and logical thinking.

However, the right hemisphere is predominantly non-verbal, non-linear, and non-rational, and is primarily concerned with the state of 'being'. It intuitively links shapes and patterns of thought into relational states of 'wholeness' by sensing, and feeling its way towards a notional idea.

THE MAIN THEME TO EMERGE... IS THAT THERE APPEAR TO BE TWO MODES OF THINKING, VERBAL AND NON-VERBAL, REPRESENTED RATHER SEPARATELY IN LEFT AND RIGHT HEMISPHERES, RESPECTIVELY, AND THAT OUR EDUCATION SYSTEM, AS WELL AS SCIENCE IN GENERAL, TENDS TO NEGLECT THE NON-VERBAL FORM OF INTELLECT. WHAT IT COMES DOWN TO IS THAT MODERN SOCIETY DISCRIMINATES AGAINST THE RIGHT HEMISPHERE. Roger W Sperry

Not many of our schools devote much time to the development of creative thought, or intuitive 'side-ways thinking', and non-verbal activities such as Art, Music, and Sport are often regarded as secondary subjects.

Students are usually educated in an environment that is left-brain dominant, structured to encourage and develop a rational and linear, a, b, c, sequenced sense of order, logic and reason. At the centre are the so-called "3 Rs"—reading, riting and rithmatic. A National Curriculum of subjects, measured grades, and competitive testing is the predominant norm of the school environment, and students are encouraged to collude with the system, by learning to answer teachers' questions with the 'right' teachers' answers. Schools tend to support the development of thought processes that involve constructing rational arguments to find the 'right' answer, and prefer the employment of logically reasoned thinking methods to solve problems. This is fine, but it tends to favour the student whose brain is left side dominant.

In his book *Hare, Brain, Tortoise, Mind*, Guy Claxton discusses a layer of thinking that is—"often less purposeful and clear-cut, more playful, leisurely and dreamy". "...able to tolerate information that is faint, fleeting, ephemeral, marginal or ambiguous". A place where we ruminate and allow the mind to wander, a place that he calls "the tortoise mind". A place where the unconscious mind "cultivates slower, mistier ways of knowing"—an 'open' place of mind that is often associated with creativity. Creative people—artists, musicians, writers, painters, chefs, footballers, comedians, scientists, and so on—tend to be able to think in this way. They often create problems to solve, and are interested in the question as much, if not more, than the answer.

THE WRONG ANSWER IS THE RIGHT ANSWER IN SEARCH OF A DIFFERENT QUESTION. COLLECT WRONG ANSWERS AS PART OF THE PROCESS. ASK DIFFERENT QUESTIONS. Bruce Mau

Learning how to ask relevant and interesting questions is an essential feature of a curious and enquiring mind, and should be at the centre of everyone's educational experience. We see our world through the kind of questions we are able to ask about it, and by asking "more interesting questions", we will discover more interesting ways of seeing it. These 'more interesting questions' are more likely to originate in the "tortoise mind" or right hemisphere of the brain, in which our intuition links unconscious patterns of thought, and presents us with creative options—"out of the blue, eureka moments of insight".

What is the purpose of Education? What is worth knowing? How do we create an environment that caters for the 'whole' person and encourages the development of both sides of the brain, or other ways of thinking?

In the context of school the students who inhabit something of a "tortoise mind" tend not to be restricted by teacher's questions, fixed ideas, and learned behaviour. They learn by osmosis—are healthily sceptical, and unconsciously absorbed, ask questions and contribute an interesting point of view.

They are likely to be open-minded and flexible in their thinking—courageous in their risky and imaginative uncertainty, and because they are able to hold conflicting opinions—they are able to suspend judgement whilst making decisions.

In the educational environment these students can be perceived as being preoccupied, 'arty' and 'a bit of a dreamer'. The art room can become a haven of respite for them. To them, Art is a free-thinking shapeless subject where anything can happen. It has no fixed boundaries, and there are no 'right' answers—only interesting questions. It supports their way of 'being' because it can be a place in which they are encouraged to value their individuality and feel at one with themselves.

For the student who got stuck with attempting to rationalise visual reality, and gave up drawing, learning how to draw requires them to re-define their idea of what a drawing is, or might be, and adjust the way they think and see in relation to it. This necessitates a shift of consciousness, which for some students requires a significant amount of unlearning, mainly of habits and preconceptions already formed. In order to do this, it is important to set up the appropriate conditions in which to draw. The mind should try to free itself from the interfering, correcting influence of the left hemisphere, and the information overload and pressures of daily life that can block our state of being. It should occupy a neutral space in which seeing is the flexible interaction between unlabelled, projected and received information, and it should be in an unconditional state of focused empathy with its subject.

OPPOSITE Leonardo Da Vinci, *A Study of a Woman's Hands*, 1490, metalpoint, heightening and charcoal on paper, 21.5 x 15 cm. Courtesy The Royal Collection © 2011 Her Majesty Queen Elizabeth II/ The Bridgeman Art Library.

IT IS OFTEN SAID THAT LEONARDO DREW SO WELL BECAUSE HE KNEW ABOUT THINGS; IT IS TRUER TO SAY THAT HE KNEW ABOUT THINGS BECAUSE HE DREW SO WELL. Kenneth Clarke

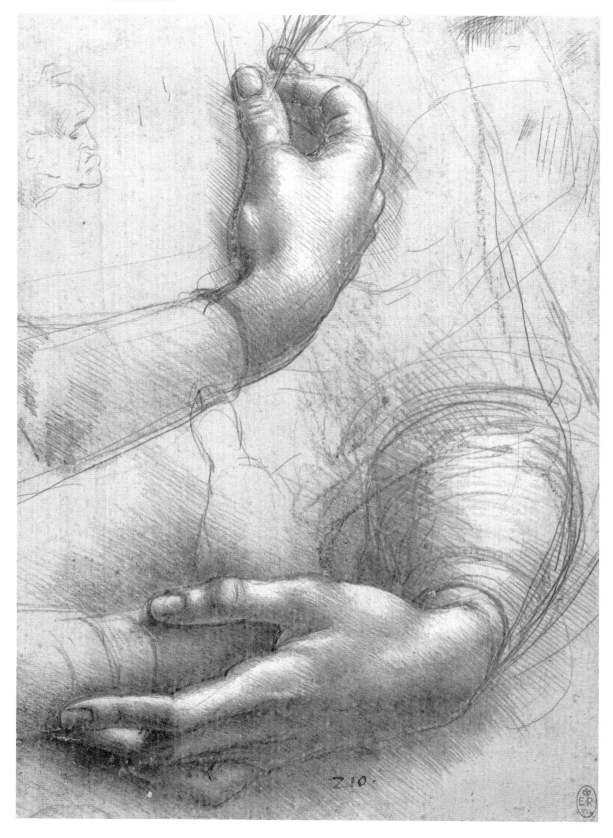

ON LEARNING TO DRAW

Every drawing has something to offer, and no drawing, or way of drawing will provide a permanent solution to what drawing is or should be.

Because of the subjective nature of drawing, and the massive potential for individuality, there are always alternative ways to make either different or better drawings. It is possible that the less skilful you are, the more skilful you wish to be, or the more skilful you become, the more, unsophisticated, and naive you wish to be.

Learning how to draw necessitates continual reappraisal of the criteria used to measure a drawing's success or failure, and it never exists in an attainable fixed state. We may only ever be just about good enough, and the quest is always the search to improve and make the next drawing better than the last. It is a continuing process that always starts in a different place, and follows neither a linear nor sequential route.

To some extent, we draw what we are, and a drawing is a visible manifestation of the personality, process of looking, decision-making, and mark-making skills of the person/student who made it. All students' start from positions unique to themselves, and discover empirically by hard work, and critical awareness, their own pathway to better drawing. It does not follow however, that we continue to improve and develop *ad infinitum*, and that each successive drawing is an improvement on the previous one. If this were the case, we would all be master draughtsmen after a few years. Progress is often difficult to measure, and as something is gained, something else may be lost.

Drawing, like juggling requires us to keep an almost infinite number of possibilities in mind and at hand, all at the same time. There are endless ups and downs, peaks, troughs, plateaus and regressions, throughout all of which we must maintain a consistent level of faith in our ability to improve. It should be a personal inquiry, based on practice before theory, whereby we are always seeking our own unique and individual solution to the problem at hand.

Our whole personality is involved in the making of analytic and aesthetic decisions, and our personal preferences, form the basis for work that should always be an expression of our individuality.

Our study should emphasise both an intuitive and analytical approach to using materials and formative principles. It should be an inquiring investigation into the world of visual appearances—and the discipline necessary to make good work should not exclude the potential for free and 'spontaneous un-thought knowing' to occur.

Unconscious impulses, following one's feelings, and the use of intuitive judgment, are absolutely essential elements in the organic development of drawing.

It is the manifestation of a mental dialogue, an expression of visual thought, the product of an assimilating process, by which information is taken in through the eyes, and other senses, examined, and restructured in the language and materials of the activity of drawing. It offers us a chance to really look at the forms, structures, spaces, and surfaces of the world in which we live, and thereby gain a greater understanding of them. It provides us with the means by which to describe, assemble and form this understanding in other materials, and express our own particular and personal point of view.

This examination of appearances, through the drawing process, forms the backbone to all the traditionally valued activities of the artist, and is the essential base upon which all the Visual Arts are formed. It is a complex dialogue of two-way selective information processing, that results in a direct and immediate means of visual communication.

WHEN YOU CAN DRAW, YOU ARE ALWAYS AN ARTIST. This quote has been attributed to Ingres, and to a large extent it is as true today as it was in his lifetime. All you need is something to draw with, and something to draw on. On a basic level, a pencil or stick of chalk or charcoal and a piece of paper, wall or any surface will be enough. You can be an artist anywhere in the world and need only the minimum amount of equipment and materials necessary to draw. To see the world through drawing is to see the world through the eyes of an artist.

ONE MUST ALWAYS DRAW. DRAW WITH THE EYES WHEN ONE CANNOT USE A PENCIL. Balthus

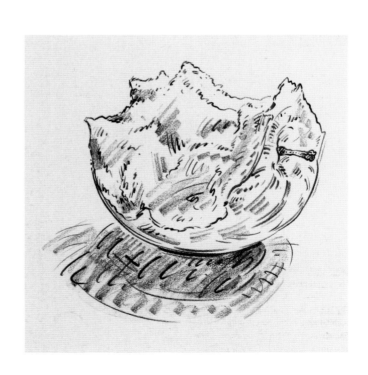

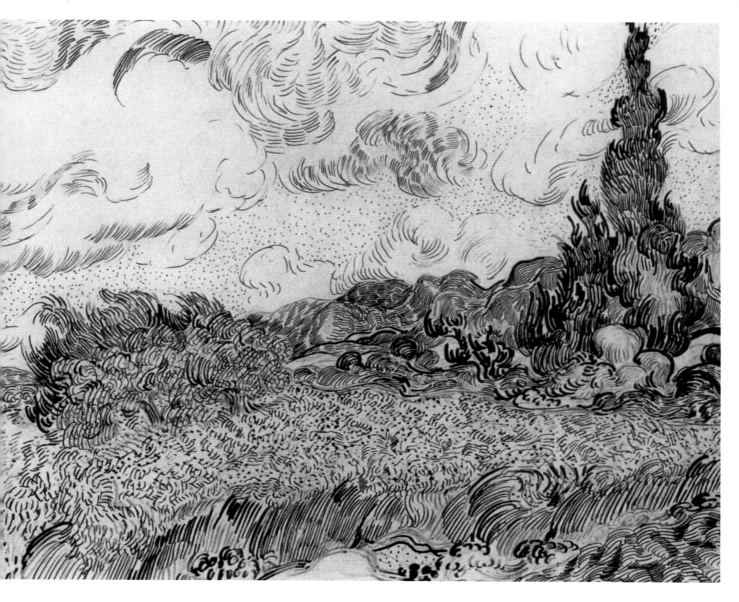

OPPOSITE *Half Eaten apple*, Mick
Maslen, pencil on paper, 20 x 20 cm.

ABOVE Vincent van Gogh, *Wheat Field
with Cypresses at the Haude Galline near
Eygalieres*, 1889, 47 x 62 cm. Courtesy
Van Gogh Museum, Netherlands.

DRAWINGS

TELLING THE TRUTH WITH LIES

ONE OF THE THINGS I'M DOING IN YORKSHIRE IS FINDING OUT HOW DIFFICULT IT IS TO LEARN NOT TO SEE LIKE THE CAMERA, WHICH HAS SUCH AN EFFECT ON US. THE CAMERA SEES EVERYTHING AT ONCE—WE DON'T. THERE IS A HIERARCHY. WHY DO I PICK THAT THING, AS OPPOSED TO THAT THING, OR THAT THING? David Hockney

Photographs are the most accessible representation of our visible world, and are generally accepted by people as being fairly accurate pictures of our shared reality. When learning how to draw, adolescents sometimes struggle with their developing understanding of what they see as reality, and their limited ways of describing it. If this is the case, it is likely that they do not have a usable definition of what the activity of drawing might be, and their limited level of understanding settles on deciding that the success of a drawing is measured by its likeness to a photographic illusion.

To make a drawing that looks like a photograph requires you to make measured judgements that have no individual human qualities or personality, and in which any trace of the human condition or gesture of the hand is denied.

EXACTITUDE IS NOT TRUTH. Henri Matisse

A camera has no feelings or spontaneous thoughts. Imagine a computer reciting Shakespeare, and then think of the camera/photograph as its metaphorical equivalent. If 20 people were all to draw the same thing, and all of the drawings looked like the same photograph, it would be difficult to distinguish the unique and individual character of any of the people drawing.

A PHOTOGRAPH IS STATIC BECAUSE IT HAS STOPPED TIME—A DRAWING IS STATIC, BUT IT ENCOMPASSES TIME. John Berger

Drawings that use photographs as their source material can be mutually supportive and can extend the potential of both. They might enhance something that is particular about the image being used—perhaps the subject matter, or any visual qualities that are integral to, and suggested by the photographic process/medium itself. A drawing made 'from the photograph' might personalise the artist's relationship with the photograph in a way that re-invigorates any personal intimacy they might feel and have for something in the content of the photograph, and in essence, their drawing transcription might describe something in a way that the photograph does not.

A drawing is often a two-dimensional illusion of an aspect of our three-dimensional world. It is a marriage of decisions and marks that are brought together and accumulated in a considered and carefully constructed order, to represent, or re-present the 'reality' of the experience, being seen, discovered, understood, and known through the eyes.

A drawing can be seen as an act of theatre. To make a drawing from life requires the artist to engage in an interactive dialogue whereby they are immersed in a performance—as,

ABOVE Dryden Goodwin, *Cradle 15*, 2008, scratched black and white photograph, 160 x 110 cm. Courtesy the artist.

OPPOSITE Dryden Goodwin, *Amit*, from the Red Studies series, 2009, watercolour on paper, 57 x 38 cm. Courtesy the artist.

actor, audience and subject. In much the same way as the actor convinces us by intelligent trickery and deceit about the truth of the character he or she represents, the good draughtsman convinces us of the truth of his drawing by making a clever illusion. It is not an exaggeration to say that the draughtsman must learn to tell the truth with lies. Being able to see the truth, and learning to approximate it with a constructed surface of carefully chosen and expressed marks/lies, is the stuff of good drawing. Sometimes these lies need to be made more dramatic, and almost presented as caricature, in the way the actor's gestures are demonstrative, and made available to the whole auditorium. Other occasions will warrant a more subtle approach. Actors get into the part they play, and develop a feeling for it. Good draughtsmen often do the same. They feel the marks they make, and believe in them as an expressive equivalent of truth, and like the actor, they must say/draw it with feeling.

THE HAND THAT SEES, LEARNING TO SEE

Learning to see is an essential part of learning to draw, and it is an ongoing and continuous process of achievement that develops with every drawing we make.

Before you are able to draw, you must learn to see, and you learn to see by drawing. Drawing is the process of seeing made visible. It is the mediating experience between looking and responding by which we learn to see.

TO DRAW IS TO LOOK, EXAMINING THE STRUCTURE OF APPEARANCES—A DRAWING OF A TREE SHOWS NOT A TREE, BUT A TREE BEING LOOKED AT. John Berger
Re-appraising the habits and conventions of the way we see is part and parcel of the continuing practice of drawing, and the development of a visual awareness through critical analysis is a necessary part of the process. Learning how to see the world as a potential drawing becomes clearer to us as we make more drawings.

The 'Medium' is still part of the 'Message' and in some ways we see the world around us through the particular and special qualities of whatever medium we use to describe it. How well we describe it is dependent on how well we are able to use our knowledge of the medium as a vocabulary of descriptive language.

WE ARE IMPRISONED SO TO SPEAK, IN A HOUSE OF LANGUAGE Edward Sapir and Benjamin Lee Whorf
Sapir and Whorf are of course referring to written and spoken language. A five year old child with a limited spoken vocabulary might describe a situation as "the cat sat on the mat". The same event might be described by an articulate 12 year old as "marmalade, the ginger cat, sprawled sleepily across the Indian rug".

Both say the same thing, but one uses 'better', and more descriptive language. A novelist or poet is likely to have a more extensive vocabulary from which to select. The writer James Joyce was reputed to have been able to speak 13 different languages. This allowed him to view his experiences through an extensive range of language, and selectively translate and re-structure them as literature in his native tongue, English. Robert A Johnson in his book, *The Fisher King, and The Handless Maiden*, states:

A poverty-stricken vocabulary for any subject is an immediate admission that the subject is depreciated in that society. Sanskrit has 96 words for love; ancient Persian has 80, Greek three, and English only one. This is indicative of the poverty of awareness or emphasis that we give to that tremendously important realm of feeling.

DRAWING LANGUAGE SKILLS

In much the same way as the articulate 12 year old increased her knowledge of words and enhanced her descriptive writing skills, we can improve our drawing language skills, by extending our vocabulary of marks, materials and approaches. Having the right language elements—selecting the right materials, point of view, etc., making the right marks in response to what is seen, and learning how to organise and structure a drawing to provide the best possible outcome is an ongoing and continuous process of achievement that develops with every drawing we make.

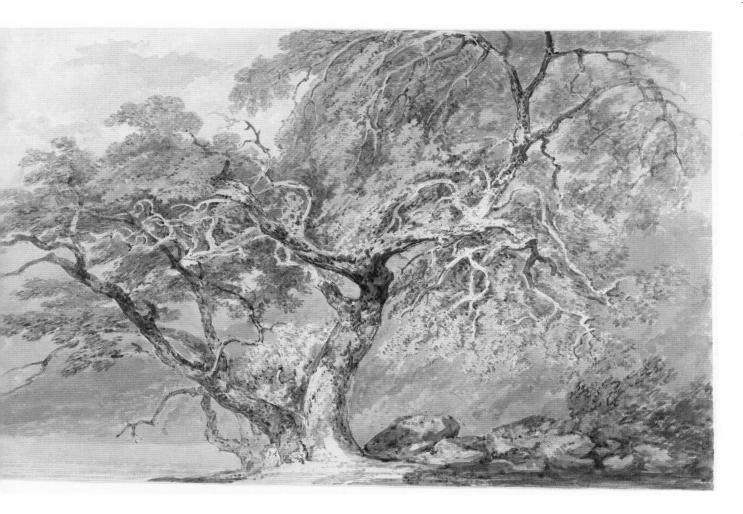

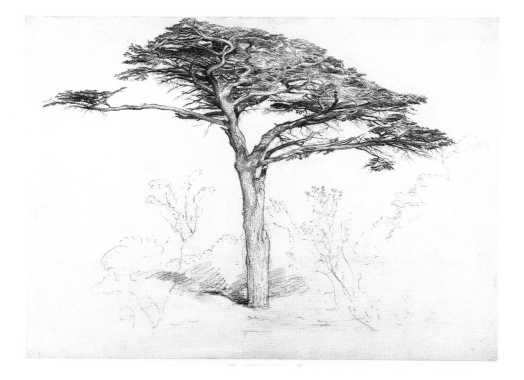

THE EYE THAT FEELS

We must learn to think with our feelings and feel with our thoughts.

> EVERY VISUAL EXPERIENCE IS AT ONE AND THE SAME TIME A RECEIVING OF FRAGMENTARY INFORMATION, A GIVING OF FORM TO THESE VISUAL SENSATIONS AND THE AROUSING OF A FELT RESPONSE. WE MUST BE CAREFUL TO REMEMBER THAT FOR THE ARTIST WHAT ULTIMATELY MATTERS IS THIS QUALITY OF FEELING WHICH RESULTS. Maurice de Sausmarez

TOWARDS A FEELING RESPONSE

We live in an age when computer generated reprographic processes provide us with a world of 'technological perfection' and 'high definition'. Three-dimensional imagery offers limited, but enhanced and often 'super-real', virtual reality. It is a time in which the large flat TV screen is providing our children with replacement substitutes for what might to a previous generation have been an exposure to, and an active involvement with, an experience of rich sensory pre-verbal childhood play. It is more important than ever that, in this world of 'perfect reproduction', our children do not literally get 'out of touch' with their senses, and that a drawing retains its value as a unique, hand-made object, which contains and expresses qualities that are as individual and special as its creator.

Human beings are lumps of perceptions in a state of flux, and 'being' is a constantly changing state of infinite variety. Drawings are made by human beings and like their makers, they can be complex, somewhat vulnerable, unresolved, and imperfect. Equally, they can be confident, measured, controlled, well understood and decisive.

A drawing is a lexis of marks that represent and describe what our eyes see, and to some extent what our minds/bodies know and feel. It is made by the co-ordination of the eye/brain/hand/medium, and arranged in an organised and cohesive way to form a visual description/illusion. It is a trail of contained energy, incorporating the history of its own making, and recorded through a passage of time. It is an approximate attempt at depicting a perceived truth, and will have been made in either a confident, cautious, well seen, well understood, generalised, decisive, indecisive, 'right,' or 'wrong' way.

> I MERELY DRAW WHAT I SEE. I DRAW WHAT I FEEL IN MY BODY. Barbara Hepworth

It is a hand-made object that includes passages of difficulty and trauma—areas worked at, struggled with, disguised, hidden and overcome, whose accessibility lies to some extent in its 'body odour' and state of imperfection.

Drawings are almost always the product of adventure and struggle, and metaphorically speaking, every drawing has a potential dragon that needs slaying on the way to freeing the princess, or securing the pot of gold. It is the fisherman's struggle to lure and land the fish, and our own search for the Holy Grail.

> DRAWINGS REVEAL THE PROCESS OF THEIR OWN MAKING—THEIR OWN LOOKING. John Berger

Every drawing should tell a story, the tale of the looking, the seeing, and the making. It should be the creation of a problem solved, whereby the viewer is offered a glimpse of the problem, and the journey and story of its solution.

Young drawing students are often rather self-conscious and tend to be anxious and over concerned about their 'style' and need to have a style. Style is naturalness consistent with the temperament and aim of the artist, and is evident in the personality of the drawing and the manner and quality of language used to describe what is seen. It may have qualities that can be described as being 'tight', 'loose', 'generalised', 'sensitive', 'tentative', 'bold', 'dull', 'lifeless', 'lively', or 'well seen'.

> THE STYLE IS THE NATURE. Jean-Auguste-Dominique Ingres

What is displayed as an important quality of the drawing and available for all to see, is the nature, character, personality, and style of the person that made it. It is not an exaggeration to say that the drawing is as much about the artist as it is about what is being drawn, and it may on occasions tell you more about the artist's state of mind, level of understanding, etc., than it does about their subject matter.

ABOVE Richard Busk, *Untitled*, 2001, charcoal on paper, 59,4 x 84 cm. Courtesy the artist.

OPPOSITE Augustus Edwin John, *Dorelia Asleep*, 1903, black chalk, 35.1 x 29.7 cm. Courtesy the Yale Center for British Art, Paul Mellon Collection, USA/ The Bridgeman Art Library.

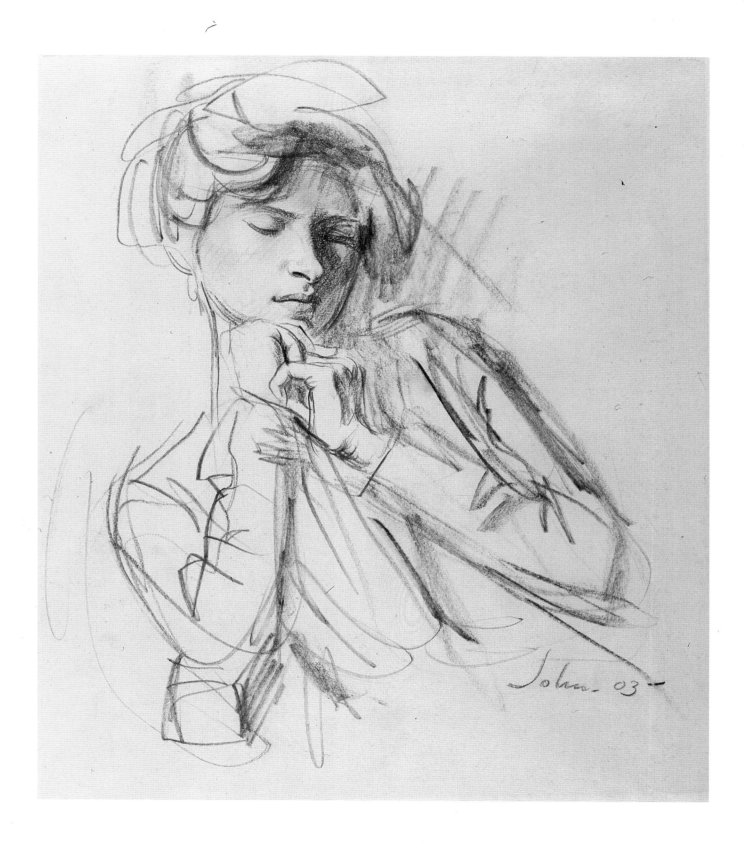

John. 03

CONCEPTS & PERCEPTS

Although our eyes are very flexible, they can only focus on a small area of the large visual field at any one time. They are generally undirected, and arbitrarily scan their field of vision, only focusing on objects of potential interest and the spatial context in which they exist. This information is perceived on the retina as a visual image, and deciphered, categorised and understood by the brain. The looking eye is largely indiscriminate in its behaviour, and it is as if its initial function is to operate slightly ahead of the brain in order to inform the brain of what is worth taking time to look at. Most of the time, it scans the world like a video camera—digests what it sees as recognisable information, and it is only when interested in the unfamiliar, that the brain directs the eye to pause and explore.

WHAT WE KNOW, AND WHAT WE SEE

Part of the continuing process of seeing the world around us is the transforming of perceived information into conceptual information. We do, in part, see with our experience and knowledge, and are thus able to comprehend that a round plate when seen in perspective as an ellipse, is understood conceptually and with prior knowledge to be a circle in real space. Both our perceived world, and the Drawings we make are a hybrid of projected and received information. They are a marriage of 'what we know', and 'what we see'. They are 'perceptual concepts'—felt thoughts that are turned into—

'REPRESENTATIONAL CONCEPTS'—THAT IS THE CONCEPTION OF THE FORM BY WHICH THE PERCEIVED STRUCTURE OF THE OBJECT CAN BE REPRESENTED WITH THE PROPERTIES OF A GIVEN MEDIUM. Rudolf Arnheim

What distinguishes the artist's way of thinking is his ability to translate his concepts into a particular medium.

When we are making drawings, we must learn to use 'what we know' selectively, and only when it helps us to communicate a clearer understanding of what it is we are attempting to describe in the drawing. Students are constantly being told by their teachers to "look more carefully", and to "draw what you see and not what you know". The most common mistake we make is to draw our limited and ill-conceived knowledge as a pre-conceived fact, and in this case we are making it up from what is probably our poor and limited visual memory. As a general rule, it is always better to look very carefully, and draw what you see. Not looking intently enough usually results in using generalised and 'unseen' information that has been conceptualised and become fixed.

EVERY MAN MISTAKES THE LIMITS OF HIS VISION FOR THE LIMITS OF THE WORLD. Arthur Schopenhauer

LABELS

Language and labels can either limit or free us.

WHATEVER STRUCTURE THERE IS TO ANYTHING IS A PRODUCT OF THE COGNITIVE PROCESSES OF

THE STRUCTURER—I.E., THE PERCEIVER WHAT WE HAVE TO REMEMBER IS THAT WHAT WE OBSERVE IS NOT NATURE ITSELF, BUT NATURE EXPOSED TO OUR MEANS OF QUESTIONING IT. Werner Heisenberg

In other words, we do not get meaning from our environment, we assign meaning to it. What is 'out there' isn't anything until we make it something, and then it 'is' whatever we make it. Most of our 'meaning-making' consists essentially of naming things. Whatever we say something is, it is not, but in a certain way, it is. Once the label has been learned, it becomes a shorthand substitute for what the 'object' is or does.

It contains and defines our understanding, and inhibits any need to discover or re-discover the object as something unknown and new. Students of drawing have a tendency to 'draw the label', and their memorised knowledge. They allow themselves to draw without really looking at their subject and make poorly informed generalisations that approximate their limited understanding and knowledge.

A student of the painter James Whistler told him that she only painted what she saw. His reply was "but the shock will come when you see what you paint". For the purposes of drawing, we should always look at objects as if they were new and unfamiliar—in a state of enquiry—and without the labels.

WISDOM IS THE FORGETTING OF ALL YOU KNOW. Arthur Schopenhauer

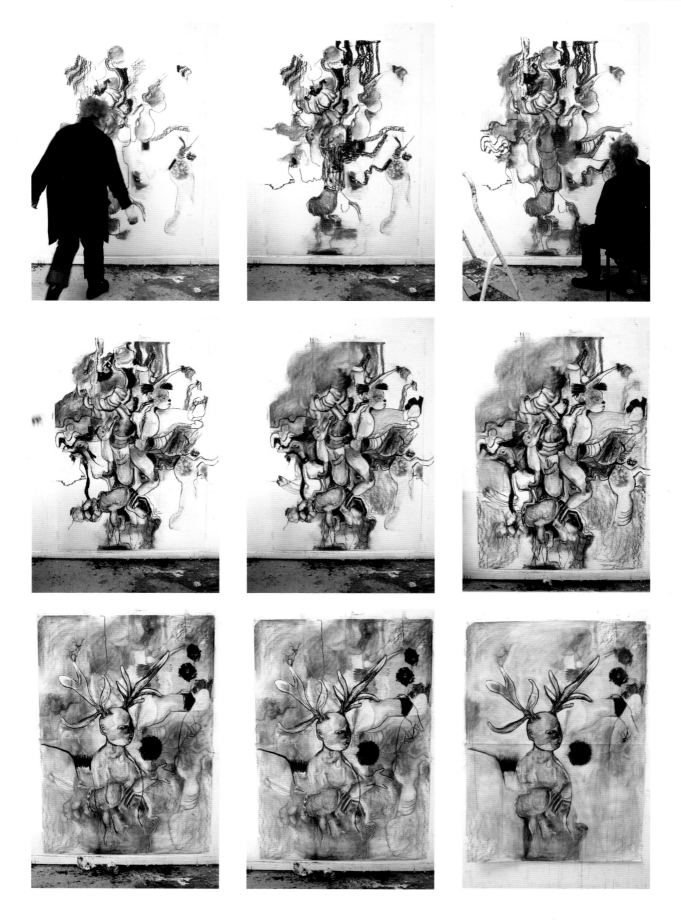

MARKS & MARK-MAKING

DRAWING IS THE SIMPLEST WAY OF
ESTABLISHING A PICTURE VOCABULARY,
BECAUSE IT IS AN INSTANT, PERSONAL
DECLARATION OF WHAT IS IMPORTANT
AND WHAT IS NOT. Betty Goodwin

Marks are the alphabet that forms the words that make the
prose, and are the elements with which the drawing is made.
Mark-making is the broad term used to include all marks that
are made visible as a manifestation of applied or gestural
energy. It is the gestural language of drawing, and marks are
the component parts within it. There are an infinite number
of marks possible, and our nomenclature for them is very
limited—lines, dots, dashes, smudges, etc.. It is difficult to
refer to specific marks, and know that the term adequately
communicates its intended meaning. Everybody makes his or
her own unique set of marks and every medium has its own
particular quality of mark.

How we 'read' and understand the meaning of a mark, or
collection of marks in a drawing, and what constitutes a 'good',
or 'better' mark, is both, subjective, and difficult to comprehend.
We might develop our understanding of what constitutes the
facility for 'good' mark-making by being aware of marks that

1_Are appropriate to our intentions—right for the job.

2_Are 'alive' and embody and express the 'life-energy' of
their maker, the artist.

3_Help to communicate and express qualities of light and its
invisible energy, and the material substance, form, volume,
and surface of the objects we are drawing.

4_Present the eye with changes of pace and rhythm that
collectively offer variety and interest. [The rich and varied
texture of nature and the world around us is our guide].

5_Express and stretch the properties of the medium that
the drawing is made from.

To a large extent our choice of medium determines the sort of
marks we make. Different papers respond to different mediums
in different ways.

IT IS ALL A GAME OF CONSTRUCTION—SOME WITH
A BRUSH, SOME WITH A SHOVEL, SOME CHOOSE
A PEN. Jackson Pollock

Some mediums make harder, more durable marks, that can be
controlled relatively easily, and hold their gesture well— pencils,
inks, etc.. Others are softer, more flexible, and fugitive, charcoal,
pastels etc.. Selecting the 'right' medium to make the 'right' mark
on the 'right' surface is an important decision to make. The size
of the marks we make, might, to some extent determine the scale
of the drawing. Marks made with a point, that are small, and/
or linear, may be best suited to smaller drawings, whilst bolder,
broader marks might suggest larger drawings. Experience will
teach what is possible, and what is preferred.

How the medium is held, is also a factor in determining the
sort of mark made. Our familiarity with picking up and holding
pens for writing creates a habitual approach to handling them,
and our lack of a reason to change, results in a mark we are

ABOVE Paul Johnson, 2008, pencil on
paper, 59.4 x 84 cm.

OPPOSITE R B Kitaj, *Ashmolean Drawing
(Oxford) IV*, 1958, pencil on paper, 53.3
x 41.6 cm. © The Estate of R B Kitaj.
Courtesy Marlborough Fine Art, London.

familiar with. Why does a pencil that is used for drawing, have to be held like a pen that is used for writing? It does not, and there are alternatives. Control is usually the determining factor when making this choice. The level of control is of great importance, but it must be in the 'right' places, and in the 'right' amount.

Too much control can result in a rigid drawing, that primarily communicates how anxious and frightened of 'getting it wrong' the artist has been whilst making the drawing. Artists often refer to certain drawings as being 'too tight' (rigid), and in order to avoid this, they develop all sorts of ways by which to make more relaxed, and looser drawings. The opposite might be too little control, resulting in loose marks that generalise the 'looking', and produce an equally unsatisfying drawing.

When drawing, we generally use marks that are made by movements from the wrist, from the elbow, and from the shoulder.

Marks from the wrist tend to be the most controlled and smaller—often being made with the support of the ball of the hand resting on the drawing. Marks from the elbow tend to be longer and more fluent—in arcs from the elbow, and without the hand resting on the drawing. Marks from the shoulder are the most fluent, and most linear.

Being asked to hold the drawing instrument differently, and to draw from the shoulder, using the whole arm might seem strange at first, but after a short time, and with practice, it will become second nature. It will provide a different quality of mark, and should be seen and valued for what it is worth.

Changing the way you hold the drawing instrument is a positive and exciting element of choice in the language of drawing.

Learning how to make the right marks is fundamental to learning how to draw. The marks that you make are the life and energy of the drawing.

FEELING THE MARK

'Feeling the mark' being made on the paper has to be consciously realised and learnt. It is a feeling that is made visible by focusing into and squeezing out of the pencil point/medium, a lighter, darker, thinner, thicker, twisted mark which is made in response to what is being seen at that precise moment.

We must learn to see as we feel as we discover as we draw, as a simultaneous act. Through the continuous practise of drawing and drawing and drawing, the intrinsic skills of looking, feeling, discovering and responding in marks can be made into one synergised action. A metaphorical equivalent for this simultaneous act in football might be how a professional footballer is able to pass the ball 60 metres to the feet of a team-mate, and precisely synchronise the distance, weight and speed of the pass all in one action of his leg.

Or in music—for example a saxophone player, it might be the simultaneous combining, in a synchronised moment, of the amount of air they control and blow into the mouth piece, with the pressing of the keys, and releasing a felt a note of perfect intent.

REPEAT YOURSELF, IF YOU LIKE IT, DO IT AGAIN,
IF YOU DON'T LIKE IT, DO IT AGAIN. Bruce Mau

Make your drawing instrument an extension of your brain, heart, eyes, arm and hand.

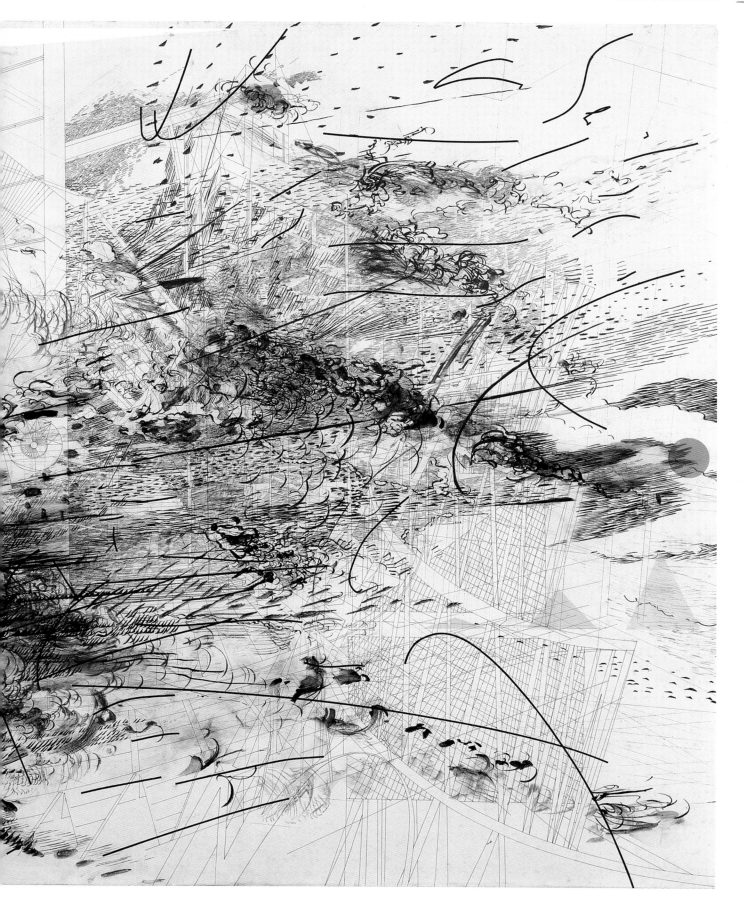

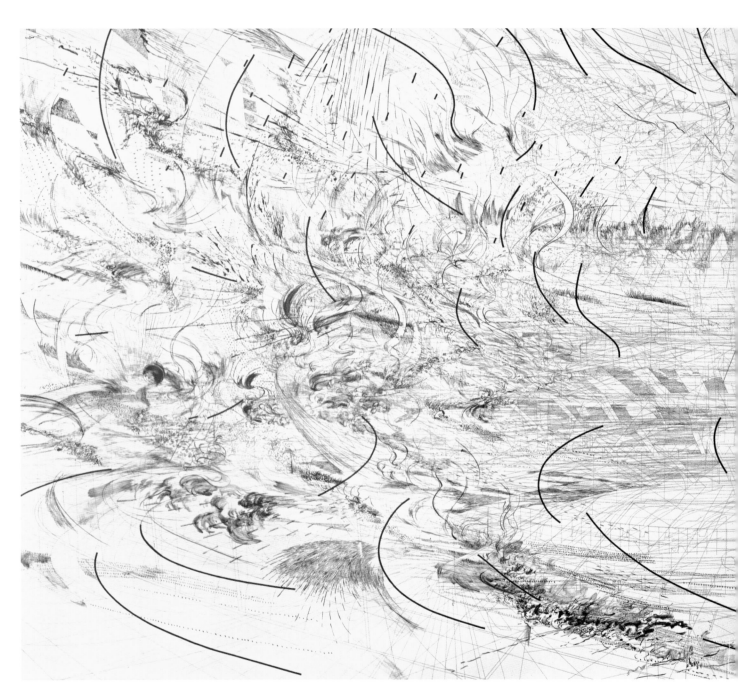

PREVIOUS PAGES Julie Mehretu,
Transients, 2006, ink and acrylic on
canvas, 123 x 154 cm.
Courtesy the artist and Marian Goodman
Gallery, New York.

ABOVE Julie Mehretu, *The Seven Acts of
Mercy*, 2003, ink and acrylic on canvas,
289 x 640 cm.
Courtesy the artist and Marian Goodman
Gallery, New York.

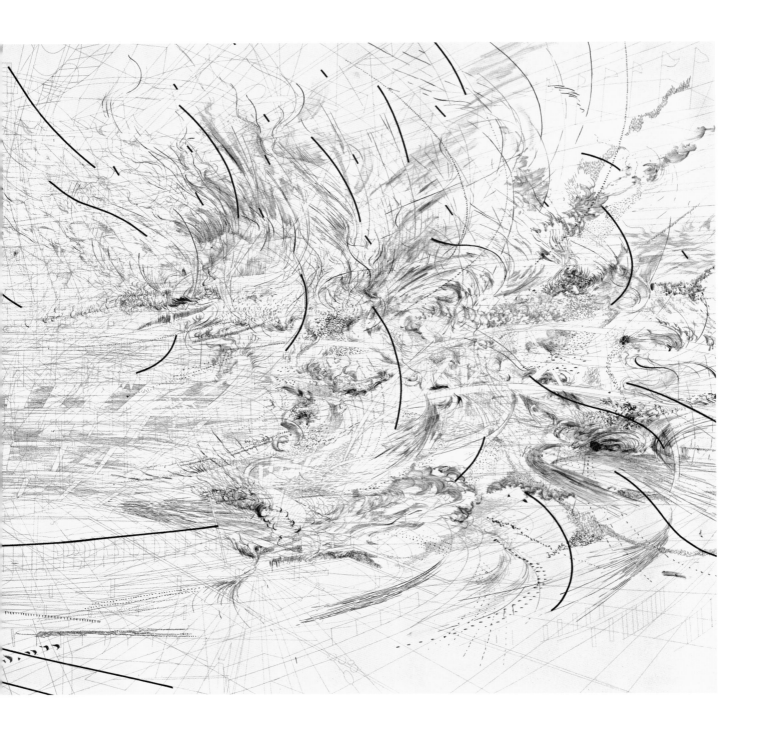

OUTLINE

Outline differs from contour line in that it determines only the boundary edge of shapes, and is perceived as being of even thickness and tone, and creates a generally flatter illusion akin to a traced shape or silhouette. Cartoons, primitive stick figures and children's drawings represent the same process, and are essentially conceptual.

QUALITY OF LINE

A quality of line refers to 'feeling' the mark as it is being made, and in response to the—'quality of seeing' and 'feeling' the contour. It is the manifestation of what is seen and simultaneously felt as the mark is made.

THE DISAPPEARING EDGE

This can be of paramount importance when it comes to drawing line. During one of the drawing workshops we carried out for this book (project three, drawing 16), a student asked an interesting question. "Where do I steal the edge from?" By "edge", she was referring to the drawing of a contour/boundary line. "Is the edge that we draw the edge of the object, or is it the edge of the space?"

It is of course both, and this provides us with an interesting clue as to how we might deal with edges and lines. Every object has a context. An object always is somewhere, and this 'somewhere' and the object are inseparably interdependent. Our perception of the object is greatly influenced by its context.

There are several things to consider. Look closely at the photograph. You will see that it is a piece of paper that has been folded into a surface of shapes which are revealed to us as a range of tones. This drawing demonstrates how objects and their context are interdependent. It also illustrates that there are 'right' places to change the weight/tone of the mark that you make as a contour, but they are only right in the context of what is being seen, and may not be right in the context of what is being felt.

Every object disappears [integrates into its context] at some point around its contour. When drawing objects as a contour line drawing, all that is demonstrated in this drawing should be considered.

The way the eye participates in looking at lines in drawings has also to be considered.

1_A line of consistent weight and thickness is strong and dynamic in tension but tends to flatten any intended 3-D illusion. It does not hold the eye's attention, and when looking, the eye speeds along it very quickly. It is in the main conceptual.

2_A broken line offers a stuttered slowing down of the eye.

3_A wobbly line might offer a touch of emotional interest, and intrigues and slows the eye down.

4_A change of weight and thickness may help to create an illusion of form and volume, and can offer interest and variety.

5_More than one line can give the eye an opportunity to participate in the drawing.

The eye is engaged in trying to decipher the image, and searches to select which one of these contours/lines is the intended one. A double edge/line or series of multiple 'echo' or 'aura' lines that run outside, and parallel to the object, will often help to seat it more comfortably into its context. This is similar to the way painters paint from both sides of an edge towards a position that suits both the object and the space.

Perhaps the student's question offered its own answer, in that there may be two, or even more edges. Edges, boundaries, and how to draw them, are one of the most interesting problems that painters and drawers attempt to solve.

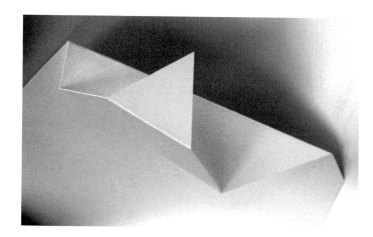

OPPOSITE Folded paper showing
the edge and drawing illustrating the
disappearing edge.

ABOVE Franziska Furter, *Vision/noludar*,
2008, pencil on paper, 21 x 29,7 cm.
Courtesy Galerie Friedrich, Basel.

TONE & LIGHT

TONE

If the world were a black and white photograph, its content would be seen as shapes of tone, ranging from white through a series of greys to black.

Tone is not to be confused with colour. Tone is a quality of lightness and darkness. Colour is defined by its hue, chroma, and 'tonal value', and it is its 'tonal value' that we need to acknowledge when making monochromatic drawings. 'Tonal value'—is the lightness and darkness of a colour, and whilst drawing, we have to constantly assess whether the colour of one object is lighter or darker than the colour of another.

When describing a shoe as being black, we are acknowledging both what is termed its 'local colour' [black] and also its 'tonal value' [black is dark]. A black shoe is only black as a labelled concept. We must recognise that within the blackness of the shoe, there will be differing amounts of absorbed and reflected light that require us to draw changes of tone. A black shoe with a shiny surface might reflect so much light that parts of it are seen as white. The same black shoe with a matt velvety suede surface might reflect a subtle range of mid-tone greys. Where these changes of tone are and how well they are seen, is crucial to the depiction of the objects character, form, and context.

A drawing that uses a range of tones from the white of the paper to the darkest tone a pencil can make is said to be showing 'full contrast', and conveys the subject as being seen in something like bright daylight, or strong artificial light. This is the norm for most drawings. Imagine a dimmer switch being turned on, from complete darkness through gradual increments of light, to reveal your subject in twilight, you would see it in 'half tone', where the lightest point would be mid-grey, and the darkest point would be black. This is a 'half-tone' drawing. Similarly a drawing of a white object in a white context, or a misty morning landscape, where the lightest tone is white, and the darkest tone is mid-grey may also be called a 'half-tone' drawing.

It is very difficult to use more than four or five tones when using a single pencil, [this is usually enough within any one drawing] but if you are using a pencil, each pencil will offer a different kind of tone, and may be used in any combination as required. The H range of pencils offers a harder mark and lighter tones, and the B range offers a softer mark and darker tones. The HB sits in the middle.

Establish the lightest and darkest points in the drawing and recognise that every tone is lighter than your darkest point, and similarly, every tone is darker than your lightest point. Use your scale of tones to match the tones you see between these two extremes.

Science tells us that all the objects and surfaces of our world absorb and reflect light, and what we see as colour, or as tone, is absorbed or reflected light. Darker objects absorb more light, and lighter objects reflect more light. Shadows are

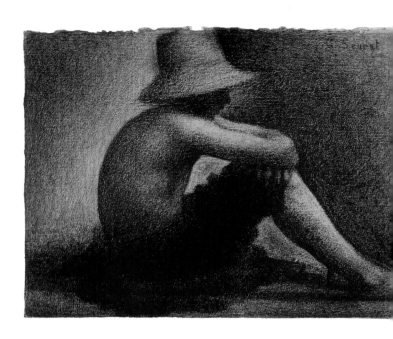

TOP Georges Seurat, *Seated Boy with Straw Hat*, study for *Bathers at Asnières*, 1883–84, black Conté crayon on Michallet paper, 24.1 x 31.1 cm. Courtesy Yale University Art Gallery. © 2011. Yale University Art Gallery/Art Resource, NY/ Scala, Florence.

BOTTOM Tonal range—from top, HB, 2B, 3B, 4B.

OPPOSITE Anita Taylor, *Resigned*, 2004, charcoal on paper, 182 x 136 cm. Courtesy the artist and Jerwood Foundation.

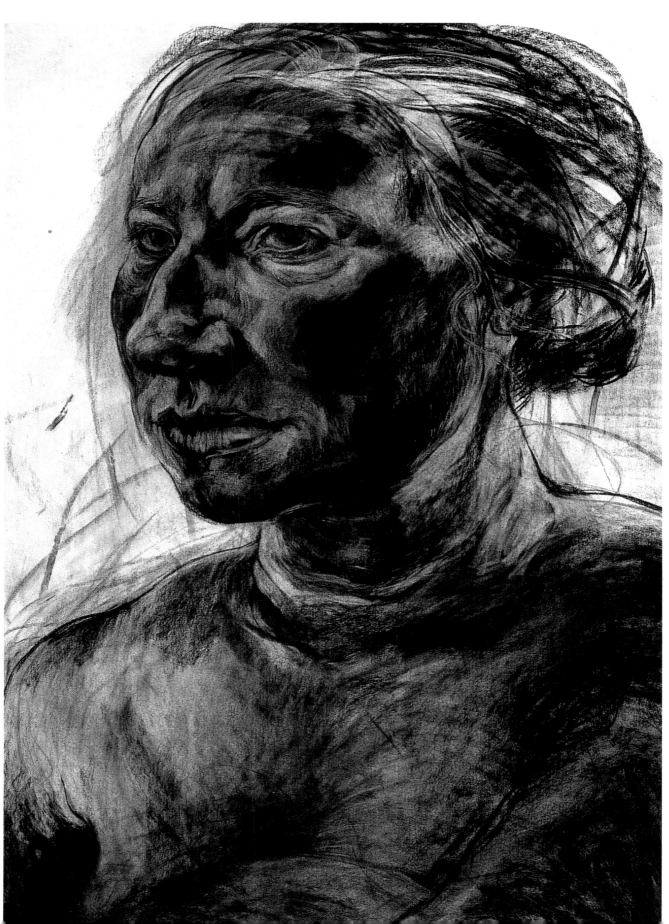

caused by an absence of light, and less and less light will result in a darker shadow. The stronger the light, the more emphatic the shadow.

When we draw the objects, surfaces and spaces of our world, we are to a very large degree, drawing an experience of light. The strange and wonderful paradox is that light is invisible, but makes things visible.

Without light our world would be invisible. The objects we know and touch are seen by the grace of light, and when we make drawings, we must not only depict the material nature of objects, but also the energy of the absorbed or reflected light that makes them visible. This light becomes the tone of the drawing, and may have very particular qualities. It may be: daylight, moonlight, night light, summer light, winter light, hard light, soft light, northern light, Mediterranean light, candle light, neon light, warm light, cold light, etc.. Light reveals form, and how we see form is dependent on how much light there is, and its directional origin.

A table top with a group of 'still life' objects on it is in effect a stage upon which the objects are actors playing a part. Their roles in this 'drama' are made visually richer by the creative and considered use of lighting, and the same objects will appear significantly different when lit in different ways. If a group of objects is strongly lit and dramatic shadows are created, the shapes and strength of tone of the shadows can be as important to the overall structure of the drawing as the objects themselves.

REFLECTED LIGHT

The term "reflected light", refers to a situation where light hits a surface, and is then reflected back onto the surface of an object in close proximity. It is particularly evident on objects whose surface is round or curved, and will be seen on the underside of them, being reflected back from the plane of the surface they are standing on. It is very important to train your eye to look for reflected light, as its depiction is especially crucial to the realisation of the roundness of form. An experienced drawer can always see inexperience in someone else's drawing, when there is no observed evidence of reflected light.

SHADING

The term "shading" is often used to describe the placing of tone in a drawing and is usually made as an optional extra. After reaching a certain point in the making of a drawing, schoolchildren often ask their teacher whether or not they can "shade it". This usually means that they want to carefully fill in a range of smoothly graded tones that direct the drawing towards a rather lifeless mechanical photographic likeness. For some students this can become a habitual mannerist solution to all tonal problems, and although useful in some instances, may need to be thoughtfully considered and only used when appropriate to the overall language of the drawing. Much the same can be said about 'cross-hatching'.

CROSS HATCHING

A cross-hatched area of tone holds the eye's attention more or less statically in a net of criss-crossed lines/marks, and the eye can sometimes have difficulty in escaping from the net to re-engage in its exploration of the rest of the drawing. It can be used to positive effect when an area of a drawing needs to appear flat.

HATCHING

When close parallel lines [hatched marks] are made, they have a directional emphasis that offers the eye a way in and out of the tonal area, and their use is often preferable to cross-hatched marks. They may also inform the eye about the direction of surface planes, and express both the energy of light and the life energy of the hand that made them.

BEAUTIFUL SCRIBBLE

It is not our intention to encourage and give license to a sloppy approach to putting tone into a drawing, and the word scribble has been used purposefully to imply an undefined looseness that has an easy relaxed feel to it. The word beautiful is used to value the scribble. If the occasion is right, make a beautiful scribble, as if you were a blind person touching the surfaces of the objects you are drawing, with sensual, tactile intent. These words are a rather limited attempt at suggesting being involved in making marks that are made in response to being in the experience of feeling with your eye/hand.

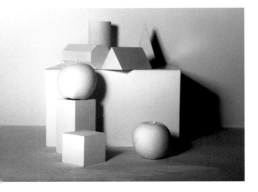

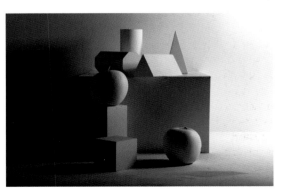

OPPOSITE Mick Maslen, *Dehydrated Bird*, pencil on paper, 21 x 30 cm.

TOP William Kentridge, *Thinking Aloud, Small Thoughts, Falcon and Dove*, drypoint from one copper plate on paper Hahnemuhle warm white paper, 20 x 25 cm, edition of 20. Courtesy the artist, Marian Goodman Gallery, New York, and the Goodman Gallery, Johannesburg.

BELOW Two examples of the way lighting effects the appearance of objects.

NEGATIVE SPACE

The area and space around and in between objects is called the "negative space". It is important to recognise the wholeness and interdependency of all the parts of your subject matter, the objects, and the negative spaces between, behind, and around them. Similarly, it is as important to recognise the wholeness and interdependency of all the parts of your drawing.

In our Western 'having' society, where consumerism and the ownership and possession of property and material things is the dominant social norm, and signals our success and status to the world, we give little regard to the immaterial.

Perhaps an eastern, more holistic attitude and awareness would allow us to have a greater understanding of the non-material and so-called "negative". Zen Buddhists would have us believe that

IT IS NOT THE CUP, IT'S THE SPACE INSIDE THE CUP THAT IS IMPORTANT.

Similarly in music, the spaces/silences between the sounds are crucial. Without them we would have continuous noise.

MUSIC IS THE SPACE BETWEEN THE SOUNDS.
Claude Debussy

THE CHERRY CAKE

The negative space in drawing is the equivalent of the cake in a mixed fruit and cherry cake. It is the relatively uninteresting stuff that binds the more important bits together. It is the subtle flavoured body and texture of the 'in between' that allows the fruit and cherries to be enjoyed as being more special. The amount of cake in proportion to the quantity of mixed fruit and cherries, and the quality of its texture and taste are vital to the balanced flavour of the cake. Too much cake/not enough mixed fruit and cherries, or, *vice versa*, might make a cake that is either bland and boring, or too rich. Students who have recently started to draw, tend to only have eyes for the mixed fruit and cherries, and not see or value the 'cake of the drawing'. They tend to go straight for the touchable, nameable objects of their subject matter, focusing in and separating out, and are quickly engaged in drawing the details, having paid little attention to the whole visual experience.

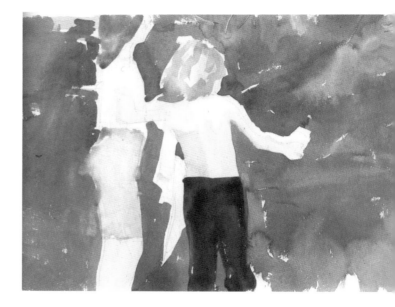

ABOVE Roger Coleman, *Study for Children with Coke and the Fence*, watercolour. Courtesy the artist.

OPPOSITE Roger Coleman, *Compositional Studies for Children with Coke and the Fence*, pencil, ink and pen. Courtesy the artist.

BEING SELECTIVE

The process of drawing incorporates important elements of decision making, and being selective. We have to make decisions about what to draw, where to draw it from, [from which point of view], what materials to use, what size it should be, how much information/detail we include in the drawing, what parts of the drawing we make more important and what parts of the drawing we make less important?

WHAT TO DRAW

It is possible to draw anything, and both what you draw and how you draw it is important. Some artists have drawn very ordinary and mundane objects, and made them appear exciting, whilst others have created dull and lifeless drawings from interesting things.

> I HAVE LEARNT THAT WHAT I HAVE NOT DRAWN, I HAVE NEVER REALLY SEEN, AND THAT WHEN I START TO DRAW AN ORDINARY THING, I REALISE HOW EXTRAORDINARY IT IS. Frederick Franck

To some people, some things will be easier and more rewarding to draw than others, and each of us discovers our own preferences.

For the purposes of the projects in this book, our choice of what to draw has been limited to accessible, interesting simple forms, that act as vehicles through which to demonstrate fundamental aspects of the language of drawing. In a letter to a young painter, Cézanne advised him to look at nature in terms of, spheres, cones, and cylinders.

Traditionally, artists were trained by copying 'master' drawings, drawing from the figure, and drawing from the cast, which was usually plaster, and therefore white. The whiteness limited the surface of the cast to areas of reflected, or absent light, and the object's form was seen more or less as a surface of tonal relationships. Selecting objects to draw should be done with consideration. Some objects inhibit and restrict, whilst others offer opportunity and freedom.

If you have only recently started to draw, then try to avoid symmetrical machine-made objects if possible. Your drawings of them will probably be inhibited, and they will tend to signal that you have failed to master their precise symmetry. A coca-cola bottle, is a coca-cola bottle, is a coca-cola bottle: regular, symmetrical, and 'right' with a hard, complex shiny surface—but no two trees, peppers or apples are the same.

NATURE IS THE ARTIST'S DICTIONARY Eugène Delacroix
Nature still provides the most interesting objects for a student of drawing to practice their drawing skills on. If possible choose objects that are flexible, and give license to make mistakes without it making a great deal of difference. A damaged rag doll, a tatty teddy bear, an old shoe that has taken on the character of its owner, a pepper carefully cut into two pieces to reveal an inner world of seeds, a cooked chicken leg, etc, offer more leeway to be approximate enough, and allow the drawing to be freed from the inhibiting need of having to make it absolutely correct.

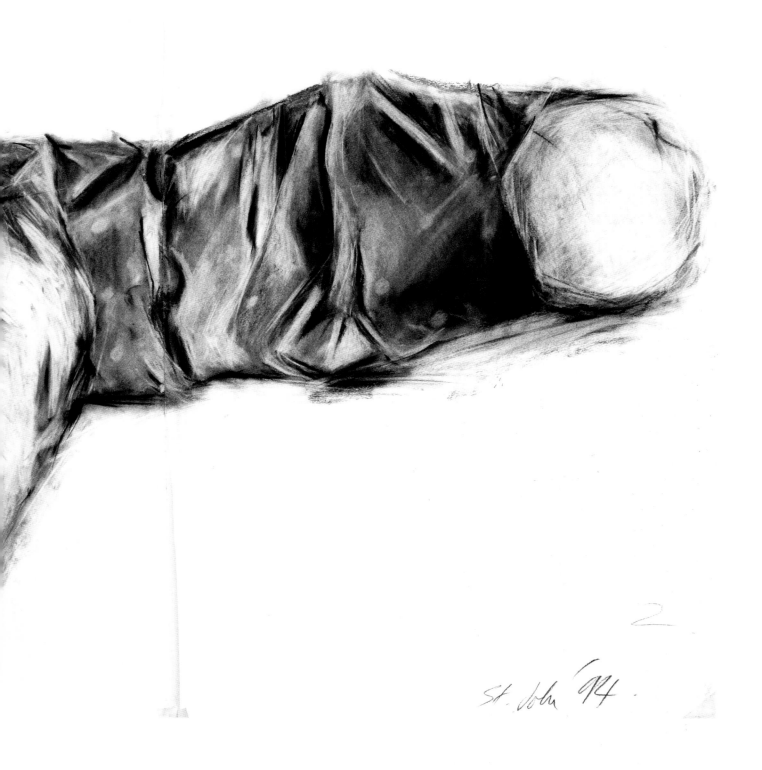

Ian St John Smith, *Fag End*, 1994,
charcoal on paper, 59,4 x 84 cm.
Courtesy the artist.

Try not to be over concerned with the accuracy of anatomical detail when drawing the figure, and draw the gesture and attitude of the pose, or when drawing an inanimate object try incorporating something of the mechanics of its functional purpose and practical use.

> TO DRAW A TREE, TO PAY SUCH CLOSE ATTENTION TO EVERY ASPECT OF A TREE IS AN ACT OF REVERENCE NOT ONLY TOWARD THE TREE, BUT ALSO TO OUR HUMAN CONNECTION TO IT. IT GIVES US ALMOST VISIONARY MOMENTS OF CONNECTEDNESS. Alan Lee

USING A VIEWFINDER

After deciding what to draw, and the scale of the Drawing, we have to visualise how it will be positioned within our piece of paper, and to help us do this we could use a 'viewfinder.' [See Materials and Equipment].

POINT OF VIEW

Deciding where to view your objects from is important, and although it is necessary to be comfortable whilst you draw, it is sometimes a good idea to surprise yourself by taking up an unfamiliar point of view. The ergonomic relationship between human beings, tables, and chairs is safe, but familiar, and it might be interesting, for example, to place the objects on a piece of paper on the floor, and draw them from above, almost as a plan. Alternatively, raise the tabletop, or lower your eye-level, or place your objects on different levels, or select a close-up section.

It is sometimes a good idea to view your objects as if you intended to photograph them, and that you had at least 12 different shots to take. The first few would be relatively easy and straightforward, but the last few would require you to search for a less obvious and more interesting point of view. Any more than 12 and you would have to work really hard and stretch yourself to find a new way of seeing your objects. It is very important to keep finding new and interesting points of view, and using a viewfinder will help you.

THE RECTANGLE

The majority of drawings produced today are made on rectangular pieces of paper. Our ancestors and other cultures, made drawings on the walls, ceilings and floors of their caves and buildings. They drew on rocks with mud and blood, and in the earth, dust, snow, and sand.

Drawings can be made by any means, on any surface, and on any scale. A child, when first discovering that marks can be made with crayons and felt-pens, will scribble and employ 'motor activity' to mark any available surface within reach, on the walls, up the stairs, on the floor, on the table, chairs, etc.. Anywhere is possible. Parents and teachers usually disapprove of this and sooner or later the child is given a rectangle of paper and encouraged to contain the activity,

and consequently the drawing. The child may even be made to feel guilty for making an uncivilised mess and going 'over the edge'. Metaphorically, this may be part of the story of our evolutionary conditioning.

In the West, we have constructed, and live in a world which is dominated by rectilinear structures. Our man-made world is full of rectangles—buildings, windows, walls, boxes, pages, books, pictures...

The development and use of the rectangular piece of paper is akin in importance to the invention of the brick, as a multiple unit in the evolution of man. Its dominant features are the combined strengths of gravity—the parallel verticals, and the horizon—the two horizontals. From these elements, we can mirror and measure our sense of contained equilibrium, and isolate, hold, and re-arrange any chaos, disorder or mess. This flat, two-dimensional box, with its parallel verticals, and parallel horizontals, is a container for our drawing. It is a 'picture window' within which we can create an ordered illusion/drama/world.

COMPOSITION

'Composition' is the term used to describe the arrangement and interrelationship of the parts within the rectangle. What this means is that within the contained space, all the parts have been organised to be mutually supportive and interdependent, and that they all contribute to make a unified and satisfactory whole. A satisfactory 'whole' is of course the personal and intended objective of the artist, and it could be that the student wishes their composition to defy conventional composition [as Bonnard did when cropping some of his paintings] and make what might be a so-called "bad" composition into a good work.

The containing edges of the rectangle frame the composition, and play an important part in giving it dynamic strength. How the internal shapes extend out of, and come into the rectangle at the edges is very important. If possible, try to tie/echo some of the internal forms and shapes to these vertical and horizontal supports.

When arranging your objects/spaces, in constructing a drawing you can learn to direct the eye in its exploration of the rectangle, and provide it with linked routes of discovery, and moments of focused interest. This can be done when physically arranging the objects, and also when pictorially adjusting them in the making of the drawing. Sometimes you can only see the composition as a potential drawing after making a preparatory drawing of it.

> EVERYWHERE I GO I FIND A POET WHO HAS BEEN THERE BEFORE ME. Sigmund Freud

THE FOCAL POINT

A focal point is probably best understood in terms of looking through a camera lens, and is the object, or part of an object, that you would select to be important enough to focus on before taking a photograph.

Our eyes are very sophisticated, and when they look at the world around us, they do not see everything in focus; they scan

around, picking out interesting things to stop and focus on, and flit from one point of focus to another, leaving the rest of their visual field to be seen as out of focus peripheral vision.

When we make drawings we tend to draw everything in focus as a result of carefully looking at all the bits separately. This is not always necessary, and it might be important to try and create areas of drawing that are in focus, and areas of drawing that are out of focus. A focal point is the equivalent of a 'home base' in a drawing.

It is an interestingly active area of the drawing at which the eye is held for a few moments before it continues to explore the rest of the drawing, and then returns, explores, returns, etc.. It might be an area of maximum tonal contrast, or an area that requires a gathering of busy, more focused marks.

When we make drawings, it is important to try and create an opportunity for the eye, whilst exploring the drawing, to discover, and make the metaphorical equivalent of 'eye-mouth' contact with it. Out of focus, and in focus areas of a drawing can be created, by giving more, or less attention to selected parts of the drawing. They may be tighter, and more developed, or looser, and left unfinished, or understated and implied. It is important to understand both, and, possibly, to set one against the other, thereby offering variety, and an opportunity to reflect the way we see.

LEFT Terry Murphy, *Seated Life Model*, pencil on paper, 21 x 30 cm.

TOP Dale Berning, *Ossia II*, 2008, pen on paper, 100 x 70.5 cm. Courtesy the artist and Nina Takegawa, Tokyo.

SKETCHBOOKS

DRAW EVERYWHERE, AND ALL THE TIME. AN
ARTIST IS A SKETCHBOOK WITH A PERSON
ATTACHED. Irwin Greenberg

Sketchbooks, sometimes called "drawing books", or
"journals", have many uses, but are generally valued for
their portable accessibility. Whatever label you use, think of
your book as being an easy to use, "information notebook"
in which all manner of things can be recorded, stored and
left to incubate. Make it a collecting point for any useful
reference that needs to be remembered—a scrapbook for
personal thoughts, dreams, interesting quotes, lists, doodles,
visual notes, photographs, and drawings—drawings, which
describe, record, investigate and develop experiences, or
drawings that are preliminary and explore working processes,
and solve problems by making thoughts visible. Use the book
as an organic, changing piece of work, and let it reflect your
interests and personality. Treat it with value, but do not be
precious. Try not to fall into the trap of self-consciously trying
to make everything in it a masterpiece. Let go—you are not
'on show'. Do not be inhibited or constrained, but be honest
and true to yourself, faults and all. Try to remember that
it has the potential to be a catalyst to activate your private
world, it is yours, primarily for you, and, in part, need only be
understood by you.

It is a unique working document, and the best things
in it will probably be glimpses of potential that come out of
private experimental risk-taking, or 'doodled' moments of
unconscious play. Do not feel that you have to start your
book on the first page. You could start in the middle and
work towards the front, or let it evolve in both directions
simultaneously. Consider working across a double page, and
continue on to the next page.

BEGIN ANYWHERE, JOHN CAGE TELLS US THAT
NOT KNOWING WHERE TO BEGIN IS A COMMON
FORM OF PARALYSIS. HIS ADVISE: BEGIN
ANYWHERE. Bruce Mau

If you are unhappy about something you have drawn, do not
tear the page out. Obliterate and re-cycle the surface, rub it out,
or cover it up, but do it in an interesting way.

TOP Sophie Kemp, Sketchbook page,
2010.

BOTTOM Terry Murphy, Doodle from a
meeting, 1990.

OPPOSITE TOP Roger Coleman,
Sketchbook page, 1991.

OPPOSITE BOTTOM Lauren Wilson,
Sketchbook page, 2010.

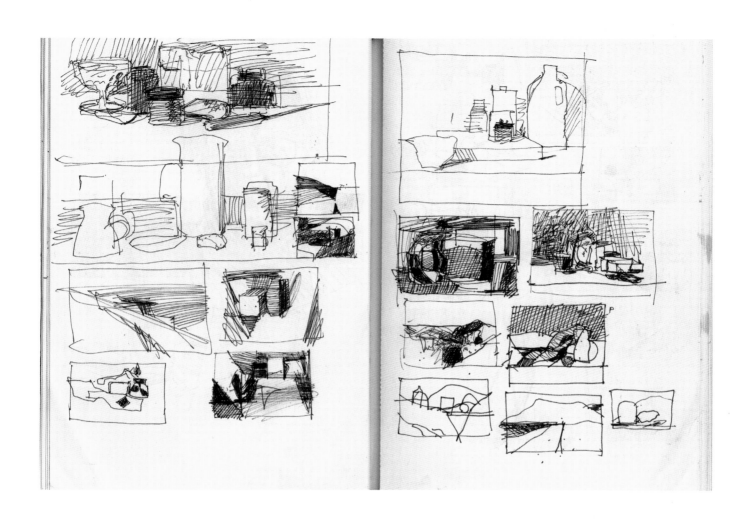

use life drawings of
face and relay hand
marks for three
dimensional drawing

place under
layers on lens

OPPOSITE TOP David Parr, Sketchbook
page, 2008.

OPPOSITE BOTTOM LEFT Andrew
Gomez, Sketchbook page, 2008.

OPPOSITE BOTTOM RIGHT Theo Smith,
Sketchbook page, 2011.

RIGHT Aurelia Lang, Sketchbook page, 2011.

DOODLES

written by Bill Prosser

DOODLING (...) SEEMED TO ME TO HAVE ENDLESS POSSIBILITIES. Robert Motherwell

Doodles are the *flâneurs* of drawing—lines that go for a walk, as Paul Klee famously said, "aimlessly". They have a long, largely unknowable history: perhaps the urge to scrawl mindless pictures is as old as we are, a biographical strand inseparable from our more focused use of images as religious or social symbols. In any event, their back catalogue includes ambling drawings by anonymous scribes that appear on such texts as thirteenth century plea rolls and eighteenth century Napolese ledgers. Scurrilous and grotesque images also infiltrate numerous other Medieval manuscripts; demotic glosses that frequently lampoon more chaste imagery, and whose subversive inclinations may explain why for so long doodles remained in the margins of art history.

First aesthetically appreciated in the 1920s by the Surrealists, doodles were of interest precisely because they had been produced on the edges, both literally and metaphorically, of culture, ranking alongside pictures by children and the insane. Surrealists were intrigued by Hans Prinzhorn's illustrated *Artistry of the Mentally Ill*, which featured doodling, the psychiatrist describing it not merely as a playful activity but also as being a potential relief for anxiety. Searching for the roots of pictorial expression, he summed up the simplest configurative urge as "un-objective, disordered, scribbling"; the compulsive precursor to imitation and ornamentation.

More popularly, the term "doodling" was catapulted into much wider public attention by the 1936 Hollywood film *Mr Deeds Goes to Town*. This comedy also highlights doodling's therapeutic potential, when at a pivotal moment in the plot examples are successfully offered in court as evidence of sanity. The success of the film stampeded a worldwide doodling craze, so that a previously private pursuit became public, with Australian restaurants handing out paper to stop diners drawing doodles on tablecloths and a London newspaper running a "Royal Academy for Doodlers".

A compendium of doodles by politicians and film stars, *Everybody's Pixillated*, was published, giving each drawing a short psychological reading. By the mid-twentieth century the mainstream media had absorbed general psychoanalytic ideas, blended with a growing interest in graphology. Doodles, spawned from a mixture of daydreaming and handwriting, offered obvious potential and were trawled for cod psycho-interpretations—with predictably comforting results.

A more thorough investigation of doodles' hidden meanings was undertaken by three psychiatrists from the Maudsley hospital in 1938. They scrutinised more than 9,000 doodles and compiled a detailed statistical analysis, under such headings as mental attitude (supplied by each doodler, e.g. complete idleness or talking on the telephone), and content (e.g. ornamental details or figures). From this they concluded that despite the paradoxical nature of their investigation—a large mass-experiment where each example was made in isolation—strands of collective psychology were at hand, providing evidence of uniformity similar to ethnological observations

of myths, sagas, and fairytales. Nevertheless, they made it clear that no meaningful psychological interpretation could be made of any particular doodle without the personal cooperation of the artist, which was of course impossible.

The therapeutic benefits of using individual patients' doodles were only later to be shown by psychoanalysts such as Marion Milner and D W Winnicott.

But what of the act of doodling itself? Generally accepted as making drawings when the mind is occupied elsewhere, the doodler is freed from the constraints and responsibilities of volition. Often created during periods of nervous tension—from boredom to anticipation—doodles seesaw between vague awareness and inattention, their rhythms acting as graphic cousins to gently pacing up and down or twiddling one's fingers.

Habitual aspects of drawing—making a mark, responding to it with another, and so on—are in doodling generated as if on autopilot, with only intermittent, half-conscious adjustments. As for the contexts that assist doodling, confined time and space seem helpful—meetings, waiting rooms, lectures—as do supports that are already in some way textually and pictorially imprinted— agendas, forms, or brochures.

Printed texts and pictures often act as prompts for elaboration, with letters being filled-in, moustaches added, and arabesques multiplying to the point of Baroque obliteration. Doodles also expand the paraphernalia and mistakes of writing and its ingrained childhood exercises: repetitions, corrections and crossings-out. Underlinings become crenellated or looped, smudges turn into hairstyles, blots to eyes.

Belonging to a group of drawings triggered by horsing around with pre-existing motifs, doodles such as these follow a lineage of chance-invoked hybrids. Medieval Japanese haboku, or thrown-ink drawings are deliberately risky. So is the accidental landscape method closely described by Alexander Cozens (a process developed from Leonardo's comparisons between natural forms and old wall-stains), while Victor Hugo's lace-print fantasies are fluent precursors of Surrealist decalcomania. But, of course, very many doodles start by staring at a page as blank as an empty mind, and take their cue from Klee's wandering line that gradually mutates and proliferates. The evolution of writing materials, too, must have influenced doodles' appearance. Dip and fountain pens, with their unexpected drips and spurts, have been replaced by Biros and rollerballs that deliver regular lines only previously available in paler pencil, contributing to the smooth complexity and bright tonality of many doodles. A series of expanding hoops or spirals might be infilled with various discs, dots or cross-hatchings, or grow cantilevered extensions.

As for a typology, numerous doodles fall into the broad categories of geometries or organics: toppling towers of squares, triangles and circles, or tightening tangles of fronds, tendrils and petals. Among the psychiatrists' 1930s' sample, however, 60 per cent of doodles showed faces. Rudolphe Topfer demonstrated in the early nineteenth century how easy it is to turn any drawn enclosure into a profile, and the ubiquity of cartoons, comics, and caricatures since can only have accelerated this appreciation. Certainly doodles by writers—from Hans-Christian Andersen to Tristan Tzara—predominantly portray faces.

Within the visual arts themselves, artists as diverse as Robert Motherwell—using doodles as a stimulus for painting—and Unica Zurn—teasing gracile drawings from a web of wandering lines—take advantage of the untargeted diffusion that doodling offers. Many Outsider artists make what have been called "meta-doodles", obsessive all-over patterns that paradoxically asphyxiate their marks but animate their surfaces.

At the other end of the scale, Alexander Calder's thin wire faces have something of doodling's spare, unpredictable concentration. Matta, Miro, and Michaux have produced spontaneous quasi-figurative forms, crossovers between writing and drawing, akin to doodling. Klee's drawings, for all their poise, follow his own advice and distractedly meander. Cy Twombly and Arnulf Rainer incorporate some of doodling's foundational aspects—repetitious scribbles, variable letterforms, or both—while the proliferation of faux-naif drawing, sometimes erroneously called doodling, has become a regrettable contemporary art cliché. Books on doodling flourish, but far from celebrating its creative potential these offer instead a series of tired and prescriptive graphic manoeuvres. Using even more mundane exercises, recent research at the University of Plymouth has 'proved' the usefulness of doodling in aiding memory.

More importantly, what might be called genuine doodling would seem to make the problematic practice of automatism, so prized by the Surrealists, routinely available to everyone.

Neo-Surrealist David Lynch says that by touching his doodles with his finger, he can return himself to the state of mind in which he made them. Perhaps we too can accept that doodling helps us revisit an earlier, less repressed, stage of creativity. As children we all, in Lynch's words, "just draw". As doodlers we can relish doing so again.

Dale Berning, *Sanaé and Euphémie*, 2008, diptych, pen on paper, 70 x 50 cm. Taken from the drawing and sound performance project, Study in Mixed Accents for Many Leaves and Other Marbles (Sanaé et Euphémie). Courtesy the artist and Nina Takegawa, Tokyo.

CORNELIA PARKER

in conversation with Jack Southern, London, November 2010.

JS When we first discussed your inclusion in this book I remember you referencing your work by saying, "It is all drawing, it does not need to be defined".

CP Yes, I think of all my work as drawing; even the sculptures. Sculpture for me is using friction to transform materials, I also feel it is drawing because it is a gestural thing, describing something in space.

DRAWING, IN THE HIERARCHY OF ART FORMS, IS ALWAYS THOUGHT OF AS AN ADJUNCT OR A LESSER ART THAN THE GREAT ART OF PAINTING OR SCULPTURE. THINKING OF EVERYTHING I MAKE IN TERMS OF DRAWING TAKES THE PRESSURE OFF, AND CAN BE VERY LIBERATING.

JS If you feel that all your work is drawing, does that mean you also feel any materials and process could be used to make drawings, no matter how unconventional?

CP A drawing could be made from anything, for example I have made drawings by heating up a poker until it is red hot and using it to burn holes into folded paper. I've made poison and antidote drawings using snake venom from a rattlesnake farm in Texas mixed with black ink, and anti-venom with white ink, to make Rorschach blots. The resulting drawings are a combination of 'good and evil'. I've made pornographic drawings out of chopped up pornographic videotape, which were dissolved in solvent to make ink. I've made a drawing from a gold tooth that I had made into wire, threaded through a needle.

JS It is fascinating to think about drawing in such broad terms. While working on this book I have spoken in depth to many artists about the process of how they approach making drawings. Rather than defining what drawing is in fixed, material terms, the emphasis has been on discussing the process of what 'drawing' represents to each individual. Many artists have talked about drawing as a way to access and process thoughts, work through ideas and understandings, release intuitive movements, feelings or energy. How do you think about making drawings in relation to the creative thinking process?

CP For me the conscious part of making a drawing is deciding on a process, what the process then releases is something else. Your unconscious mind always knows more than your conscious, and you hope that it is going to tell you a lot more than you knew before. What you need is a catalyst to release that knowledge. A concept can be that catalyst, or even a decoy. I am always thinking of strategies to unleash whatever it is that is dormant or latent, and drawing is a perfect way of doing that.

TOP *Pornographic Drawing*, 2005, ink made from dissolving video tape (confiscated by HM Customs & Excise) in solvent, 63 x 63 cm. Private Collection. Courtesy the artist and Frith Street Gallery, London.

BOTTOM *Red Hot Poker Drawing*, 2009, folded paper, 63 x 63 cm (framed). Courtesy the artist and Frith Street Gallery, London.

OPPOSITE *Poison and Antidote Drawing*, 2010, rattlesnake venom and black ink, anti-venom and white ink, 37 x 37 cm. Courtesy the artist.

WHAT AM I TRYING TO REQUIRE OF DRAWING? THAT IT TAKES ME ON A JOURNEY, NOT THAT I KNOW WHAT THAT JOURNEY IS WHEN I START BECAUSE, MY WORK IS USUALLY QUITE INTUITIVE.

I was bought up on a smallholding in the country, and realise now that a lot of the daily chores and repetitive activities I had as a kid have been incorporated into making my artwork. For example, it was my job to lay the fireplace in the morning, folding up newspapers to make paper sticks, and using the poker to keep the fire going. I later ended up using both processes as tools to make my red-hot poker drawings. Another repetitive task was to string up hundreds of tomato plants. All those hours of unravelling, cutting and tying knots in string, milking cows by hand, scything hay or planting seeds become a kind of choreography that you accrue over years, that is then released into the work.

JS And with this very personal definition of what drawing is in your work and what those processes mean to you, what was the beginning of the journey? Did your drawing evolve from something more formal or rigid?

CP It is interesting you should ask that, because with your visit in mind I dug out this drawing of a stuffed lapwing, which I made when I was 18. I remember borrowing the bird from a museum and sitting drawing it, trying to make an accurate representation. A couple of years ago my daughter Lily who was seven at that time found this drawing and said, "Mum! I did not know you could draw, I love this!" She then drew her own versions of my drawing, and I think one or two of them are brilliant, very spontaneous and gestural, in sharp contrast to the near photographic neatness of mine. So I have framed them both, and she's going to have them hanging in her bedroom. But I definitely prefer hers!

So by 18, my drawing had become very self-conscious and tight. I felt that drawing was just a tool to try and capture accurate snapshots of reality, but we have got cameras for that. Now my drawing is hopefully going back towards Lily's; a more improvised, emotional, physical trace of a spontaneous thought process.

JS And where did your drawing go after that?

CP Well, I was doing painting for the first half of my degree. I struggled with that because I found it difficult to represent something on a flat surface. I remember making paintings, which were trying to describe the illusion of light coming in through a window. I realised I was much more interested in the real light coming through the real window and that I needed to work with the real thing, the real materiality, not create an illusion with paint. That is when I realised I was a sculptor.

ONE THING I LEARNT MAKING 'SCULPTURE' IN THE OLD FASHIONED SENSE OF THE WORD IS THIS ETHOS OF USING MATERIALS FOR WHAT THEY DID BEST. SO THE IDEA OF BEING TRUE TO MATERIALS BECAME A VERY LITERAL THING.

BUT IN A WAY THAT LIBERATED ME BECAUSE I THOUGHT THAT IF YOU START OFF WITH THE FOUND OBJECT, THAT OBJECT ALREADY HAS A HISTORY TO DRAW ON.

And in terms of trying to capture things in two dimensions, I found it interesting to have this trace of a real experience on the paper rather than trying to draw representations of things. It is like it's being true to the materials, which are also the subject.

SO I MIGHT SUSPEND THE CHARRED REMAINS OF A CHURCH THAT HAS BEEN STRUCK BY LIGHTNING, AND IT IS NOT A DRAWING OF THE CHURCH THAT HAS BEEN STRUCK BY LIGHTNING; IT IS THE CHURCH THAT'S BEEN STRUCK BY LIGHTNING.

JS And in terms of making drawings, making marks; with drawing being a medium that people often talk about in terms of its immediate qualities. It seems relevant that you use what is around you to make drawings, what is to hand. For me this has a kind of resonance in term of the fundamental use and relationship of mark-making, materials and objects throughout history.

CP Absolutely, mark-making is probably at its most basic, the first art form. In thinking about drawing as the very first primal activity, you might think about cave painting, painting on the body or drawing in the fireplace with a stick. Using materials like charcoal from the fire, clay from the earth or blood from an animal. Drawing seems very elemental and inherently human, it is the most 'true' art form in a way. Man has created culture and made artefacts that embody that culture. Metal ores have been taken out of the ground, smelted, then fashioned into wedding rings and crucifixes; clay has been fired to make pots and buildings. To make drawings I like using real materials with a history, like you say, using the cultural things that are to hand, the things that are ubiquitous in our society, to make a mark with as it were. It feels like that is a really fundamental thing to do.

MY WEDDING RING IS MADE OUT OF A 200 YEAR OLD SILVER SPOON, AND MY HUSBAND'S GOT THE OTHER HALF. WE LIKE THIS IDEA THAT IT WAS ONCE A SPOON USED FOR STIRRING AND NOW IT IS A PAIR OF RINGS.

I like to take these things that have become so 'cultural', and then subject them to some kind of violent transformative act, like shooting a dice through a gun. Putting objects through extreme processes such as explosion, burning, crushing, stretching or submerging, and often ending up with something that is more abstract, more primordial. So I am trying to extract the unknown, out of the known. It is almost like taking it back to the raw materials. It is unravelling culture, unpicking it in a way.

JS And the transformations are made all the more pertinent or resonating because the objects you seem to choose are very familiar, from the everyday, which I feel leaves space for an extensive conceptual journey.

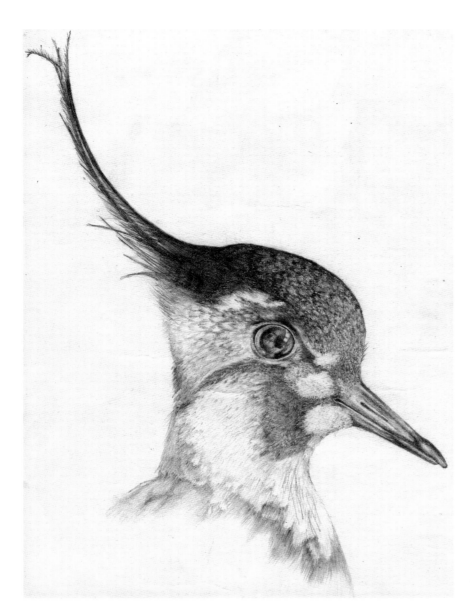

TOP LEFT *Lapwing*, 1974, pencil on paper, 23 x 18 cm. Courtesy the artist.

TOP RIGHT *Lapwing*, 2008. Lily Parker McMillan (Cornelia's daughter), 23 x 18 cm. Courtesy the artist.

BOTTOM *Untitled*, 1975, installation in a derelict house. Courtesy the artist.

CP I like using physical objects from the world that are particularly familiar and representational, which have a cliché value: well worn cultural symbols. Like using a diamond ring to scratch a piece of glass, which I did for an engagement ring drawing, or melting down a wedding ring then drawing it into a wire (*The Circumference of a Living Room*). These are both examples of a kind of rubbing up against the world in a way. I love the irreverence of that, the undermining of the object's place in society.

JS You have also made a number of wire drawings, which, trapped between glass, as many have been displayed, have the wonderful visual quality of a beautiful, expressive, fragile line drawing, but were once physical objects and the kind of cultural symbols we have been talking about such as bullets, money or wedding rings, etc..

CP I have made various drawings by melting down and drawing objects into wire. The properties of the objects have changed; they have been transformed into a line. But also, interestingly, the process of making wire is called "drawing". The reason I started making wire drawings is that I was hanging objects on metal wire for my installations and when I took the things down I would end up with this tangle of wire. I loved the visual qualities of wire and thought that I would love to exhibit it. I then started to think about what this wire could be. I wanted it to be an object in its own right and wondered if I could suspend the object within the wire, so that is how these wire drawings came about.
 The first wire drawing I made was in 1996, called *Wedding Ring Drawing* (*Circumference of a Living Room*). It was made from two gold wedding rings I bought from a pawnshop, which I melted down and 'drew' into a wire measuring the approximate circumference of a living room.

JS So abstracting the objects, as you have mentioned in broadly talking about the work. But this example illustrates the different levels of abstraction. It is like asking multiple questions of the object. Could the object physically be something else? Could it mean something else? Could it have multiple meanings? Could it transform and transcend its cultural identity? The work asks questions of its physical materiality but of course the connotations, associations and cultural language surrounding the object too?

CP Yes, that is important, so it is trying to make this sort of 'portrait of a marriage' as it were. It is referencing the domestic living space within the band of gold. The established language and connotations around an object give it the potential to "mean something else", as you put it. Like wedding rings and dollars and bullets, for example, bite the bullet, the silver bullet. I am interested in taking them and trying to push them to the opposite of representation and stretch their physicality and possible meanings as far as they might go. In *Measuring Liberty with a Dollar* for example, I have taken the height of the Statue of Liberty and had the silver dollar drawn

TOP *Measuring Liberty with a Dollar*, 2007, silver Dollar drawn into a wire the height of the Statue of Liberty, 63 x 63 cm. Courtesy the artist.

BOTTOM *Measuring Niagara with a Teaspoon*, 1997, Georgian silver teaspoon melted down, and drawn into a wire the height of Niagara Falls, 63 x 63 cm. Private Collection. Courtesy the artist and Frith Street Gallery, London.

OPPOSITE *Mass (Colder Darker Matter)*, 1997, charcoal retrieved from a church struck by lightening, Lytle, Texas, USA, 396 x 320 x 320 cm. Collection Phoenix Art Museum. Courtesy the artist and Frith Street Gallery, London.

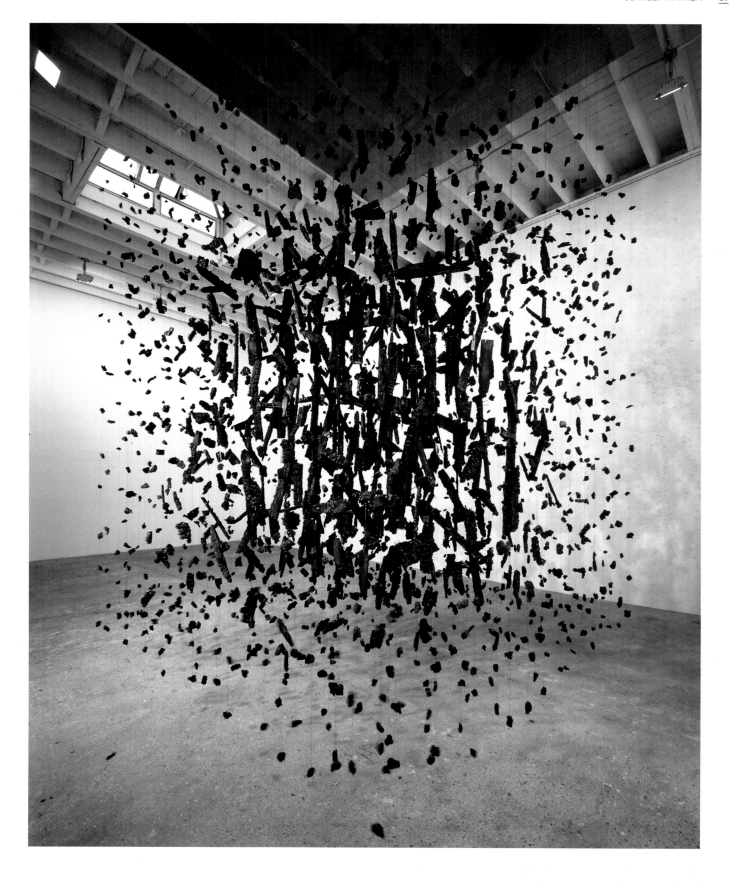

into wire to that exact height. So it literally is measuring liberty with a dollar. You do not get the Statue of Liberty and you do not get the dollar, you just get the measurement in between. The dollar becomes a measuring device with which you try to measure the concept of liberty, which is an abstract thing.

JS And you have used cultural symbols of firearms and bullets to make work, which obviously have quite extreme connotations as objects. You've made various drawings from melted down bullets?

CP Yes, I had a quantity of bullets melted down and the lead from them drawn into wire. And then I worked out from the weight of that wire, how much was a magnum 44 bullet's worth of lead, and I took that as the amount to make each drawing from; so each one was a bullet's worth of wire. And then the idea of gathering up the trajectory of the wire, the distance the bullet might travel, started to dictate their display.
A LOT OF MY WORK IS ABOUT DISTANCE OR MEASURING OF SOME KIND.

JS From the first bullet drawings, the way they were presented and displayed changed, could you go into that a little bit more?

CP Yes, I started making them into woven net shapes. I like the idea of the net because it can have connotations of being a snare or a trap. So then I trapped the net between two sheets of glass, in a shallow box frame, a shadow of the net is cast on the white backing board. I like this kind of visual ricochet that you get. The lead line looks like a pencil drawing. First they were just straight grids and then they became slightly more distorted as I went along, like casting an individual net every time.
 Contrary to the idea of Minimalism, where they got rid of the content; they emptied out all meaning using very industrial materials. I am trying to do the opposite. I like the idea of the modernist grid made out of a bullet. It is a bit perverse in a way that it is trying to make something that is loaded with so much anger and danger, conform to some rule. In a show at the Baltic last year, the six shots were displayed next to the embryo firearms, which you referred to earlier. So the drawings fit into a bigger scheme of work. The *Embryo Firearms* piece was an early work; I think it is quite an important one.
 What you see here are Colt 45 guns, in the earliest stage of production, and I had asked the factory workers to give them the finish they would give a finished gun. So they polished them up but they have been interrupted, their potential to kill nipped in the bud, although they already undeniably look like guns.

JS: That is really interesting because it is a very different kind of transformation to other works we have talked about. It is transforming an object through skipping part of the object's production rather than transforming an object with a history?

CP I quite like the fact that the object is not yet born; it is the beginning of an icon, but it is not yet an icon; it is pre-empted, so it becomes an abstraction in a different way.

JS I find the work endlessly fascinating because the pieces are so rich and diverse in all of their references. There are so many ways a work like that could be interpreted, different conceptual journeys to go on with the work?

CP I hope the audience take the journey they want to take from it, and the objects have new potential for interpretation. In the case of *Embryo Firearms* the pro-gun lobby really liked them because even as an embryo they were beautiful, and the anti-gun lobby liked them because I had aborted these guns.
 Both those factions were there at the opening. The guys from the Colt firearms factory who would helped me with the project came, as did the liberal lot. There was an interesting friction going on between the audience as well as the object. In the end, the object is just a catalyst to a thought, however big or small; a discussion, debate or whatever it might be.

ABOVE *Embryo Firearm*, 1995, Colt 45 guns in the earliest stage of production, edition of two, special thanks to Colt Firearms Manufacturing, CT, USA, each 19 x 13 x 2.4 cm. Courtesy the artist.

OPPOSITE TOP LEFT *Bullet Drawing*, 2010, lead from a bullet drawn into wire, 63 cm x 63 cm. Private Collection.

OPPOSITE TOP RIGHT *Bullet Drawing*, 2010, lead from a bullet drawn into wire, 63 cm x 63 cm. Collection Whitworth Art Gallery, Manchester.

OPPOSITE BOTTOM *Bullet Drawing*, 2010, lead bullet drawn into wire, 65.5 x 65.5 cm (framed). Private collection. Courtesy the artist and Frith Street Gallery, London.

THE PROJECTS

The following projects are designed to give a student of drawing a set of aims and objectives within an established framework, that collectively assemble into what might be called "a Foundation Course in Drawing". These are presented as a sequential progression, starting with projects that require no obvious drawing skills, and developing into projects that require more.

It is important to recognise that the sequence has been very carefully considered, and to understand that the first 14 drawings, are generally about becoming familiar with—learning to look and see—eye/hand coordination, trust, control, concentration, confidence, and the language of the mark. We suggest that you attach a level of importance to these first drawings—really concentrate whilst making them, and repeat them several times.

The important thing about these drawings is that their visual content is in the quality of the 'language' and range of marks that are used as a visible response to looking and trying to describe what is being seen and felt by the eyes.

To some people these first drawings may look like a surface of uncoordinated abstract marks; that might seem to have very little value. It is important to recognise that the main purpose of drawing in this way is to focus on, and develop the process of what is happening in the eye, brain, and hand whilst making them.

PROCESS IS MORE IMPORTANT THAN OUTCOME. WHEN THE OUTCOME DRIVES THE PROCESS WE WILL ONLY EVER GO TO WHERE WE'VE BEEN. IF PROCESS DRIVES OUTCOME, WE MAY NOT KNOW WHERE WE ARE GOING, BUT WE WILL KNOW WE WANT TO BE THERE. Bruce Mau

Our aim is to train the eye, brain and hand to work together with one purpose, in sync, whereby they learn to trust each other. Subordinate to this is the 'look' of the drawing in relation to it being a likeness of what is being drawn. To be over-concerned with the 'look' at this stage is a misplaced priority, and usually causes a tentative and inhibited response based on a fear of failure to get it to 'look right'.

The drawings that are presented alongside the projects are not intended to illustrate them in an exemplary 'how to do it way'. The students on the workshops were not rote taught, and they each interpreted the projects in their own way. Our hope is that by attempting the projects your understanding of drawing, and your ability to see and draw will greatly improve, and that you will develop the confidence and desire to 'draw in your own way' and go on to devise your own projects.

CREATING THE CONTEXT FOR LOOKING

To create a context for looking, you will need to push a table up against a wall, and cover both the table-top and adjacent wall with white paper. The wall will act as a blank backdrop against which your objects can be clearly seen, and the white paper will neutralise the spaces.

The distance between the nearest point, [front of the table] and the farthest point, [the wall], is called the "depth of field" and for different projects you might vary this distance by choosing to place either the side of the table, or length of the table against the wall. This will give you either, a shallow or deeper space in which to place your objects.

Place your objects on the table and use a viewfinder or digital camera to help create your composition. Explore the 'depth of field', and try several different arrangements of objects before selecting a suitable one. The junction between the table and the wall is an important structural element in the overall composition. As a horizontal line, it links the two vertical sides of the rectangle, and ties the whole thing together. Whenever possible, use this to your advantage.

When making more than one drawing, change your point of view by positioning the horizontal line either, higher up or lower down in the rectangle. The ergonomic ease of the table-top/wall relationship should not become the only solution to the context for looking, and whenever possible you should always consider alternative and perhaps more interesting points of view.

SOURCE OF LIGHT

When you tackle the projects created for the book, if possible have a single source of light, [perhaps from a window] by which you can see both the objects and your drawing. Remember that if you are drawing in daylight, the amount and direction of light will change throughout the day, and so starting the drawing in the morning, and finishing it late in the afternoon might necessitate making significant changes. It can be a bit like a dog chasing its own tail—drawing and re-drawing something whose appearance is continually changing.

Drawing with artificial light, [an Anglepoise] for strong directional light, or the main room light, will produce something more constant and will therefore allow you to return to it as being more or less the same, at a later date

SETTING UP YOUR EASEL

Whether standing or sitting when drawing, you need to be in a comfortably considered position. The easel needs to be firmly set up, and the centre of your drawing board should be level with your shoulder. This position should alleviate the possibility of neck and backache caused by unnecessary stretching and bending.

If you draw with your right hand, you may find it easier to look on the left side of the board, and similarly, if you draw with your left hand, it may be easier to look on the right side of the board. Attach the paper to your board with a piece of masking tape across each corner, and so that the middle of the paper is level with your shoulder. Attach it either to the left or to the right side of the board, depending on whether or not you are looking from the left or the right. Position the easel so that, at one step back, you can see both the table-top/objects and your drawing paper simultaneously without moving your head.

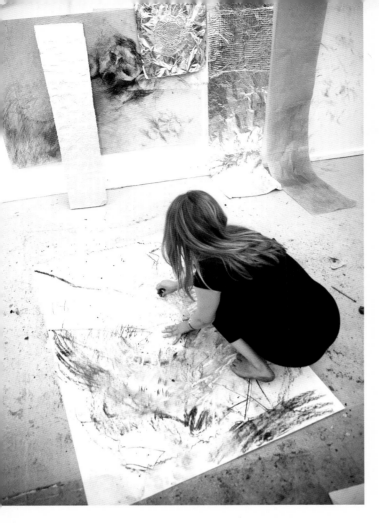

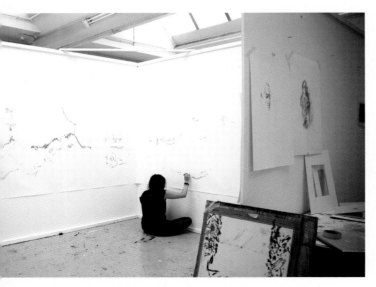

TOP Ruth Chamber's drawings becoming more sculptural towards the end of the Workshop 1, April 2010.

BOTTOM Lily Hawks allows her drawings to grow at the beginning of the Workshop 2, July 2010.

Ruth Chamber in conversation with Jack Southern, workshop 2, July 2010

JS Ruth, I have noticed that your drawings have become increasingly physical during this workshop. Physical in the way you are applying marks and using materials, but also in the sense that you have begun to draw onto floors, walls and found objects. You have brought a lot of objects into the studio with you to work from. Do you have a specific relationship to these objects, and do they relate to work you have been making since the last workshop?

RC Yes, these are all objects I found on a derelict estate in South London, which is soon to be demolished. I feel a personal engagement with them; they feel really significant to me. I find it interesting that these objects have a history, which I have no relationship with, or access to, but I still find thinking about the context in which I found them, and their associations, incredibly moving. Many of them were in a state of decay when I found them.

On bringing them into the studio I instinctively knew I wanted to portray my relationship with them through a more physically engaged process than drawing them in a conventional sense. I wanted to keep an open mind and explore the objects in an intimate and empirical way.

The domestic and functional nature of the objects made me want to touch and handle them, which led me to experiment with pressing the objects into various surfaces, such as paper and foil. Through making imprints of the textures and shapes of objects, the drawings started to make themselves. The work grew directly out of this physical engagement with the objects.

I have now developed my process by tracing one object onto the surface of another, making incisions into malleable materials and surfaces using a scalpel. I have noticed that the processes I have been using are very lengthy, labour intensive and physically tiring, which somehow seems appropriate.

JS And in making these translations of the physical objects onto other materials, what do you think you might be evoking?

RC I want to create traces of absent objects, that were once physically there, but are now gone. The marks I am making are 'all-over' patterns across the surface of freestanding, three-dimensional objects, making physical my emotional engagement with them. It is almost like allowing my feelings about them to take on a material presence.

It feels like an ongoing chain of events. From initially finding the objects, to making the works, to the physical life that the works would have after I had made them. I want to create a sense of the ephemeral or transient through the fragile materials I am using, which would continue to evolve, change and decay.

control
PROJECT 1

THE
EXTENDED ARM
marks into meaning

DRAWINGS 1/2/3/4/5

Duration
10–15 min.

Subject
One, two or three objects, e.g.—an old boot/shoe—a pepper cut in half, with stalk and seeds—a small posy of flowers—a figurine—a friend or member of your family.

Technique
Orthodox hand, looking at the drawing.
Your drawing should be no larger than 30 cm.

Materials
Use a combination of B, 2B, 3B, and 4B pencils on white cartridge paper.
Two sticks—one 0.6 m stick [approx.] and one 0.3 m stick [approx.].

Aims
Our familiarity with picking up and holding pens for writing creates a habitual approach to handling them. Why does a pencil that is used for drawing have to be held like a pen that is used for writing? It does not, and there are alternatives.

This exercise is essentially about making marks with varying amounts of control over your drawing implement. The further away you hold your pencil from the point, the less control you will have.

Your aim is to hold the pencil in four different ways and make five drawings, where the responsive, sensitively drawn marks are seen as the content of the drawing and as something in themselves.

ABOVE Melanie Chitty drawing with a 0.6 m stick on the first drawing of Workshop 1, April 2010.

LONG STICK - graphite stick

MEDIUM stick - graphite stick - Hard

SHORT STICK - graphite stick

AT POINT of graphite stick

Method

DRAWING 1

1_Lay a piece of white paper at the junction of the floor or table-top and a wall, and attach another piece to the wall as a vertical backdrop.
2_Place your object(s) on the horizontal piece of paper, so that they can be seen against the backdrop.
3_Place your drawing pad/board on an easel, or the floor or against the wall next to the object(s).
4_Attach your sharpened 4B pencil to a stick, which is approximately 0.6 m long.
5_Stand or sit at a comfortable distance from your drawing pad so that your outstretched arm holds the stick as far away from the drawing pad as possible but only—just maintains contact with the drawing paper.
6_Look carefully at the object, and respond to what you are seeing with descriptive marks.

DRAWING 2

Repeat the process with your 3B pencil attached to a 0.3 m long stick.

DRAWING 3

Repeat the process, and hold the 2B pencil at its end, as far away from the point as possible. If you are not using an easel, you will probably have to place your pad/board on the seat of a chair, and leaning against the upright back of it.

DRAWING 4

Repeat the process, and hold the pencil between mid way down the shaft and the point—across your four fingers as if you are holding a knife or fork. You can use any pencil.

DRAWING 5

Repeat Drawings 1 to 4 and superimpose each successive drawing over the previous one—gradually tightening up the drawing by increasing control and adjusting each of the previous set of marks. Use a rubber if necessary, but do not erase the drawings history.

Results

Each of your drawings can be seen as being complete in itself, or may be used as a base upon which to continue drawing with more control.

Enjoy each of them as pure visual sensation—exciting marks on white paper, that when separated from their reference [the object] exist as beautiful, somewhat abstract drawings in their own right.

Alternative and Supplementary Options

1_You might try drawing in any combination of the following—instead of a 0.6 m stick, use the full length of your arm, and hold the pencil across your four fingers.

2_With the pencil held either, between your teeth, or between your toes.

3_Hold the pencil like a dagger as if you were about to stab someone, and make dark angry, awkwardly interesting marks.

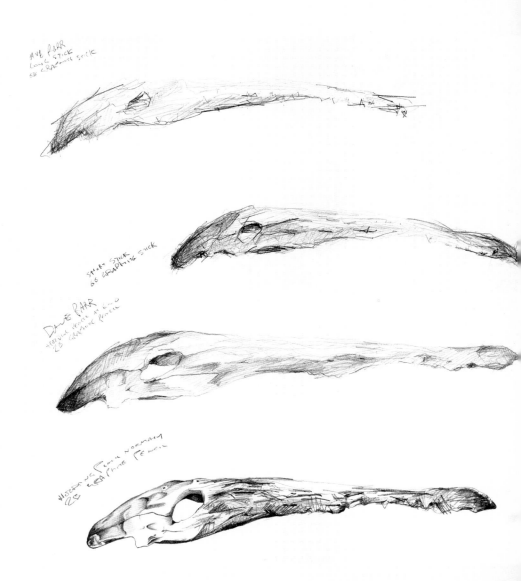

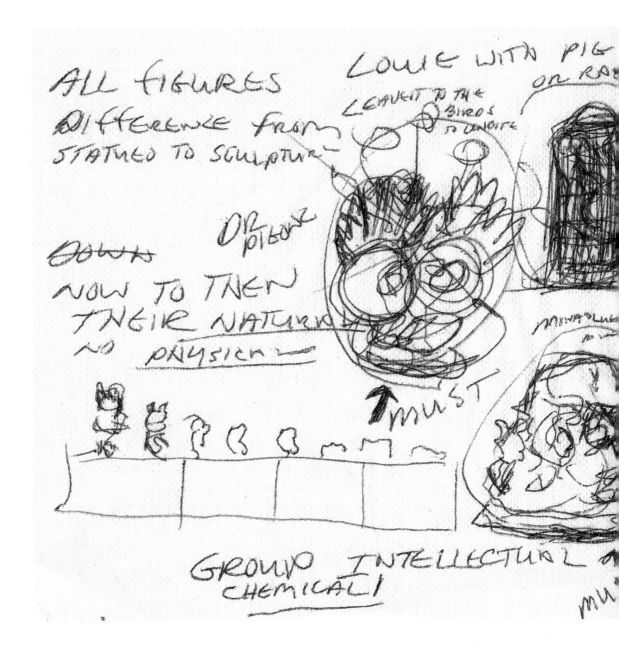

JEFF KOONS

Art is about profundity. It is about connecting to everything that it means to be alive—but you have to act. If you have an idea, you have to move on it, to make a gesture. Drawing is an immediate way of articulating that idea—of making a gesture that is both physical and intellectual.

I have always enjoyed this drawing. It was made at the very end of 1985 when I was making decisions on my stainless steel *Statuary* series. I was trying to decide whether to make an inflatable rabbit or an inflatable pig. I was going back and forth in my mind about which one I should make, so I have a drawing that is half rabbit, half pig.

There are other pieces here on the napkin: the Italian woman, the bust of Louis XIV. And there is a small shape here which is, I think, a little Bob Hope trophy. There is one piece that I did not make, which has an 'X' through it. They were doves. I scratched that idea out.

"Complete" is a note-to-self to go forward. "Best" means I believe in it. At the bottom I wrote "GROUP INTELLECTUAL CHEMICAL". I was thinking about how art makes you feel, how it makes your body secrete different chemicals depending on its colour, texture and surface.

I always try to stick to my initial ideas but there are problems you have to work out along the way. If I am making a sculpture, at

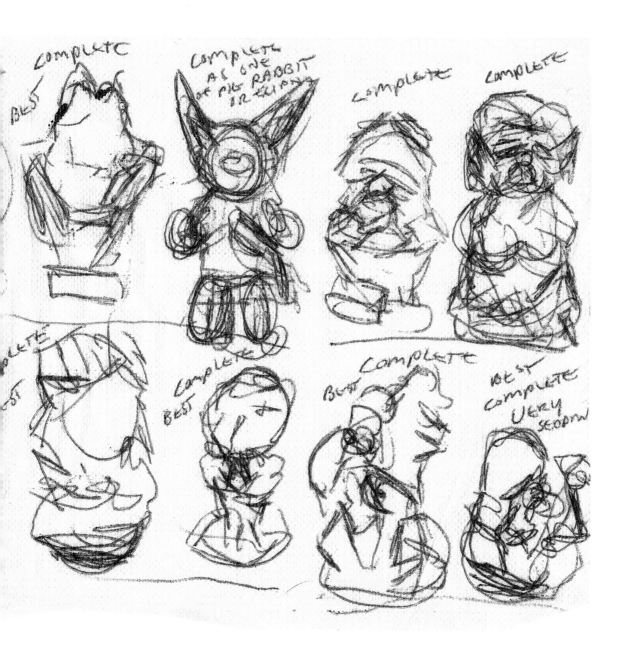

a certain point I will have to make sure it can stand up properly, but I always try to keep the finished object as close to that original idea as possible.

I like my drawings to be direct. I do not generally work on them for too long, but that does not mean that they are not works in their own right. I might sketch an idea for a sculpture, like this one, or a painting, and the sculpture or painting themselves might take a few years to be completed, but those initial drawings are complete. They have a certain openness—space for the viewer to fill in with their own mind and thoughts. If I try to articulate every little detail in a drawing, it would be like missing the forest for the trees, so it is just about getting the outline of the forest.

Concept drawing for *Statuary*, 1986, pen on napkin. Courtesy Jeff Koons, Gagosian Gallery and the Eli and Edythe L Broad Collection.

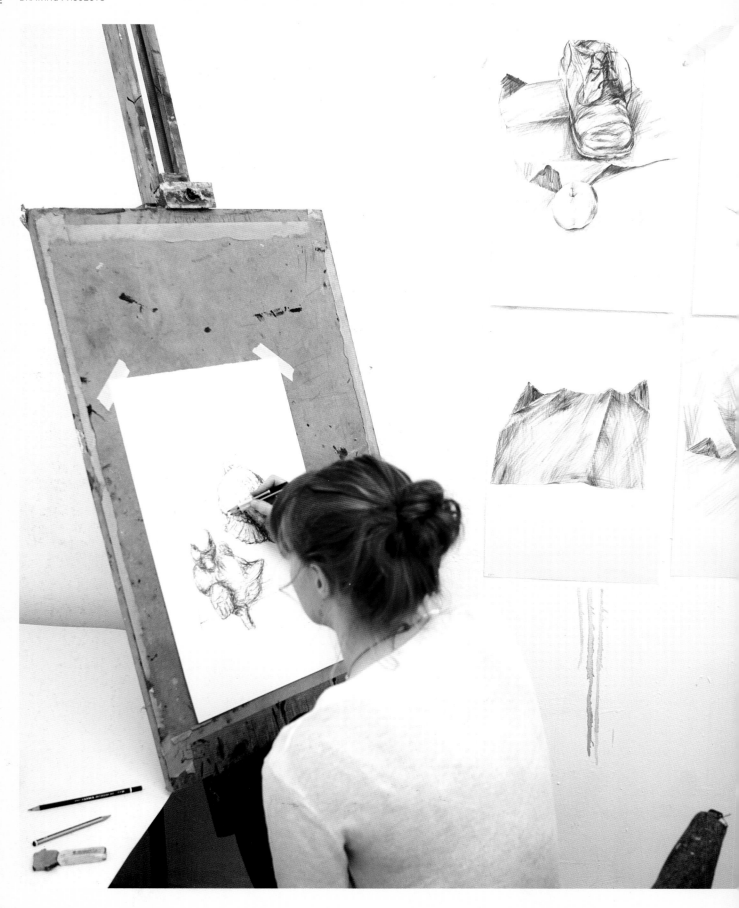

control
PROJECT 1

TWO PENCILS
an awkward start

DRAWING 6

Duration
15–20 min.

Subject
A single object, a self portrait, or a seated friend.

Technique
Orthodox hand, continuous contact, eraser.
Your drawing should be no larger than 30 cm.

Materials
Use a combination of B, 2B, 3B, and 4B pencils on white cartridge paper.

Aims
By using two pencils bound together, you will produce a range of dense and sometimes, unpredictable marks that will provide you with a surface to adjust, re-structure, and work, both with, and against. This drawing provides you with an opportunity to start by making marks inside the form, and there-by break the habit of using line to draw the outer contour edge first.

Kate Holford develops a body of work using the two pencils technique, during the second week of Workshop 1, April 2010.

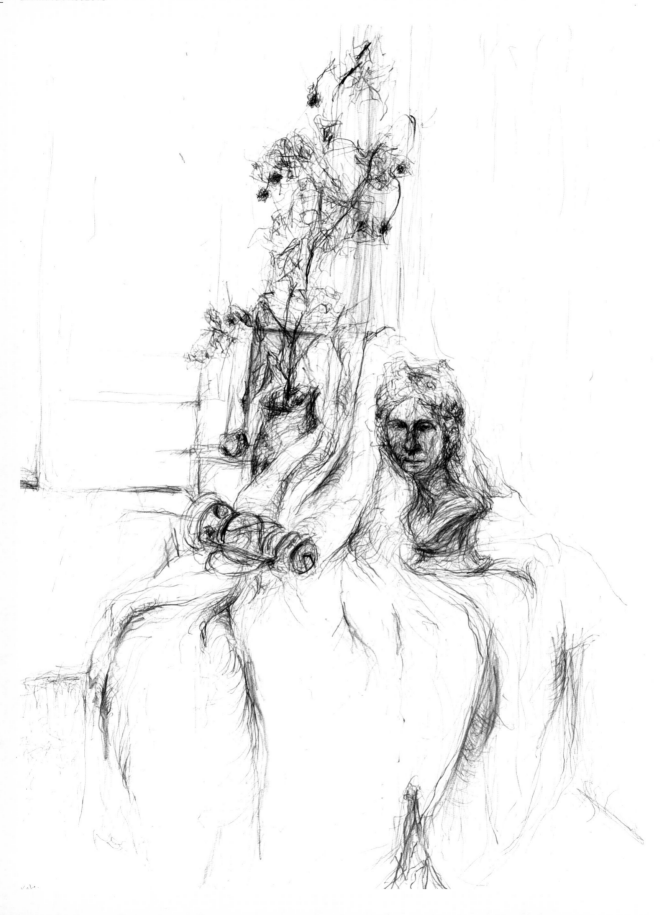

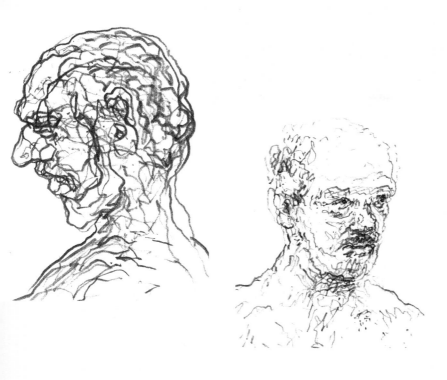

Method

1_Tape two sharp pencils together to become a single unit.

2_Start the drawing with a B and 2B and draw in a fairly light, loose and flexible way.

3_Start by making marks that are structural and essentially well placed—try and follow the feel and flow of the form.

4_Do not draw an outline and fill it in—try to work from inside the form. Concern yourself with the shape of your subject, so that it becomes a bit like a silhouette of fairly dense marks.

5_Feel the marks as you make them. They will be awkward but interesting. Make them lighter or darker—as is appropriate.

6_Vary your mark-making vocabulary to include dots, dashes, smudges, etc.. Repeat some of the marks you liked most in the previous project.

7_After ten minutes or so, separate the pencils and use only one at a time.

8_Look closely at the object, with a view to making a more focused drawing on top of the earlier marks.

9_Adjust and clarify your drawing, by placing small, perhaps darker marks in the 'right' places—as if you were sharpening the image, by gradually turning the lens of the camera into focus,

10_Lightly use a putty rubber to adjust and 'knock back' any marks that are either too dark or inappropriate. This clarification may be tighter, [more focused] but the tightness will rest on top of, and integrate into the earlier and looser drawing process.

It may be necessary to repeat this process, and knock back and adjust the drawing from out-of-focus to in-focus, or from two pencils to one several times.

Results

Some of the lively, awkward marks that were made with the double pencil should excite the eye, and their qualities should be examined, and valued enough to become part of your mark-making vocabulary.

These qualities might be incorporated into other drawings—e.g. Drawing 19, Multiple Lines.

If you feel that you have made a successful drawing, try copying it in order to understand why it succeeds, but this time use only one pencil.

Supplementary Option

Combine a pencil with a red pencil crayon, or two coloured Biros or fibre pens. Try three or more pencils—experiment and play.

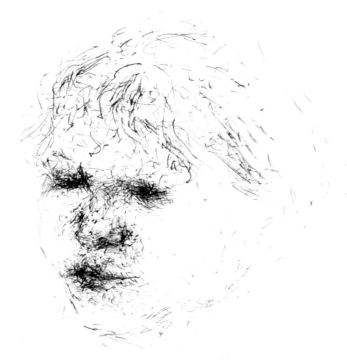

TOP LEFT AND RIGHT Mick Maslen,
Man's Head, two pencils.

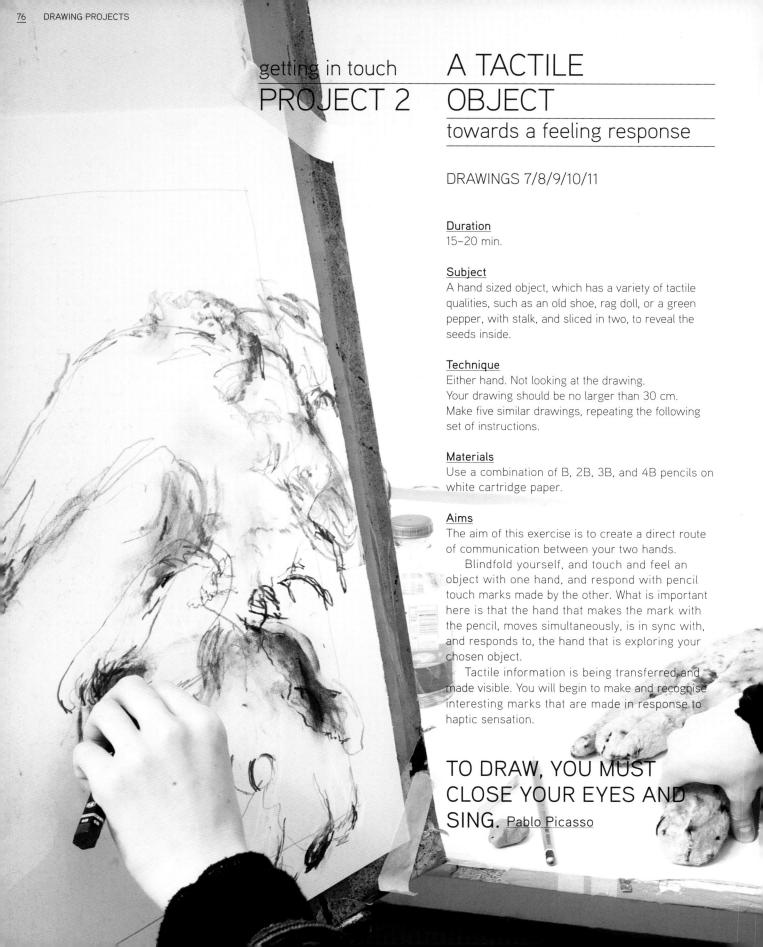

getting in touch
PROJECT 2

A TACTILE OBJECT
towards a feeling response

DRAWINGS 7/8/9/10/11

Duration
15–20 min.

Subject
A hand sized object, which has a variety of tactile qualities, such as an old shoe, rag doll, or a green pepper, with stalk, and sliced in two, to reveal the seeds inside.

Technique
Either hand. Not looking at the drawing.
Your drawing should be no larger than 30 cm.
Make five similar drawings, repeating the following set of instructions.

Materials
Use a combination of B, 2B, 3B, and 4B pencils on white cartridge paper.

Aims
The aim of this exercise is to create a direct route of communication between your two hands.

Blindfold yourself, and touch and feel an object with one hand, and respond with pencil touch marks made by the other. What is important here is that the hand that makes the mark with the pencil, moves simultaneously, is in sync with, and responds to, the hand that is exploring your chosen object.

Tactile information is being transferred and made visible. You will begin to make and recognise interesting marks that are made in response to haptic sensation.

TO DRAW, YOU MUST CLOSE YOUR EYES AND SING. Pablo Picasso

NANCY TROTTER LANDRY

It takes me ages to get to the place where it is happening in the right sort of way. I like the way your eye scoots across the form and finds somewhere to stop and explore.

I like the feeling when you are just in the place where the line is simultaneously doing what you are thinking. The only problem is that when you've done the drawing, that is it—like you have been on a journey. It is complete in itself, you can not rework it, or it becomes another drawing.

OPPOSITE Emily Mason making her first tactile drawing on Wednesday of Workshop 1, April 2010.

Method

DRAWINGS 7/8/9

1_Make three similar drawings, and use the following instructions as your guide.
2_Examine your object in silence, for five minutes or so.
3_Write a detailed description of it. Describe its size, weight, colour, surface qualities, and look for any special feature that you can make into a focal point.
4_Blindfold yourself.
5_Use a range of pencil marks that are made with your drawing hand to describe what your touching hand is feeling.
6_Push and pull, twist and turn the pencil, press firmly, press gently, in order to produce a variety of thicker, thinner, darker, lighter marks. Make dots, dashes, smudges—whatever is appropriate to what you are touching/feeling.

DRAWING 10

Put the object out of sight, take the blindfold off, and make a memory drawing of it. Concentrate on remembering the observed qualities on your initial list, and try to incorporate some of what you feel are the most successful marks from the last three drawings.

DRAWING 11

On completion of Drawing 10, re-examine all of your drawings and repeat Drawing 7 using any knowledge gained so far.

Results

Look at the drawings very carefully and re-examine the object in relation to them. Write a criticism of them observing which marks describe best what your touching hand has felt.

The drawings should show a sensitive response to touch and contain a range of interesting felt marks. They may look like a dog made them, but at this point in our project, that is not important.

Supplementary Option

Try working with a friend as your subject/model. Work life-size, and have the subject either nude, or clothed.

If you draw the subject clothed, try and use a range of textural differences—consider layers. From outer clothes to no clothes, maybe draw one layer on top of another layer. Use colour? Consider gender—a ballet shoe, a football boot, a hairy leg, a leg as smooth as silk, a formal shirt and tie, a soft ruffled blouse.

Use two models, one male and one female, and perhaps combine masculine and feminine elements.

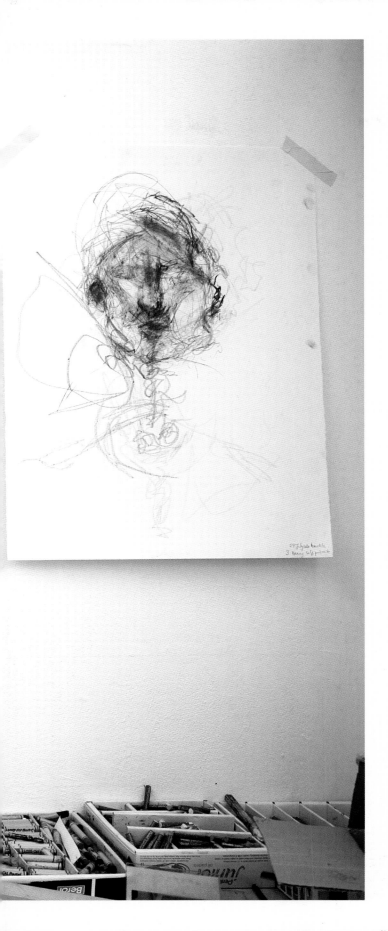

NANCY TROTTER LANDRY IN CONVERSATION WITH JACK SOUTHERN, WORKSHOP 1, APRIL 2010.

NT I was just thinking about the sensation of drawing with my eyes closed as being similar to listening to a song on a walkman, while singing along. Sometimes you feel you are singing in tune, but you are not sure. While drawing from touch, I feel like I am making coherent marks in relation to what I am feeling, but I'm not sure. Until I open my eyes.

JS That's a fascinating way to think about it. I was just talking to Cleo in the other room who was saying that she finds the moment she opens her eyes on completing a drawing really interesting. She described how in the last drawing she made, there were parts of the paper that she thought she had filled in. Places she imagined when opening her eyes would be covered in marks, but when she finally looked at the drawing, where empty.

You could only get that kind of 'slippage' between what you think you are drawing and the actual marks made, when making a drawing without looking. There are two interesting things happening in parallel. There is your interpretation of what you think you are drawing, and then the discovery of the reality of the marks made, which is revealed when you open your eyes. It is exactly like your description of singing, and not knowing whether you are in tune because you cannot hear your own voice. You do not know where your voice runs in and out of tune, as you do not know where the marks run in and out of the 'right place', if there is a right place?

NT Yes exactly, and you get a distinct chance aspect in the results. For example you might unintentionally overlay one mark with another, discovering a combination of marks you wouldn't have if drawing with your eyes open. And I agree there is a subconscious reaction that you get with this kind of drawing that you cannot get otherwise. For example, your perception of boundaries is distorted. And if you were looking at the drawing you might consciously avoid running into certain visual boundaries. While drawing in this way I feel completely uninhibited; I am discovering so much about mark making through doing this project.

JS The process we are going through with these early projects in one in which you are able to 'unlearn' and feel less self conscious of how your drawing should look. Freeing yourself from the bounds of representation can be very liberating, and lead to more interesting descriptive drawings. We are pulling everything apart, in order to make all these new discoveries about mark-making. In a week's time you could make a well-observed drawing, with all these new aspects of drawing language to refer to. It is simply like you are constructing an alphabet; a vocabulary of marks from which to draw on.

NT Yes, I like that; the fact that we are developing within a coherent structure but, as this stage, it does not matter what the results look like. We are freed from feeling there must be a level of 'representation accuracy', which we are usually very conscious of.

Julie Mehretu, *Notations*, 2009, ink and
acrylic on canvas, 305 x 425 cm.
Courtesy the artist and Marian Goodman
Gallery, New York.

OPPOSITE TOP *Mind Breath Drawings (16)*, 2010, graphite on paper, 63.5 x 91.4 cm. Courtesy the artist and Marian Goodman Gallery, New York.

OPPOSITE BOTTOM *Mind Breath Drawings (15)*, 2010, graphite on paper, 63.5 x 91.4 cm. Courtesy the artist and Marian Goodman Gallery, New York.

TOP *Atlantic Wall*, 2008–2009, ink and acrylic on canvas, 305 x 427 cm. Courtesy the artist and Marian Goodman Gallery, New York.

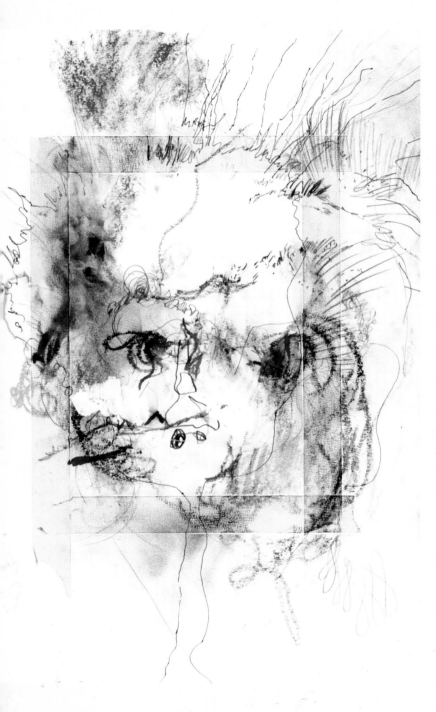

getting in touch
PROJECT 2

A TACTILE
SELF-PORTRAIT
towards a feeling of response

DRAWING 12

Duration
20–30 min.

Subject
Your own face.

Technique
Orthodox hand, continuous contact, synchronicity.
Not looking at the drawing.
Your drawing should be no larger than 40 x 50 cm.

Materials
Use a combination of 2B, 3B, and 4B pencils on white cartridge paper.

An alternative could be to mix a variety of mediums and use any combination of fibre pens, pencil crayons, oil pastel, soft pastel, chalk, graphite dust, face make-up, wax crayon, candle wax, etc..

Aims
The aim of this exercise is to create a direct route of communication between your two hands.

You will close your eyes, touch, feel, and explore your face with one hand and respond with pencil/medium marks made by the other. What is important here is that the hand that makes the mark with the pencil moves simultaneously, is in sync with, and responds to, the hand that is exploring your face. The fingers that are touching the face are the metaphorical equivalent of a blind man's eyes. Tactile information is being converted into visual information. You will begin to make and recognise interesting marks that are made in response to haptic sensation.

OPPOSITE Nancy Trotter Landry feeling her face while drawing as we introduce the notion of the tactile self-portrait during the second day of the Workshop 1, April 2010.

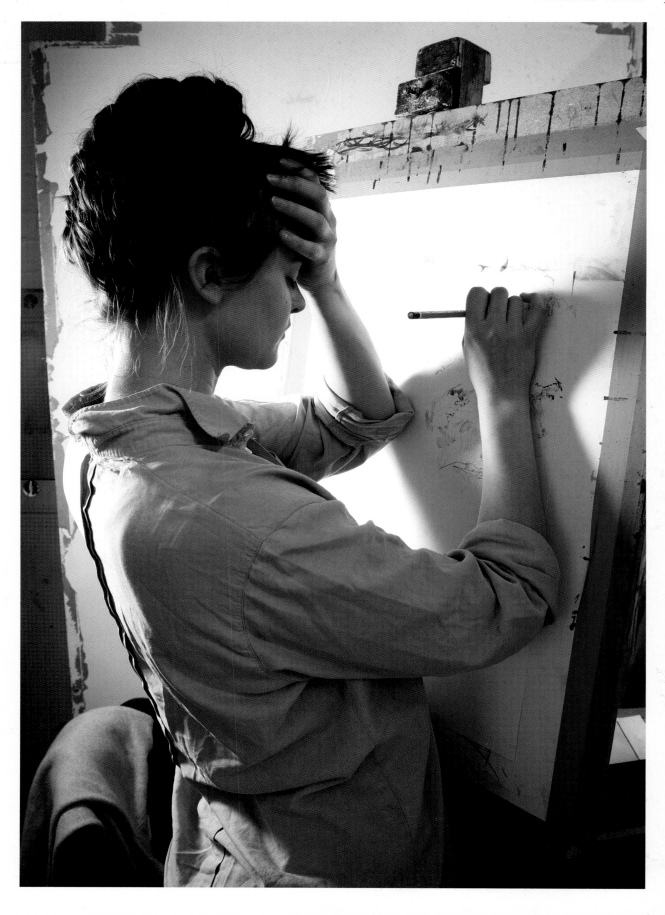

DAVID PARR IN CONVERSATION WITH JACK SOUTHERN, WORKSHOP 1, APRIL 2010.

JS Dave, you seem to have really taken to the ideas and making process involved in the blind drawings?

DP Yes, I have got a bit hooked on it. It is all I have been doing since we did the blind drawing portraits project on Monday. I find it a really interesting process. When drawing blind, there is no second dimension, only three dimensions through feeling depth and physicality. I love the fact that it is possible to feel the whole 360 degrees of the head with your fingers, discovering all the crevices and wrinkles, and the prominence of facial features in relation to each other.

JS And in that project we used a range of materials but it seems like you have pared it down to just using fine liner pen?

DP These drawings evolved out of that project, and a series of experiments led me to using black fine line pen. Partly, because I found it easier to key into my sense of touch if I tried to ignore my visual sense. I almost suspend my knowledge of colour, tone and shading, and in doing that, it seemed appropriate to make the drawings monochrome. I was also thinking a lot about the fact that I found it difficult to express three-dimensional form through line alone, so I developed a technique of applying small dots and dashes to mark

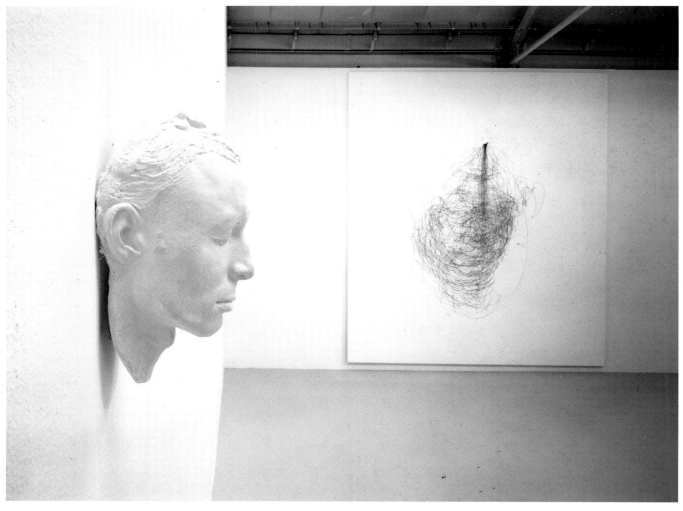

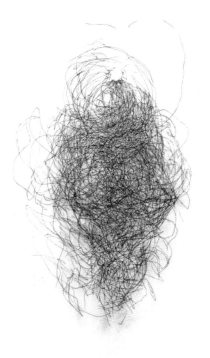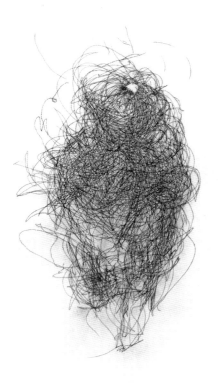

Willendorf Venus, 1997, alkyd resin,
chalk powder, acrylic on canvas,
150 x 339.5 cm, Walker Gallery,
Liverpool. Courtesy the artist.

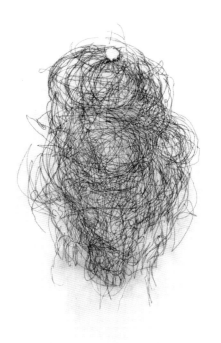

the side was casting a shadow to be traced. These are something like what an architect would call "plans" and "elevations". The effect was like learning for the first time how to steer a bicycle, both hands on the handlebar. Reproduced here is *Pitcher Plant*, drawn on transparent sheets, using upright sections only. At the time, I wrote:

> When you follow the movements of a football across a flat TV screen, you sometimes have the sensation that the ball is going in a certain direction when it turns out to have a different arc altogether and ends up at the feet of a different player than you had first thought. Its true movements are hidden by the flatness of the screen until it arrives at some particular part of the pitch. This same kind of sensation sometimes happens while drawing, when you attempt to compress the sight and touch of a solid object onto various parts of a flat surface. Working from plants now, it will also be interesting to see whether it is possible to set them down just as they are, but as if rendered by a three-dimensional computer programme that has taken a holiday from mathematics.

Another subject has been the Ben Nevis mountain range in Scotland. When you take certain pairs of aerial photographs and view them through the mirrors of a stereoscope, the scene below the aircraft appears to have real depth. It is as if you are looking at a miniature and highly detailed model of the mountain. In a similar technique to the approach taken when drawing plants, I drew the mountain on surfaces that were at right angles to each other. The 'plan' of the mountain is on the lower half of the sheet, and on the upper parf are the depths that I had been given a sensation of while looking at the illusory view of the mountain. Also drawn in this way were man-made landscapes in Scotland, a quarry and an oil refinery.

In 2004 I was invited to be a guinea-pig for a digital drawing system that could record my hand movements. This was a new experience, that meant having to put aside a lifetime of making marks on flat sheets, to make full use of the real space that I could now draw 'in' or 'on'. Now it was possible to make a single drawing and then choose to see it from any number of possible points of view. (I could also draw and return to 'feel' it with the drawing apparatus, which is designed to reinforce the impression that your work is physically present, using what is called 'force feedback', or resistance to the touch). Often I preferred to draw first and then look later, so as not to lose my bearings or my place in the work sequence. It may sound like a cerebral method, but drawing in this way is very much a physical process too. In this way I have approach a number of subjects, including anatomy, music, ethnographic and historical material, and a constellation or map of all of the known and measured galaxies and other bodies in the universe.

"Draw what you see, not what you know" had been the advice I was given as a child. But how is this achievable? The answer for me has been to keep moving the goalposts, changing the rules, and challenging myself by making obstructions to work around.

ABOVE *Ben Nevis*, screenshot from Tacitus three-dimensional drawing software, Edinburgh College of Art, 2004. Courtesy the artist.

OPPOSITE TOP *Ben Nevis (3)*, 2003, acrylic inks on triacetate film, 59.4 x 42 cm. Collection John Talbot, UK. Courtesy the artist.

OPPOSITE BOTTOM *Ben Nevis*, 2003, acrylic inks on triacetate film, mounted onto Perspex, 42 x 59.4 cm. Collection Vincent Bazin, France. Courtesy the artist.

LAUREN WILSON

Making marks without looking at my drawings in 'Bridging the Memory Gap' was really relevant to me because the visual qualities of the drawings relate to the ideas and objects that I work with in the studio at college.

The process of unconsciously layering fleeting fragments of marks, runs threads through the ideas of memory, history, and nostalgia—themes that are seemingly present within my work.

Resting an old photograph in a glass jar full of water behind a magnifying glass meant that the visual that I was referencing became distorted, and the blind marks could be amplified. As the ink from the photograph faded and bled into the water, the marks I made to document it became more delicate; recording its transformation. Drawing from an old postcard created a similar dialogue between the density of the marks made on paper and the history of the object.

bridging the memory gap
PROJECT 3

EYE/HAND SYNCHRONICITY
the hand that sees

DRAWING 13

Duration
15–20 min.

Subject
A single or a collection of up to four objects.

Technique
Unorthodox hand, continuous contact, synchronicity.
Not looking at the drawing.
Your drawing should be no larger than 30 cm.

Materials
Use a combination of 2B, 3B, and 4B pencils on white cartridge paper.

Aims
The aim of this exercise is to create a route of synchronised communication between the eye and the hand, and develop trust between the two.

To make a mark with 'feeling' in synchronised response to the information your eye is seeing, and to recognise the sensitive quality of the mark your unorthodox hand is capable of making.

Most drawing activities require a look-draw-look-draw approach, and if the gap between the drawing and looking is too big, perceived information is changed or gets lost as it is transferred. Ideally, when drawing, your eyes would need to be looking at both the subject and the drawing simultaneously with no gaps. [If you did not have to look at your subject, and then your drawing, but could look through a sheet of glass and trace your drawing, or alternately if you could look at your subject with one eye, and your drawing with the other—it would be easy.]

In this drawing you are looking only at the object, and not your drawing. Your drawing hand is moving in sync with what our eye is seeing, and it is very important to give this process of looking/feeling/drawing, your total concentration.

You have to learn to 'feel with your eyes, and respond with the pencil'. Your response has to be a simultaneous and seamless act of communication, where what you are seeing is felt and expressed in the mark at the exact moment you make it. Think of your pencil as being an extension of your brain, heart, eyes, arm and hand.

Method

1_Position your easel/drawing pad on your left or right hand side, depending on which arm/hand you intend to draw with. You should be able to see your object, but not your drawing, and you should try to position yourself at arms length away from the drawing, in order to extend the controlling distance from the shoulder to the pencil point.

2_Place the pencil in your unorthodox hand (the hand you do not write with) and hold it in a relaxed and comfortable way.

3_Place the pencil on the paper, and without looking at the drawing, pull and push the pencil around, trying to synchronise the line/mark you make with what you are seeing.

4_Try to keep the pencil in contact with the paper—move it continuously, and only take it off the drawing when your shoulder is hurting.

5_Work slowly. See the looking/drawing as a journey. You will have to stop, but try and plan your stop to come at the end of exploring a particular part of your object.

6_Make the exploration continuous, and try to 'feel' the marks as you make them. Twist and turn the pencil as you push and pull it around, sharpen it, press harder, press lighter. If appropriate, incorporate some of the dots, dashes and smudges learnt in the previous drawings. Try to produce an unpredictable, neurotic, intense, awkwardly interesting mark.

7_Do not concern yourself with the drawing—your eye will not trust your hand, and you will be desperate to look—do not.

8_Draw until you have completed a circuit of looking at your object, and if you feel that it is the right time to stop, do so. It might only take five minutes, but could take 20.

Results

Your drawing should show a sensitive response to what has been carefully looked at—a 'patch' of uncoordinated lines on a piece of paper, that excites the eye. Enjoy the gesture of the marks and their sensual relationship with each other and with the empty, untouched purity of the white paper. After examining your drawing, and if you feel that you wish to re-draw part of it, use an eraser, and lightly 'knock back' some of it to leave a ghost drawing, then superimpose a second drawing on top, done in the same way.

ANDY GOMEZ

I find not looking at the drawing allows me to focus my attention on the object—the drawing isn't inhibiting me or coming between me and the object. I am interested in the marks more than the subject matter. I like the way that the drawing is not just an illusion of a pepper, but has its own identity somewhere between the pepper and an abstract set of marks.

DRAWING 14

Duration
15–20 min.

Subject
Same object as Drawing 13.

Aims
To repeat Drawing 13, but in this drawing, use your orthodox hand.

Results
Compare the two drawings and recognise their differences. Because you are using your familiar hand in this drawing, it is likely that you might be a little over-confident, and tempted to speed your 'looking' up, and in doing so, make generalisations—do not.

Like the previous drawing, this drawing should show a sensitive response to what has been carefully looked at; a 'patch' of uncoordinated lines/marks on a piece of paper that excites the eye. Look closely at your drawing, and recognise where it is most successful and where it fails. Compare it to Drawing 13.

What is important is that you have opened up a route of synchronised communication between the eye and the hand. Practice this drawing as much as possible—spend an evening drawing a friend reading a book or watching TV.

Supplementary Option
This drawing is an optional drawing in preparation for Drawing 15, "taking a sneaky look".

Change your point of view, and use your orthodox hand to draw with. Follow the same instructions for Drawings 13/14, but in this drawing you will combine looking at the object with looking at the drawing.

1_Draw for 30 seconds without looking at your drawing.
2_Take your pencil off the paper, and look carefully at what you have drawn.
3_Re-engage the pencil with the drawing.
4_Make a decision as to whether or not you draw over or alongside your first piece of drawing, or alternatively continue the drawing from the point at which you left it.
5_Do not start from exactly the same point start slightly off register, and continue to draw for 30 seconds, but this time look at both the object and your drawing.
6_Repeat the process, changing from not looking to looking every 30 seconds until you feel that the drawing is complete.

MARTIN WILNER

in conversation with Jack Southern, New York, September, 2010

I AM OF TWO MINDS WHEN IT COMES TO TALKING ABOUT A DRAWING. I HOPE THAT THE WORK COMMUNICATES ITSELF SUFFICIENTLY SO I DO NOT HAVE TO EXPLAIN IT, AND AT THE SAME TIME, I HOPE THAT IT IS ENGAGING AND THAT PEOPLE WILL WANT TO LEARN MORE ABOUT IT. IN SOME WAYS I FEEL THAT DESCRIBING THE PROCESS IS ALMOST LIKE A COMEDIAN EXPLAINING THE PUNCH-LINE OF A JOKE.

JS Monochrome, graphic; so visually dense and detailed. There is so much labour in your work; when I look at these drawings I feel like I am looking at the evidence of a constant search for visual connections through unrelenting endeavour.

MW Endeavour is an important aspect of both the drawings and the process; I remember an interview with Lucian Freud in which, and I can only paraphrase him now, but he said that when he paints he is always trying to "surpass himself"; always trying to get beyond what he thinks he is capable of doing. That idea felt very relevant and meaningful to me. That is how I feel about drawing; I feel like I am trying to do something beyond what I know how to do. As if I do not even know how to draw, and am learning it anew with every drawing.

Whenever I draw a face, I feel like I am doing so for the first time. Like Borges reimagining Don Quixote as if Cervantes had not already written it. I do not know where the nose goes; I ask myself, is this where the ears are? Is this the contour of the face? Maybe you have to re-experience the process of drawing your subject every time, even if you have been drawing it for years and it is really familiar. The fun for me is in the continuous reinvention.

JS The attitude you seem to employ when making drawings is very inquisitive; like you are constantly asking ingenious questions.

MW As an artist, I think it is really healthy to be asking questions and to want to be looking at things as if you have never seen them before. It is a lot more interesting to approach your subject from a sense of wonder, and then try to put something new, something of yourself into the drawing.

JS Yes, that is interesting, because that is very much how we discuss drawing objects when we begin drawing workshops with students; to lose the labels of language, and to observe their subject like they have never seen it before, no matter how familiar.

MW Well, that sounds really refreshing. I did not really have any formal drawing training. I taught myself to draw; in elementary school I would sit in the back of the classroom and draw in the margins of my notebooks, imitating drawings from underground comic books and magazines. I had friends; like-minded souls, also sitting in the back of the class drawing. I felt some of them were better than I was and I aspired to be as good; I was determined to develop my drawing.

And then, I took some classes in oil painting at Columbia University because I had this bourgeois notion that to be an artist you had to paint. My first exhibitions were of paintings, but artists and gallerists I interacted with early on kept saying to me that my work was more about drawing than it was about painting. At first I was a little offended, but gradually I started to think that they might be right. About seven or eight years ago, I said to myself, "no more painting, just draw". I felt I had finally figured out what I was trying to do and I decided to concentrate on drawing. I also decided to define very particular conditions for myself.

I OFTEN HEAR PEOPLE TALK ABOUT WHETHER DRAWING IS A MEANS TO AN END OR AN END IN ITSELF. FOR ME, DRAWING IS THE END IN ITSELF. MY DRAWINGS ARE NOT PREPARATORY SKETCHES, THEY ARE NOT DOODLES, THEY ARE NOT, LIKE, SOME DAY I AM GOING TO MAKE SOMETHING OUT OF ALL OF THIS... IT IS WHAT IT IS. AND HOPEFULLY PEOPLE WILL APPRECIATE IT AT THAT LEVEL.

JS What do you mean by defining very particular conditions for yourself?

MW I mean the conditions of how, where and what I draw. The conditions are very evident in the evolution of these two long-term projects I am going to show you. For example in this project Journal of Evidence Weekly, I work exclusively in pen and ink with continuous line, on a small scale, and the drawings are made while travelling on the subways in New York. So the format and medium are conditions, as well as the fact that the drawings have to be done every time I take a trip on the train, I do not skip any trips. These are self-imposed conditions. They are not simply drawing conditions. They are life conditions.

MY WORK IS ALWAYS ABOUT WORKING WITHIN DEFINED LIMITS AND PARAMETERS.

JS Do you feel the development of the projects benefit from these 'drawing' and 'life' conditions?

MW Yes, definitely, in the early stages I decided that I would work in a very narrow vein and try to go as deep as I possibly could. I found that extremely satisfying and it is a process that allows me to keep pushing myself forward as an artist. I think it allows me to grow. My gallerists have been very supportive of my work. Sometimes they could see the slope of my growth curve before I even calculated it myself.

THE WAY I WORK IS ALMOST LIKE BUILDING BLOCKS, IT IS VERY SIMPLE AND ELEMENTAL; I USE VERY SIMPLE STRUCTURES.

JS And do the constraints breed their own freedom and possibilities?

MW My drawing conditions afford me seemingly instant access to my unconscious imagination. So I do not have to work at getting into any particular state of mind. I do not have to prepare myself; I am there and the task is before me. I do not wonder if I am ready?

TOP *Making History: July 2006*, 2006
ink on paper, 29.2 x 29.2 cm. Private
collection.

BOTTOM *Making History: June 2007*,
2007, ink on paper, 29.2 x 29.2 cm.
Private collection.

Am I unprepared? Is this going to be a good drawing? Is this an off day? Everyday is an 'on-day' because I have compelled myself to draw. In that way I feel like I have given myself a gift. I never look at the blank page and think: what could I possibly draw? I would certainly encourage anyone who was going to make any kind of art to find their own way of doing that. You just know what to do because it is an ongoing and compelling enquiry.

I HAVE ALWAYS ENJOYED DRAWING FOR HOURS AT A TIME. YOU GET INTO A CERTAIN PLACE IN YOUR MIND WHERE YOU'RE SOMEWHERE ELSE. YOU ARE JUST IN SOME KIND OF PURE VISUAL REALM, AND TO BE ABLE TO ACCESS THAT IS A WONDERFUL EXPERIENCE.

JS How do you access that? Is there some way to access it immediately?

MW I find that the way I draw now allows me immediate access.

JS Could you describe the process of how you begin to work when you get on the train?

MW As soon as I am in the train, I start to draw. When I am drawing I sort of let it happen, and so the drawing comes to me, almost. You could call it a mediumistic process; I am just the vector through which my hand is operating. And so it just happens, the narrative

theme of the drawing unfolds as it goes along but it is not linear and it is not a narrative that I have complete control over. I indicate as I go along where I get on the train, where I get off the train, what line it is, what date it is and I keep working in these books until the book is completed.

JS And outside of those formal aspects of recording your travelling experience, what do you feel drives the drawings? What do you find yourself focusing on?

MW I observe the underground world of the subways and the subways tell me, as I spontaneously experience it, what is going to happen in the drawing. It is improvisational so I can introduce anything at any point. A drawing like this is a combination of figurative elements and text. The text consists of mostly snippets of overheard conversations, sounds, announcements by the conductor, music, and occasionally a completely imaginary element of some sort.

THESE SUBWAY DRAWINGS ARE ALMOST LIKE ANTI GRAPHIC NOVELS, THEY'RE NOT NARRATIVE, BUT THEY CERTAINLY DRAW FROM THE IDEAS OF TELLING A STORY IN A LONGITUDINAL FASHION.

JS So the drawings are a combination of observational drawing and working from your imagination. Do you generally leave observation quite quickly when you are working on the drawing?

MW It always starts with observation, but by the nature of the way that I draw, it becomes something else, something imaginary quite quickly, but it goes back and forth to a certain degree. Sometimes it is quite subtle because I intuitively make gestural extensions or exaggerations of the way things look; small things, like the way you draw somebody's hair, or the way figurative elements connect with one another. At other times there are more conscious shifts and departures from observation.

For example, I will choose elements of the drawing and wonder what would happen if I have hands reaching out on alternating pages, and then the hands sort of morph and change into faces which in turn become other body parts and so on. By adding another element, the drawing can begin to go off in ways I cannot predict. When I establish a new 'condition' it opens everything else up. So I put one condition in and often I create ten more possibilities. And that is the fun of it, that is what keeps making me come back to it and looking forward to the next trip, the next instalment so to speak.

JS The more 'imagery' parts of the drawings move away from representation and into abstraction. As I read the drawings from left to right as they were drawn, I feel I am temporarily allowed to enter a world of abstraction and at times surrealism, and then there will be a symbol, image or political reference which pulls me back into a more literal world. Is that very consciously conveyed in the composition?

MW I am not deliberately setting out to do that, but I definitely agree with what you are saying. I have noticed myself that even though all the elements of my work are all representational—texts, portraiture, cartoons, signage, music; the result becomes something quite abstract, which is also a part of what I find so interesting; when you play with the way you represent things, you can create possibilities for abstraction.

BECAUSE I LEARNED TO DRAW FROM OBSERVATION, I HAVE NEVER FELT THAT THERE WAS SOME GREATER VALUE TO ABSTRACTION OVER REPRESENTATIONAL WORK; IF ANYTHING MY BIAS IS TOWARDS MORE REPRESENTATIONAL WORK, IN WHAT I DO AND IN WHAT I LIKE TO LOOK AT.

JS Yes, that is very evident and in a way you could say it is one of the characteristics of your drawings, which defines the very distinct style, and aesthetic of the drawings. This leads me to wonder where it came from; was it from a breadth of experimentation or something you arrived at quite instinctively early on in the project?

MW It was both, it is a whole process of organic development; this was a long evolution. I started this project with these really early drawings in spiral bound note books riding on the trains in 1998. On 11 September, 2001, I boarded the last train to leave Canal Street, after watching the two towers being struck by airplanes, and I began to note the days in relation to that attack. I did these very

LEFT *Journal of Evidence Weekly Vol. 148*, 2009, ink on paper, 14.7 x 25.4 cm. Courtesy the artist and Hales Gallery.

MIDDLE *Journal of Evidence Weekly 11/3/01–11/19/01* (detail), 2001, ink on paper (spiral-bound book), 28 x 10.2 cm. Courtesy of the artist.

RIGHT *Journal of Evidence Weekly 11/13/02–11/23/02* (detail), 2001, ink on paper (spiral-bound book), 28 x 10.2 cm. Courtesy of the artist.

morbid drawings for the first 100 days, and noted on each drawing how many days after 11 September, the drawing was made. There were all these strange sorts of eviscerated characters and obviously these were only very loosely based on people on the trains. It was a kind of mourning process. I was disturbed by what was going on; it was frightening living down here in Soho at that time. You could see the Twin Towers from my studio windows here; they were about ten blocks away. I will show you some of the drawings from the second year of the project, and you can see that there is a whole process of experimentation that led to developing and choosing the format.

JS It is amazing to see the origins of this project; It is almost like every visual element within these recent drawings has a tractable history, for example how the mark-making changes and evolves over time.

MW Exactly, they all have a history. Sometimes I will go back and look at some of the older books and realise where certain things came from… it is partly the way I drew as a child, but it

is also just a real evolution of figuring out how to do this, how to draw.

JS And you can also see the relationship of aspects of these drawing in relation to the other bodies of your work. I think, with most artists, everything they do is part of the same process. To a degree, every piece of work they make, ideas and thoughts they have, contributes to the whole. What is really interesting for me is seeing your practice so holistically; I can clearly see the visual relationships and links, and how things have fed each other; the projects are interlinked, through process.

MW Absolutely, in many ways *Making History* grew out of that. And you are right, that it is not just about 'this' piece; 'this' piece is the beginning of the next piece; and it just keeps going forward. Hopefully this enables me to continually move the process and my own development forward. You mentioned the projects being interlinked by process, but they are also linked by content.

For example *Making History* was influenced by and evolved from *Journal of Evidence Weekly*. It began in the aftermath of 11 September. The drawings done in the 100 days after 9/11 led directly to Making History. You can see how many of the stories are about 11 September and the war in Iraq that was developing in the very first drawings of the series in January 2002.

JS Yes, interesting that they have that overlap in content but quite different in the sense that one documents your very personal, immediate experience of travelling on the metro and the other documents a global narrative you extract from newspapers?

MW Absolutely, you could describe their difference as micro and macro. In *Journal of Evidence Weekly*, I observe life a bit more at a micro level; I am looking at my immediate surround in an enclosed environment; my immediate field of vision. And in *Making History* I am looking outward in different ways using print and digital media as sources of inquiry, it is a much broader context—the

whole world potentially. So in some ways one is more intimate and improvisational, and the other more formal and compositional.

I call the project *Making History* but in effect I am making my own version of history through this process of drawing every single day. I am not trying to say this is some kind of definitive statement about what the progress of history is; I am saying almost the opposite, that history has an absurd quality to it, you could write it from many points of view; you can draw it in many different ways. In *Rashomon*, one event is told from a variety of vantage points. In *Making History* I am forced to select one event each and every day and let the story thereby tell itself.

I have not done today's drawing yet. I do not yet know what is in today's paper. I do not know what is going to interest me in today's paper or how I am going to connect it to the previous day's story or the previous week's stories but somehow there is a kind of faith in the process, that carries you through; that somehow this is going to work out.

THE PROJECTS TEACH ME AND MY WORK IS A
RECORD OF MY ONGOING STUDIES.

Journal of Evidence Weekly Vol. 144,
(detail), 2008, ink on paper, 14 x 36.1 cm.
Collection, Paul Smith studio, London.

bridging the memory gap
PROJECT 3

TAKING A SNEAKY LOOK
fast windscreen wipers

DRAWING 15

Duration
15–30 min.

Subject
A single object of your choice.

Technique
Orthodox hand, continuous contact, synchronicity.
Looking at the drawing.
Your drawing should be no larger than 30 cm.

Materials
Use any combination of 2B, 3B, and 4B pencils on
white cartridge paper.

Aims
You are going to continue to encourage the eye to trust
the hand—but allow yourself to take a 'sneaky look' at
your drawing whilst drawing. Your aim is to begin to
co-ordinate the looking/feeling/drawing into an image
of a recognisable object. Spend some time examining
the drawings you have made in the previous projects,
and establish what drawing language qualities you
would consciously like to re-create and transfer into this
drawing. There may be a sensitively felt line that was
drawn by using your unorthodox hand to hold the pencil
in a particular way, or a double image, brought about by
a superimposed second drawing that corrected the first
or a dense patch of dark tone made with two pencils.
Re-create the best of these qualities in this drawing.

By analysing your drawings you will begin to
understand where they succeed and where they fail, and
start to develop a critical understanding of your work.

ONE EYE SEES, THE OTHER FEELS. Paul Klee

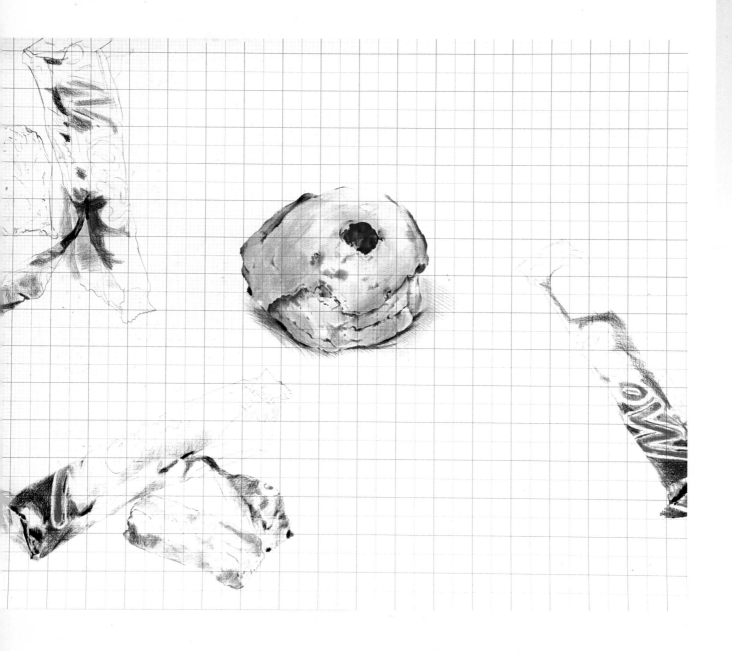

Method

1_Select a single object, take a different point of view and consider a change of lighting.

2_It is very important to position yourself in the right place in relation to your easel/drawing pad, and object and there-by reduce 'the memory gap'.

If you are drawing from an easel, the centre of your drawing board should be level with your shoulder. If you draw with your right hand, you may find it easier to look on the left side of the board, and similarly, if you draw with your left hand, it may be easier to look on the right side of the board.

3_Position the easel so that at one step back, you can see both the object and your drawing paper simultaneously without moving your head.

4_If you are not using an easel, and are sitting down, have the pad on your knees, and lean it against the table edge, or the back of a chair, so that all you have to do is, look at the object, glance at your drawing, look at the object, glance at your drawing. All you should need to do is move your eyes. This is very important, as the time it takes between seeing and putting a suitable mark down needs to be as short as possible.

5_Make sure that you look more at the object than your drawing, and only look at your drawing to check that you are drawing in more or less the right place. For the purposes of this drawing, see it as cheating—'take a sneaky look', but do not catch yourself doing it.

When making a drawing, we often look more at the drawing than the object, and suddenly find ourselves embellishing the drawing with poorly remembered information. Think of 'taking a sneaky look' as a kind of 'checking out' moment.

Results

You should now be able to see the relationship between looking, feeling, and responding, and the marks that you have made should be appropriately descriptive, visually exciting, and collectively combine to resemble an image of your object.

CHARLES AVERY

in conversation with Jack Southern, London, October 2010

CA Ever since I was a child, I have loved drawing. I do not know why that should be, but I think some people just have a natural attraction to it as a form of expression. Throughout my life I have met various people who I have felt a connection with on that basis; I have recognised a shared sensibility for drawing. Personally, I think there is something very intuitive and innate about it, which I attribute to having a feeling of the grain of the universe, of this kind of energy it has.

THE WORLD HAS GOT GRAIN, EVERYTHING HAS A DIRECTIONAL SIGNIFICANCE, WHICH THE MOTION OF A MARK CAN EXPRESS. LINE DRAWING ENABLES YOU TO GO IN THAT GRAIN. I REMEMBER SEEING A REMBRANDT DRAWING OF A LANDSCAPE WITH TREES AND IT MADE ME VERY AWARE OF THAT.

JS How did your drawing develop from your first interest in it as a child? Were you encouraged to explore drawing?

CA Yes, my mum was an artist and she worked from her imagination, as I do, so I probably got that from her. She certainly had an aptitude for it, so for me that seemed like the way to do things.

JS And later in life, did you learn to draw formally?

CA No, I did not really, I got rejected from several art colleges in Scotland; I think because drawing from your imagination was not valued. So I went to life-drawing classes, and I just practised. I drew from the figure as well as from still life, but both felt perfectible to a certain degree. I learnt so much by copying old master drawings as well, anatomically speaking, but you can only develop that so far. The main way to learn is to relentlessly do it, do more and more, like rehearsing lines, and you just get obsessed.

JS So your drawing ability is largely self-taught and you feel drawing from your imagination is key to your development?

CA Absolutely, with drawing from the imagination there is always room for improvement. I definitely feel like I am getting better. For me it is to do with having a very direct relationship with the drawing as opposed to constantly referencing something else, as you do in observational drawing. When I am drawing something from direct observation I feel like it is kind of going through me, it is not really being stopped or challenged.

DRAWING FROM YOUR IMAGINATION IS MUCH MORE ABOUT WHAT YOU DO NOT KNOW, HOW DISTORTED YOUR PERCEPTION IS, IT IS MUCH MORE INTERESTING FROM THAT POINT OF VIEW.

JS And in drawing from your imagination, you are constantly challenged to make visual connections, associations and resemblances, with virtually no reference or source materials at all. I find that incredible.

ABOVE *Untitled (Ceci n'est pas un bar)*, 2008, pencil on paper, 49 x 36.5 cm. Courtesy the artist.

OPPOSITE TOP *Untitled (MaGregors Bar)*, 2008, pencil and charcoal on paper, 115 x 162 x 5 cm. Courtesy the artist.

OPPOSITE BOTTOM *The Place of the Route of the If'en*, 2007, pencil, ink and gouache on paper, two panels, 162.6 x 243.5 cm. Courtesy the artist.

Untitled (View of the Port at Onomatopoeia),
2009/2010, 240 x 510 cm, pencil and ink on
paper. Courtesy the artist.

CA Occasionally I 'rehearse' a drawing, or one of my assistants may make a model of an invented building so that I understand it, in order to conceive it in the drawing. But yes, most of the time I work without any visual references. It is really difficult, but I think it makes you much more aware of how the world works. Particularly the aspects of the world you study; how one part connects to another, and you suddenly feel like you know it. When you draw from your imagination you realise you have so much sub-conscious knowledge. Instinctually, you have an awareness of the visual relationships of the world, which you can tap into. So much of what I draw, I have never drawn from life, so I guess in a way, I have perfected that.

JS It is interesting to think about drawing as a process that can allow you to recall different levels of knowledge that you might not otherwise realise you have?

CA Yes, well exactly, and I find it quite empowering, because you feel like you are in control of the world; the world is your idea. It does give you a unique sense of freedom and latitude when drawing.

JS It seems amazing to me that you have developed such a distinct and personal drawn visual language. I guess that is a product of the constant engagement in your own visual realm? Do you continuously make discoveries when drawing, which you then use again and develop?

CA Yes, exactly and that is what I was referring to earlier, when I said that I feel I am getting better. I have built up an intuitive visual repertoire, with both materials and processes, which I can keep adding to. For example, technically speaking, I instinctively know that if I am drawing a pan, I will use a really hard pencil like a 6H, if I am drawing aluminium it is HB, whereas if I am drawing a roll of lead it is probably only 2B. When drawing a reflected surface, I leave white bits where the light is hitting, and go over it with a rubber once. Drawing something wet; I throw water at it, drawing something textural, like posters on walls, I use a rubber to tear and blister the paper, etc.. All sorts of techniques I have built up to give whatever I am working on substance, textural depth, and contrast.

I THINK I LIKE THE MEDIUM OF DRAWING BECAUSE OF THE LACK OF POSSIBILITIES. THE SIMPLICITY, FOR INSTANCE, I PREDOMINATELY WORK IN MONOCHROME, I HAVE GOT A BUNCH OF PENCILS, A POT OF INK AND A COMPASS, IT IS JUST VERY LIGHT IS IT NOT? I LIKE THE LIMITATIONS.

JS I guess the technical developments in your drawing are so entwined with the subject matter; the objects, characters, and places of your ongoing project *The Islanders*, in which the drawings depict various episodes of the fictitious world you have been developing over the last five or six years? There must be a fluidity of practice, which allows for pure invention, both technically, and in terms of the content of the drawings?

CA Exactly. As I am working I am continually coming across new ideas, and ways of doing things. Constant invention breeds a state of unpredictable flux in the drawings. I can take advantage of the accidents as they happen. So working quickly, I naturally enhance mistakes, pushing things about, making little exaggerations, extend limbs, etc, which makes the drawing as a whole plausible, in a way that a character on its own often is not. To a degree the mistakes make this project; often it feels beyond my control.

JS So those small actions, gestures and nuances, in turn, determine what the charters look like, what they might be doing, and the overall narrative content of the drawings?

CA Yes, quite often I will end up drawing a man that becomes a woman and vice versa. And sometimes what the characters are doing completely changes as well. At first the process is quite free but the more the drawing comes together, its meaning becomes increasingly restricted and coherent.

JS In your drawings there are a lot of lines and marks, especially in people, that look like they have been made very quickly. In relation to what you were just saying about the improvisational thinking process, does that fluidity and continuity allow you to almost draw as fast as you think?

IT IS QUICK, IF YOU HAVE GOT A LOT OF STUFF TO SAY, A LOT OF STUFF TO GET DOWN, DRAWING IS THE WAY TO DO IT.

CA Precisely, that is exactly what I was going to say; you took the words right out of my mouth. I draw as a way of thinking, but not having to come up with a specific truth or an answer, and the fluidity in the line that you refer to emphasises the fact that the drawings are always provisional. I leave all my old lines in; I do not attempt to create something perfect, that is a masterpiece. I am very against the idea of something proclaiming to be 'right'. It is all about the process; it is all continuous states of development.

YOU CAN INVEST THE IDEA OF TIME AND SPEED OF MOTION IN THE DRAWING, NOT JUST BY WHAT YOU ARE DRAWING, BUT BY THE SPEED AND TEMPO OF YOUR LINE.

JS So every part develops in relation to the other visual elements? It is very interesting to think about that in terms of the process of the image building as a whole. Spaces and characters developing in unity.

CA There are lots of logical steps, which gives the drawing a sense of coherence. The drawings have a feeling that the whole composition and narrative is predetermined, but how it came about is, to a large degree, improvised.

I LIKE THE WAY YOU CAN JUST DRAW. YOU DO NOT HAVE TO FILL IN THE WHOLE SPACE, JUST DRAW A SINGLE SWEEP. WHEN DRAWING A FIGURE YOU DO NOT EVEN HAVE TO DRAW A BODY; YOU CAN IMPLY A BODY. WITH THAT LICENCE TO WORK QUICKLY, YOU CAN JUST MOVE ONTO THE NEXT THOUGHT.

When I start a scene I might draw a specific facial feature. As the drawing develops, I then get the image of a character, who might have a very particular attitude or personality which emerges. Once I have drawn him/her, the next person seems to react to that person, and then the whole thing builds up through a logical progression from that arbitrary starting point of say a nose, for example.

JS So when working on a particular section of the drawing, you are constantly in review of the whole? All those visual connections must feel difficult to maintain sometimes?

CA Yes, and that can be a bit of a problem, because I get easily distracted, and you need a certain level of intensity of concentration, it is quite tiring. It is almost like method acting, because you are introverting yourself, in a way that's difficult to manage when you are aware of, and having to engage with the world at large.

JS Yes, I can see that, and I find the extremity of that engagement fascinating. Submerging yourself into the subconscious to that degree must require blocking out any reference or involvement with your immediate physical surroundings? That allows you to be completely involved in the physical, psychological and emotional relationships in the drawing? In a sense you are there, involved with whatever you might be drawing, not reflecting on it, or making a rendition from a distance?

CA Yes, absolutely, and I am aware that when I am drawing certain things, I am deeply involved in the subject. For example, if I am drawing a character that is sexually attractive, there is sexual charge there; in a sense I am having a love affair with them. It is like when children draw cars, they will be doing the sound effects of the car as they make marks. They get really passionately involved with the idea of the car, as opposed to drawing the reality of its likeness.

JS And that level of engagement seems remarkable to me, especially considering many of the drawings are on such a large scale?

CA Yes, when working on a mammoth drawing like the one on the wall over there, which is two and a half metres by five metres long, there are so many different relationships going on. As soon as I introduce another character, it will have a knock on effect, and change other sets of interactive relationships in the drawing.

I find it important to have some kind of scheme, as a departure point. For example, consider the way the main characters are going to develop and how they are going to anchor the drawing. But then it is important that that system is not sacrosanct.

These recent drawings of people in the town are set in very defined physical spaces, so that introduces further problems. It is even more difficult to get the relationships between characters and their environments right; I work very hard at that.

JS In relation to the way the drawings develop, some elements have an unfinished quality to them. Areas seem consciously left, and other parts of the drawing are really densely complete. Is this intuitive; moving on to another part of the drawing when it feels right?

CA My answer to that question would probably be two-fold. I certainly am very aware of the fact that contrast is an effective visual device. So to have one area that is very densely full and described, in contrast to something that is very lightly delineated, gives visual balance and interest. And in my drawings specifically, I think the less described parts give it this kind of movement, and emphasises the provisional nature or uncertainty of some parts of the drawing. But it is also an analogous strategy for the project as a whole. I am developing my own fictitious world, but I am not trying to create an exhaustive encyclopaedia of the universe, or go into more and more detail of a complete realm. There are huge areas of the Island that are very lightly sketched, similar to one's perception of the world. As in a very detailed and intimate knowledge of one's own direct environment and pathways throughout the world, but then huge swathes of it of that are unknown, unclear and undefined.

JS Does that sense of balance, both visual and metaphorical, also serve to underpin and re-affirm the fact that everything that 'makes up' the Island, objects, peoples, places, etc, can be seen as relational?

CA Yes; I would not have said that was the primary message of the work. But it is something that I am acutely aware of when I draw; things relate to each other, which gives a sense to the world I draw.

JS So the relationships formed in the drawings of the Island, allow you to develop a personal system of re-assessment of the relationships in the world? Or at least the particular relationships, which you choose to focus on and investigate?

CA Well drawing and thinking about the Island helps me understand the world. When you make things up you really have to think about how they function in order to give them verisimilitude. If I am drawing a building for instance, I think about how the building is on the inside, how the circulation would work, where the bathrooms, stairs, etc. would be.

I try and think about how and why the building would have come about; I make up a story for it. This approach of course acts as a critique on the real world, or at least makes me think about how the world goes together. Sometimes that can be misinterpreted as satire. It is not—really I am very much in earnest, perhaps to the point of naivety.

THE DRAWINGS DO NOT LOOK LIKE DIAGRAMS, BUT I DO THINK OF THE PROJECT IN A DIAGRAMMATIC WAY, IN THE SENSE THAT I AM TRYING TO TELL YOU, AND SHOW YOU ABOUT SOMETHING. SO THE DRAWINGS ARE LIKE RECORDS OF SOMEWHERE I AN UNABLE TO PHYSICALLY TAKE YOU TO. I ALSO CANNOT TAKE A CAMERA TO THE ISLAND, BUT I CAN DRAW PICTURES OF IT.

JS So the project allows you to place the evidence of that questioning of relationships in a structure. But that structure does not have a definitive order, beginning and end, is in constant change, movement and evolution?

CA Yes, and I think that kind of a temporality of the whole thing is

really important in talking about my project. To not have a chronology; there are events, which are remote in time, but being remote in time is not linear, characteristically. Like a myth; we have myths that are remote in time but they are not placed in a chronological order.

<u>JS</u> And that lack of chronology facilitates a methodology of a re-classification of meaning? Less about a logical order, and more about a kind of philosophical relational, significance?

PHYSICALLY EVERYTHING HAS A MEANING, THE MEANING OF A KETTLE IS TO BOIL WATER, THE MEANING OF A TABLE IS TO SUPPORT THINGS, THE MEANING OF A WALL IS TO DIVIDE ONE SPACE FROM ANOTHER. SOME THINGS IN MY DRAWINGS HAVE A MEANING, OTHERS DO NOT, THEIR MEANING IS TO MEAN.

<u>CA</u> Well, how I think about it has changed. As the project has evolved, I have been through different stages and processes of thoughts in relation to your question.

When I first conceived of *the Island* as a project, I wanted to create a structure for myself. That wish was driven by an acute awareness that when you make an artwork you are able to control the meaning of the work in the studio, but when it goes out into the world, it is open to being perceived in different ways. Its meaning may change depending on how other people see it and how it is contextualised.

I could never control that, but what I could do is create a system whereby the work had a pure meaning in relation to that system. So no matter what happened to it outside, in the world at large, it still retained its pure meaning as well. But how pure, how structured, how stable, and how much of a 'terra firma' I wanted that body to be, has changed. It started off that I had created a definite territory, with very distinct parameters and restrictions.

Part of me realised the impossibility of such a concrete, rigid structure, and also I was prohibiting myself to certain kinds of creative adventures by sticking to it. I decided I wanted to loosen up, to lose my bearings slightly and explore the lack of control. So I created something which is in between, so it is not all at sea, but it is not very firm, rigid kind of territory either. So I feel like I have been through different stages and maybe will continue to do so. It is a work in progress and it kind of always will be. I think that requires the trust and the tolerance of the audience; an understanding that it is in earnest. The fact that it is primarily drawing helps; I see drawing as a very earnest medium.

THERE ARE LOTS OF ELEMENTS IN THE PROCESS OF THINKING ABOUT THE ISLAND LIKE WRITTEN NOTES, SKETCHES, DIAGRAMS WORKING OUT POSSIBLE SHAPES OF BUILDINGS, ETC. I SHOULD BRING THESE INTO THE GALLERY CONTEXT TO EMPHASISE THE CONTINUITY OF THE PROJECT BEYOND THE EXHIBITION, OR BEYOND MY LIFETIME EVEN. IT WOULD PREVENT THAT BUSINESS OF IT BEING PRESENTED IN A GALLERY AND THEREFORE BEING PERCEIVED AS FINALISED AND SOMEHOW 'CORRECT'.

Untitled (Stone-Mouse Sellers), 2008,
pencil and gouache on card,
96 x 132.5 cm. Courtesy the artist.

bridging the memory gap
PROJECT 3

A SINGLE LINE
thoughts follow lines

DRAWING 16

Duration
15–20 min.

Subject
A single object of your choice.

Technique
Orthodox hand, continuous contact, synchronicity.
Looking at the drawing.
Your drawing should be no larger than 30 cm.

Materials
Use any combination of 2B, 3B, or 4B pencil, either singly or in combination on white cartridge paper.

Aims
To further develop the relationship between looking, feeling and drawing by creating continuity in the looking/drawing process by having as small a gap as possible between looking at an object, making a decision and responding with a line. It is important to LOOKDRAWLOOKDRAWLOOKDRAWLOOKDRAW Try to keep the pencil moving whilst looking. Think of the process as being joined-up and continuous, like fast windscreen wipers.

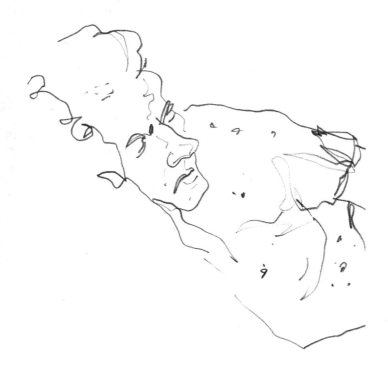

IF I TRUST MY DRAWING HAND, IT IS BECAUSE IN TRAINING IT TO SERVE ME, I FORCED MYSELF NEVER TO LET IT TAKE PRECEDENCE OVER MY FEELINGS. Henri Matisse

ABOVE Mick Maslen, *Sleeping Woman*, pencil on paper.

OPPOSITE Lilly Hawks and Andrew Gomez begin to work together on large scale line drawings towards the end of the first week of Workshop 1, April 2010.

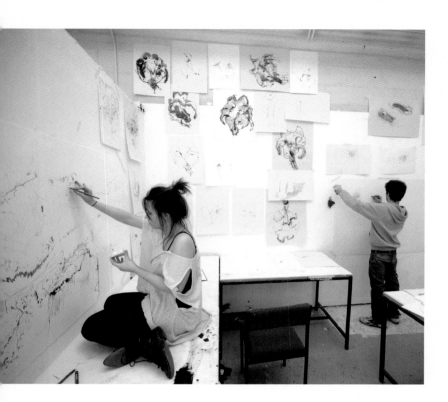

Method

Change your point of view, and arrange yourself, easel/drawing pad so that your drawing and the object are side by side in your field of vision, and as close to each other as possible.

All you should have to do is move your eyes in a 'lookdrawlookdraw' continuum between the object and the drawing. Your eyes and hand should work in synchronised unity.

1_Repeat the drawing method used in drawing 16.
2_Try to split the looking fairly evenly between the object and the drawing.
3_Keep drawing whilst looking at the object, and feel the mark as you make it.
4_Do not draw too quickly—draw in a slow and searching way, and keep in touch with the pace of your looking.
5_Let the line meander as it explores and discovers—from the outer contours to the inner shapes and forms. Find relevant ways across the form, like well-walked routes across a landscape when seen from the air. See the drawing as a journey, on which you come across areas of interest and detail. Take time to make them a point of focus, like bumping into an old friend whilst out on a walk, and stopping to talk.

Contain the big and empty shapes, and juxtapose them with the smaller densely busy areas.
6_When you feel that the time is right, stop drawing.

Results

Having integrated the looking and the drawing, you should now be becoming more confident about making drawings. You learn to draw by drawing—and like a musician must continually practice his or her musical scales, so the drawer must practice drawing. It must however, never become unfelt and routine.

GEMMA ANDERSON
in conversation with Jack Southern, London, March 2011

GA For me, drawing facilitates thinking. The drawing process is so crucial to me, and gradually I have noticed that the activities in life which I prioritise and repeat outside of drawing allow a similar kind of thought process to take place, for example spending time walking is really important to me.

Through walking I consciously create time to think, observe and explore. But, I also see walking as a linear journey or path through a thought process, similar to that of making a drawing. I think the other parallel is motion. I find it easier to think when I am in some kind of motion. Drawing is a form of motion, which for me is particularly conducive to contemplation.
DRAWING IS SUCH AN IMPORTANT PART OF MY LIFE THAT I HAVE TO REALLY MINIMISE MY LIFESTYLE, IN ORDER TO CREATE THE TIME TO DRAW.

JS So a conscious concentration on observation, and processing thoughts those observations generate, is key to making your drawings, but also, to how you live your life?

GA Yes, drawing and observing are mutually dependent and happen simultaneously when I have a pencil or etching tool in my hand. But unlike drawing, observation can be practised anytime and anywhere. The continued and consistent observation of the world around me is when a lot of the ideas for the work take place, which feeds directly into my drawing practice.

The process of making drawings then allows me to distil the experiences, related thoughts and observations, into the simplicity of a line. I can then use the language of that line to convey the visual relationships and resemblances I see and recognise as interesting and meaningful.

JS So you put visual aspects of the world together by drawing them in relation to each other?

GA Yes, I work in a kind of collage practice where I often draw things together because of their shared anatomies. I borrow and transplant visual signifiers, symbols, shapes and forms, from the people, specimens and objects I draw. Like an operation; where drawing is the technology, parts are removed, added, exchanged, merging forms that are analogous.

JS Considering your practice is based in London, and much of your work is centred around the subject matter of the natural world, it is almost as if the conditions you set up for both your life, and work, provide an antidote to your immediate surroundings?

GA Yes I think that is right, and I am becoming more aware of that the longer I am in London. I find that in contemporary culture, it is hard to do anything slowly, and I feel that drawing is a continuous effort to maintain a slow and conscious way of life.

TOP *Life Drawing*, 2003. Falmouth book of 105 Life Drawings, Rotring pen and ink, 25 x 33 cm. Courtesy the artist.

BOTTOM *Alice*, 2007, copper etching, *à la poupée*, 100 x 80 cm. Courtesy the artist.

OPPOSITE *Elsy*, 2008, copper etching, *à la poupée*, hand-coloured with Japanese inks, 80 x 60 cm. Courtesy the artist.

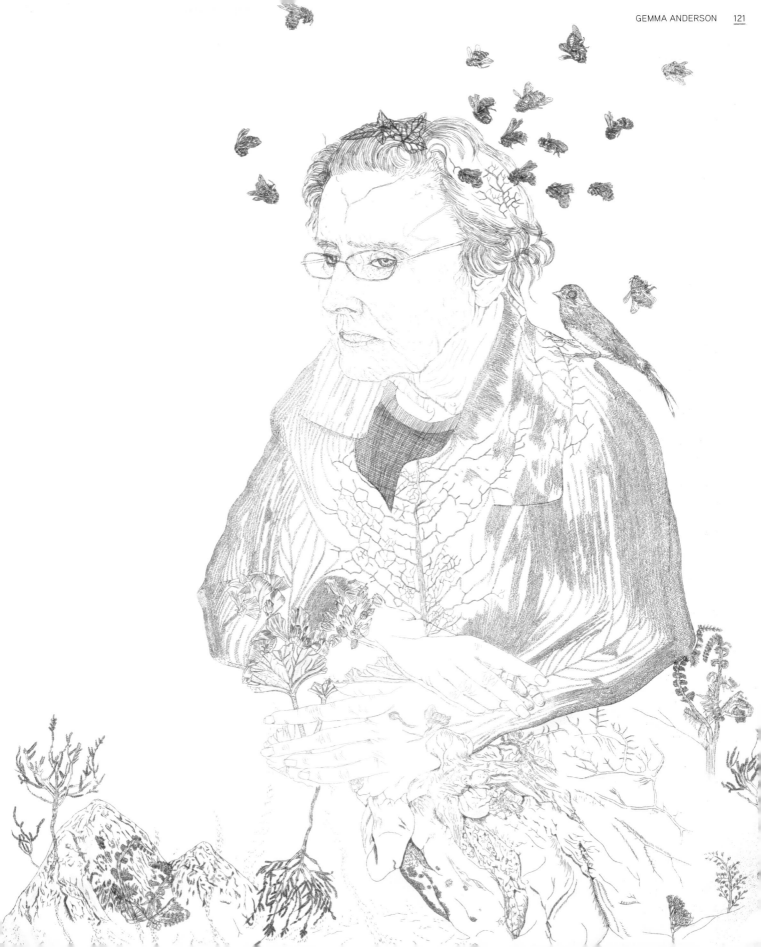

JS It is almost as if the way you live your life deliberately places value on observational practices or methods we might associate with the pre-industrial world? You seem to explore the contemporary world with empirical principles that allow you to discover and look at things with wonder, insight and reverie?

GA Yes, well, I suppose it is to do with the particular things I place value on in life. And I guess the things you rightly point out are aspects of the world which could be associated with practices in periods of history I am particularly interested in, like in early scientific exploration.

JS It is really interesting to think about intrinsic human traits, principles and ways of life that seem to transcend time and place. In relation to your comments on navigating contemporary culture, it is fascinating to think you can feel connected to a specific period of history through feeling an affinity with practices you learn about. And of course making drawings is part of that; it sort of makes the connections tangible, visual and present in your life?

GA Yes, I think so too, in the sense that I draw as a method of recording my observations and discoveries, and drawing of course was the only way to record discoveries made on early voyages.

Before the creation of modern science, natural philosophers like Aristotle and Pliny observed the world holistically, often basing their classifications on anatomical resemblances. I do not really know why, but I really relate to their approach, it feels instinctive and a natural way to approach learning about the world, through comparisons. I naturally abstract what I see into shapes, a bit like a child or an alien, discovering everything for the first time. I try to see each specimen or object I draw, without its labels, but as an abstract form full of the hieroglyphics of nature.

JS: It is interesting you reference observation in relation to learning. When we work with students we place an importance on acknowledging and understanding the 'currency' of looking and observing the world around you. So in the light of what you have been talking about, have you always recognised and valued observation as a tool for direct learning?

GA Yes, and I think it is how I learn best in the sense that I have always valued learning through experience, and drawing from observation is a way of experiencing, learning and evidencing at the same time. Throughout art school I always maintained a really rigorous life drawing practice. I loved the intense observation. Even when my work started to change, I always drew from life alongside any other work I might have been making.

JS When you say it changed; do you mean your main focus moved away from observation?

GA Well, for a period, during my foundation course at Belfast and first year of my BA at Falmouth I worked solely from life.

At some point I became a bit frustrated with it. I could not work out how the drawings could express ideas I was interested in, and I was conscious that the creative potential of drawing was not really expressed in what I was doing. Whereas, now, years down the line, everything I draw is a truthful observation but the compositions are invented, so I hope the work somehow balances the factual and the fictive.

I AM INTERESTED IN MAKING WORK THAT IS SOMEWHERE BETWEEN AN EMPIRICAL PRACTICE OF RECORDING, AND BUILDING A SUBJECTIVE PERSONAL ARCHIVE.

JS So when and how did the work begin to change to incorporate both of these aspects of drawing?

GA Well, I had a bit of a breakthrough in my second year at Falmouth. Primarily because I became so fascinated with the natural environment in Cornwall. I would spend so much time walking outside and consciously observing plants that I started to see resemblances between plant and human anatomy. I began to amalgamate theses two worlds through drawing.

In the life room I would elaborate on my drawing with plant forms from memory. At that time I was drawing the human figure on a sketchbook, and the lack of true scale meant it seemed to make sense to make up the plant forms. That shift in content also coincided with a really important development in the materials I used to make drawings. I went from drawing in pencil, to a really fine drawing pen, then to a Rotring pen, until someone suggested I should try etching because of the fine quality of the line and the anatomical nature of my work.

JS Most of the drawings you make are now etched. Why, on first using etching, did the way you worked, or subject matter you dealt with, translate particularly well to the medium?

GA Well etching and engraving are widely associated with drawings of anatomy and the natural sciences, which I have always been into. But I also just immediately liked the alchemy of the etching process; using, fire, metal, acid and water. I really love copper as a material. Drawing on the smoked ground of a copper plate is a process of removing the ground, so it is more of a sculptural process. Like carving, a process of subtraction, as opposed to that of drawing with pencil on paper, which is more of a process of addition.

Drawing an object on copper, feels like processing one object into another object and once etched, the drawing becomes a physical mould, like a blueprint of the object, which is a lovely thing in itself.

JS So you began working with the medium by drawing directly onto the copper plate? Did you ever make drawings that became etchings?

GA No, when I started working with etching I immediately treated copper like a piece of paper. I have never made a drawing in preparation for a drawing. It does not really make

sense, because it is very risky but I like the energy of the first drawing and observation of the subject. Even when I was working on life size portraits, on the largest copper sheets I could get, I would still draw directly from life onto copper.

JS And in the light of what you have already said about the subject matter of the work at that time, I guess it seemed entirely appropriate to capture the energy of a living, growing organism with the energy of an immediate mark on copper?

GA Yes, but it is really interesting you should make that point, because while living in Cornwall everything I drew was plucked from the living environment around me, but moving to London forced a big change in the subject matter of the work. Although the content still involved making transcriptions and translations from the natural world, the move to London led to the change of drawing inanimate or dead objects.

JS Is that because you had to seek out subjects from archives and museum collections?

DRAWING FROM SPECIMENS IN MUSEUMS FEELS LIKE A MACABRE EXPLORATION OF THE UNDERWORLD; THE WORLD OF THE DEAD. A WORLD OF ARCHIVES FORMED FOR RESEARCH AND STUDY OF THE DEAD, IN ORDER TO UNDERSTAND AND DEVELOP THE WORLD OF THE LIVING.

GA Yes, at first I drew from the Hunterian Museum (Royal College of Surgeons), but found the distance of drawing specimens behind glass too detrimental to the observation. I asked for permission to draw specimens from the research collections at the Natural History Museum, in order to be able to observe at close range, developing a more intimate, and personal relationship with the objects. It was important to me to explore collections first hand, in my own time, making my own discoveries.

APPOINTMENTS ENTIRELY DEPEND ON THE FLEXIBILITY AND GENEROSITY OF THE INDIVIDUAL. SOMETIMES I HAVE TO CONTACT A NUMBER OF PEOPLE, BEFORE GETTING ANY REPLY, BUT IT IS IMPORTANT TO PERSIST. DRAWING FROM A FORMAL PUBLIC ARCHIVE IS A COOPERATIVE PROCESS WHICH REQUIRES PATIENCE AND RESPECT.

JS Working from collections has become such an embedded part of your practise. In that development, has your approach become increasingly restricted in some ways? The connotations of the history, and priorities of the classification of whatever you might be drawing must have changed how you think about the subjects?

DRAWING HAS BECOME A WAY TO LEARN ABOUT ALMOST ANYTHING I WANT TO LEARN ABOUT, BECAUSE THROUGH DRAWING, I HAVE GAINED ACCESS TO COLLECTIONS AND PEOPLE THAT OTHERWISE I WOULD NOT HAVE COME INTO CONTACT WITH.

TOP *Basaltic Lava, Pyroclastic Rocks and Sulphur Butterfly*, copper etching, 30 x 35 cm, hand-coloured with colour pencil and Japanese paints, Galápagos Islands, 2010. Courtesy the artist.

BOTTOM *Fumaroles and Hornitos of Volcan Chico*, Ninachumbi, copper etching, hand-coloured with colour pencil and Japanese paints, 2010, 30 x 35 cm. Courtesy the artist.

GA The intention is always the same thing, whether drawing in a field or drawing in a museum; to discover all the shapes and forms that exist in the world, which is ambitious, I know! But the more forms I draw, the more relationships I see and in turn, the more ideas I have about ways in which to draw one thing transforming or appearing as something else.

OVER YEARS OF PRACTISED OBSERVATION, I HAVE BEEN CREATING A BANK OF FORMS, STORED IN MY MEMORY. DRAWING IS A MNEMONIC DEVICE, AND THE MORE I DRAW; THE MORE FORMS AND IDEAS ENTER MY COLLECTIVE MEMORY.

But you are right in the sense that on a walk, it is only me, as an artist, placing an importance and deciding something is worth documenting. Whereas, the objects in museum collections, all have a place of scientific importance in the classified world of natural history. I am an artist approaching a science archive, and classifying what I find according to my own principles, which often displaces the object and creates a playful disorder.

IN THE CONTINUING COMPARATIVE STUDY OF FORMS, I AM QUIETLY SUBVERTING THE CONVENTIONS OF MODERN CLASSIFICATION.

JS I think that it is so interesting that you, as an individual, go into institutions and collections, which have been formed by a number of scientists and academics. You are using the same collections and apparatus, but you are following a creative endeavour, forming a unique knowledge of what you work with. You are united with the scientists in your collective drive to 'know' and understand these collections.

GA Yes, you are right, and I really value the interactions with individual scientists and curators I work with, I think we are curious about each other's work. I often find that there is a genuine exchange of knowledge. A kind of symbiotic learning that goes on.

Last year, I made a drawing of the moon observed through a telescope, with the help of astronomy staff at University of London Observatory. The observatory technician opened the dome and I climbed a ladder to the telescope, covered one eye with an eye patch, put my copper plate at arms length and began to make marks; I had no idea how long I had before the clouds came back. The longer I observed through the telescope, the more my eyes adjusted, and the more I could see of the moons forms.

JS You talk a lot about the acquisition of knowledge. But as we have discussed, you focus on knowledge which relates to science, history and the natural world. I am interested in how this is reflected in the way you limit what you draw to subjects which are raw materials of nature; people, plants, animals, minerals, etc.. You do not really draw man made objects?

GA I hope my drawings intrigue people, making them curious, and encouraging them to re-assess their relationship with the phenomena of the world around them. So I suppose that is

always going to be reflected in the subjects I choose to draw. The natural world offers an endless variety of shapes in its materials whereas the range of shapes in the man made world are more limited. But I also think I draw natural forms because I am fascinated by the origins of things, and the raw materials of the world. If I was to draw a man made object for example, I would naturally think about its origins. How it existed before it came to be in the state in which I found it, which would inevitably lead me back to the natural materials involved in the objects construction or manufacture. I am interested in finding the shapes and forms of the materials within man made objects which may begin to give the work a complex process as many of these shapes can only be visualised using scientific technologies.

My drawings document the interest I have in finding shared shapes between forms, for example, ramifying plants and lungs, or coral and mineral forms of aragonite. I find these relationships very poetic as they exist as curiosities outside the conventions of classification, related but segregated through formal classification into different kingdoms. Shapes tell us things, and I am becoming more and more fascinated by the abstraction and relation of shapes in Elucidean space, and how this can be combined with observational drawing.

I LIKE THINKING ABOUT DRAWING AS A MEANS OF COLLECTING AND POSSESSING THE WORLD WITHOUT ACTUALLY HAVING TO COLLECT OR POSSESS ANY "THING" AT ALL.

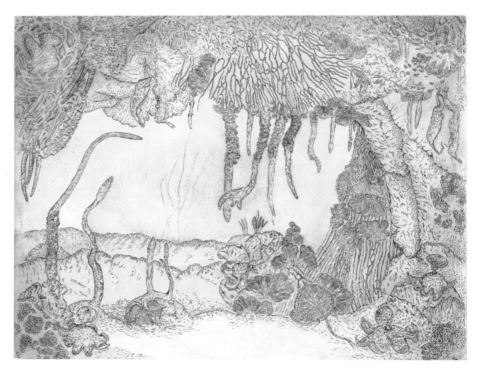

PREVIOUS PAGES *Aragonite under moon*, copper etching, drawn from the collections of the Natural History Museum, 2011, 45 x 60 cm. Courtesy the artist.

OPPOSITE *Haematite*, after *Haemaglobin of the Brain* by R Hooper, copper etching, drawn from the Geology Collection at University College London, 2010, 18 x 12 cm. Courtesy the artist.

TOP *Moon*, after *The Moon, viewed in oblique sunlight* by William Herschel, drawn through the 20 cm fry refractor at University of London Observatory, copper etching, 30 x 35 cm, 2010. Courtesy the artist.

BOTTOM *Mycology*, after *The grotto at Antiparos* (Unknown), drawn from the Mycology Collection at Kew Gardens, etching on copper, hand-coloured Japanese inks and colouring pencil, 2010. Courtesy the artist.

A LINE IS A DOT THAT WENT FOR A WALK. Paul Klee

bridging the memory gap
PROJECT 3

TAKING A LINE
FOR A WALK
the route of discovery

DRAWING 17

Duration
15–30 min.

Subject
A 360 degree panoramic view of the room you are in.

Technique
Orthodox hand, continuous contact, synchronicity.
Looking at the drawing.
Your drawing may be continuous over as many
sheets of paper as you like.

Materials
Use a 2B 3B or 4B pencil, fibre pen, rollerball Biro or
any 'free-flowing' mark-making instrument on white
cartridge paper.

Aims
Your aim is very similar to Drawing 16. Link your eye
and hand in synchronicity and take them on a recorded
'walk' through 360 degrees in the room you are
working. Your drawing will be the recorded trace of this
journey of looking.

Method
You could use single sheets of A2, A3, or A1 paper, and
join them together on a 'walk' from left to right, or a
range of odd sized smaller pieces, and improvise on the
direction of your 'walk'. Go right, go down, go left, go
down, go right, and continue through the 360 degrees to
finish where you started.
1_Start at a point on the left-hand vertical edge of a
sheet of drawing paper, possibly at seated eye-level.
2_As you move your pencil, you will have to
LOOKDRAWLOOKDRAW.
3_Move the pencil slowly to the right, and take time to
explore anything of interest that your eye comes across.
It might be that you bump into a standing figure, or vase
of flowers—explore them with your line. Your drawing
does not have to show the whole picture, and you might
run your line from the profile of the figure's head—into
the eye, nose, and mouth, and on a journey down to
a very detailed exploration of a shoe, and back up to a
table-top, along to a chair—and down the side of it to the

cat that is sitting on it. From the cat, down the chair leg along the skirting board, up the door frame and along the top of it to the right hand vertical edge of your sheet of paper. Start a new drawing at the point you leave the old one, but on the left hand vertical edge of a new piece of paper. It is very important that you are selective in your decision-making. You need to have the right balance between what you draw, and what you leave as empty white paper—between areas of detailed interest/ focal points, and pure line.

Draw until you have completed a full circle, then attach each successive drawing to the one before. You might consider Klee's notion—point into line—and as you hesitate and stop moving your pencil, register this rest point with a slightly darker mark, a dot of sorts.

Employ the same drawing procedure as in Drawings 15 and 16, and make sure to synchronise your looking with your moving hand. Work fairly slowly—take a 'sneaky look' to check out your drawing. Allow your mistakes to remain in the drawing.

Supplementary Option

A supplementary option might be that you make a second and third drawing on the same pieces of paper, but this time start in a different place and go on a different journey. Let the drawing 'bump into' the previous drawing in an interesting place. Try one that follows a vertical route from ceiling to floor, or loops back on itself in a more organic 'looping' journey. Alternatively, follow the same procedure as described above, but concentrate on taking the line for a walk that only explores the features of a friend, and links them into their seated context.

Results

Your drawing should be a unique record of selective looking.

TIM KNOWLES

I do not divide my practice into drawing, sculpture, film... the boundaries are fluid and not of significance to me, though the idea of drawing in its widest sense plays a strong role in my practice.

Works that might be described as more obviously drawings, such as the tree drawings or the postal drawings exist as a drawing accompanied by a photograph or object, a mechanism or apparatus revealing the process by which the drawing has been produced, these are not documentation as such but an integral part of the work.

To me it is about the process by which the drawing/work has been generated or produced and the drawing and any accompanying parts serve as mechanisms to transport the viewer into the process, understanding a little more about the characteristics, structure and motion of a tree in the wind, how the wind moves through a city and what it might be like to follow its turbulent meanderings.

For me drawing is all about movement, it is always the result of an action, a record of motion as a result of a force exerted over time. Whether it be the artist's hand or body, seismic movement, the motion of a tree branch or the path followed by the wind through the landscape it is always the result of movement.

Within his work Roman Signer talks of actions resulting in sculptures, in *Stool with Rockets*, 1984, the artist sits on a stool with a rocket strapped to each of its four legs, the rockets are lit and attempt unsuccessfully to takeoff with stool and artist. This action results in a simple sculpture [which could also be seen as a drawing, with the mark-maker left on the page] that clearly tells the story of its own creation, the burnt-out rockets attached to the stools legs and the sheet of timber on which it sat, now with four scorch marks.

Serge Tisseron talks of children's earliest drawings as "not guided by visual exploration of space but an exploration of movement, at its origin graphic expression is blind". A child drawing a trailing line with a stick on a sandy beach is not thinking about some large drawing, rather their route, path and the movements that they and another following the line must make.

When I think of Douglas Huebler's *Duration Piece # 5, New York*, a work consisting of ten photographs and the following signed text:

During a ten minute period of time on 17 March, 1969 ten photographs were made, each documenting the location in Central Park where an individual distinguishable bird call was heard. Each photograph was made with the camera pointing in the direction of the sound. That direction was then walked toward by the auditor until the instant that the next call was heard, at which time the next photograph was made and the next direction taken. The ten photographs join with this statement to constitute the form of this piece.

Though this work is photographic and text based it has a strong relationship to drawing at its core for me, when I look at this work, I think about the process involved in its making, of Huebler's peculiar random, zig-zag, route criss-crossing an area of central park as he paces out his route.

Drawings fix a moment, a period of time and action compressed into a still object. Whether a line traces out an hours walk time is always significant. By selecting particular inks and papers for many my drawing works they become a record of movements and time, with my *Postal* drawings for example the drawing is continuously being produced as the parcel travels through the postal system, as well as recording the box's movements, wobbles and vibrations, periods of stasis are recorded as the ink continues to flow from the pen producing a larger and larger blot as time goes by.

The Nightwalks such as *Valley of Rocks#1* map a path across the landscape in another way, two large flood lights carried by the artist expose the black moonless night landscape, revealing his illuminated route through the countryside during an hours walk. This sliver of light drawn out across a landscape passing through leaving no mark on the surface to which it is applied, is recorded on the camera negative a path viewed from a horizontal perspective, rather than from above as with a map route or GPS trail.

Does a drawing need to have a permanence or can it leave its mark in the mind? A child's drawing in condensation on the window may be gone with the morning chill, but was still a drawing and may be vividly remembered. Francis Alys' *Paradox of Praxis 1*, 1997, the act of pushing a block of ice around Mexico city until it melts away to nothing, was an act which left a very temporary mark evaporating quickly in the Mexican sun.

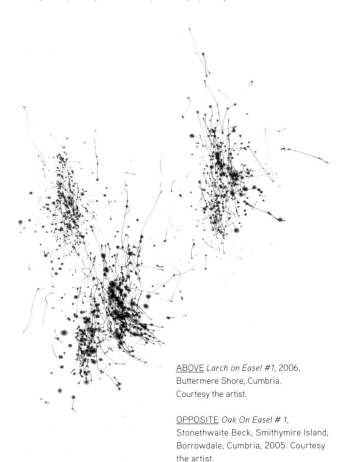

ABOVE *Larch on Easel #1*, 2006, Buttermere Shore, Cumbria. Courtesy the artist.

OPPOSITE *Oak On Easel # 1*, Stonethwaite Beck, Smithymire Island, Borrowdale, Cumbria, 2005. Courtesy the artist.

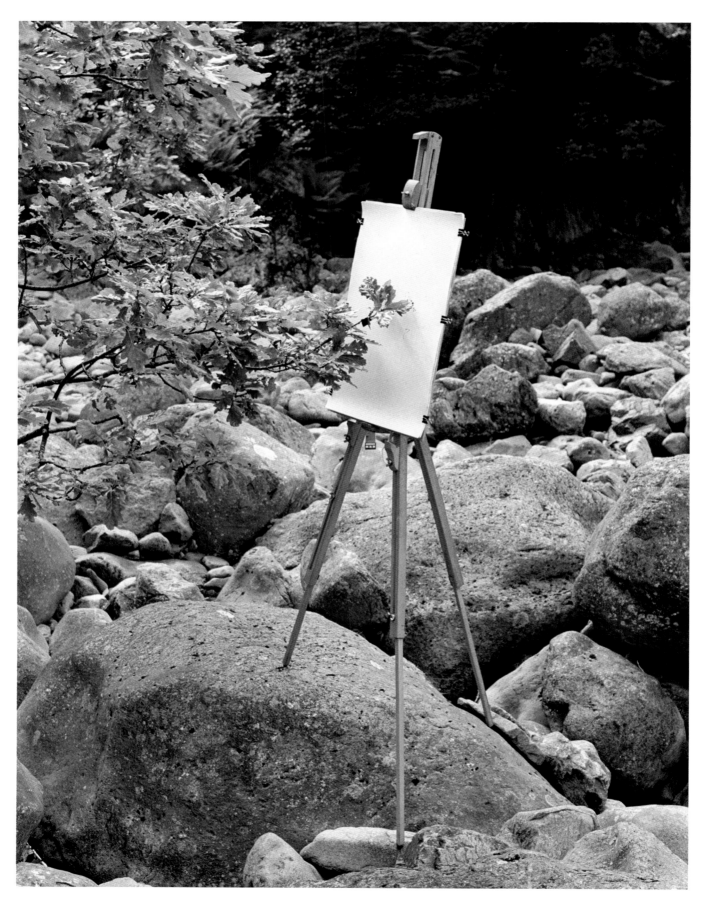

Windwalks—Seven Walks from Seven Dials, 2009

Seven walks departing from Seven Dials, Covent Garden, London, each walk, guided solely by the wind [directed by pivoting helmet mounted wind vane] lasted for a one hour period and is recorded by a bullet camera mounted on the wind vane. By monitoring the wind and waiting for the correct conditions each of the walks sets off down one of the seven streets emanating from the Seven Dials. The artist wanders through the city guided by an invisible force, meandering across roads, circling on corners or in cul-de-sacs caught by the wind's turbulence and vortices as he and the wind are steered by the cities architecture and urban obstacles.

The work takes the form of an installation comprised of seven channel video projection [each showing the footage from one of the walks], an Inkjet print 120 x 120 cm [or wall drawing of variable dimensions] and the helmet with wind vane attached suspended at head height.

Each walk is painstakingly plotted giving an accurate plot of the route taken by the artist. Seven continuous lines emanate down each of the streets leading out from the Dials. The drawings' lines, marking each route can be unravelled and followed from their mutual beginning to the disparate destinations. Like some child's puzzle game where one must follow the tangle of lines to discover which one leads to the prize.

Francis Alys' work *The leak*, 1995, in which he departs a São Paulo gallery carrying a leaking tin of paint wandering through the neighbourhood he eventually retraces his steps by following his own dribbled trail, returning to the gallery and hanging the empty tin on the gallery wall, similarly traces a route in a continuous thread. This is a work, which could surely be described as a performance, a drawing work and a sculpture. For me it does not need to be compartmentalised it is an act and it's result.

The meandering walks reveal the way the wind moves through the city's structure, channelled, diverted, trapped and disrupted by its architecture. The drawing describes an action—walking guided solely by the wind, as well as a space—London's cityscape. The line's route is random wandering aimlessly at times giving no clue as to the structure of the city, but at others tracing out building walls, railings, parked vehicles or ventilation shafts as the random meandering repeatedly meets with a fixed boundary.

ABOVE Seven Walks from Seven Dials, 2009, archival inkjet, 120 x 120 cm. Courtesy the artist.

OPPOSITE TOP *Windwalk—Five walks from Charing Cross* (installation view), 2008, mixed media object, helmet with pivoting wind vane and bullet camera. Courtesy the artist.

OPPOSITE BOTTOM *Windwalk—Five walks from Charing Cross* (documentary image), 2008, video still. Courtesy the artist.

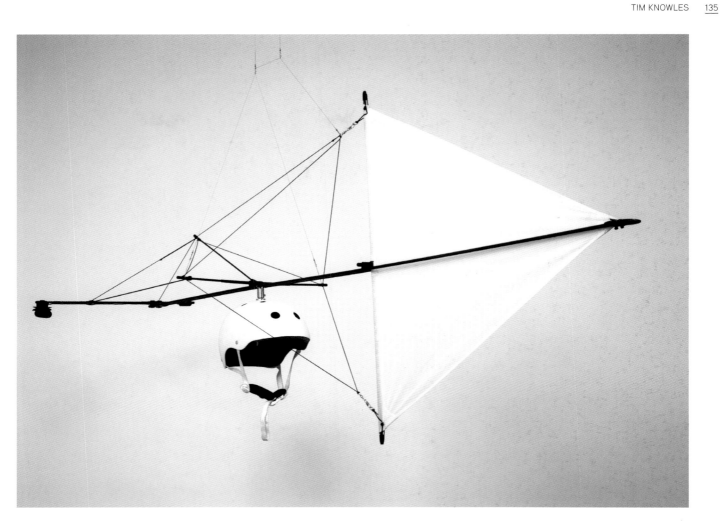

bridging the memory gap
PROJECT 3

SUPERIMPOSED DRAWINGS
marking time

DRAWING 18

Duration
15 min.

Subject
A standing figure/object.

Technique
Either hand, continuous contact, synchronicity.
A sneaky look at the drawing.
Your drawing should be no larger than 40 cm.

Materials
Use any combination of 2B, 3B, and 4B pencils or
five different coloured fibre pens or pencil crayons
on white cartridge paper.

Aims
Your drawing will show a sequence of still
moments—static points in time that link together to
suggest either movement, or 3-D volume in the half
round [180 degrees].

As with Drawing 15, this exercise requires you to
resist from looking at your drawing too much whilst
making it, and to continue with the idea of checking it
out by taking a 'sneaky look'.

You will redraw the same subject five times, seen
from five different points of view, and superimpose/
overlap each drawing one on top of another. You will
continue to develop an understanding of the relationship
between looking and responding, and by changing your
point of view, will begin to see your object as having
volume, and existing in three-dimensions.

Your eye should now be starting to trust your hand.

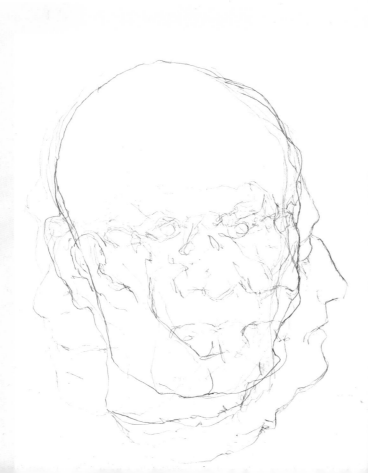

OPPOSITE Lauren Wilson and Sophie
Kemp drawing together on the last day
of Workshop 1, April 2010.

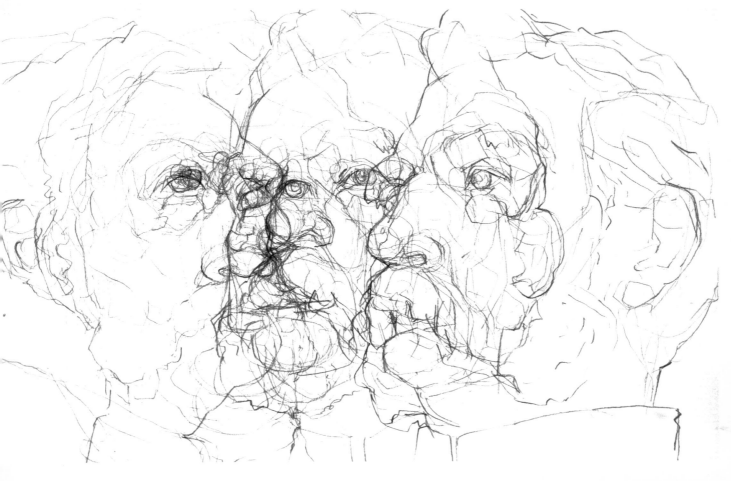

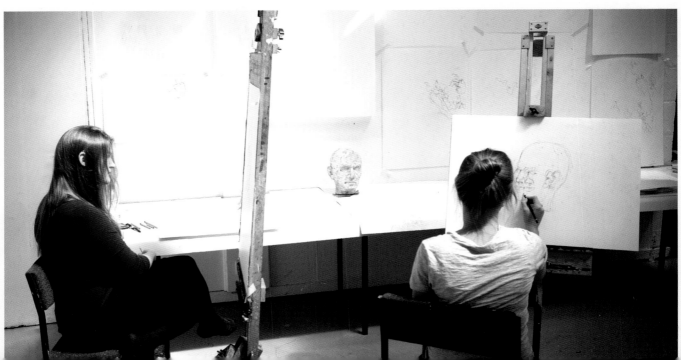

Method

1_Repeat Drawing 14, but this time, superimpose five drawings on top of each other, and show the object turning through five points of view, and 180 degrees.

2_Use the same pencil for each drawing—keep it sharp, and squeeze an interesting line/mark out of it. Look and draw in synchronicity. Alternatively use the five different coloured fibre pens.

3_After completing each drawing, examine it, and either start your next drawing in the same place as the last one or slightly overlap the next drawing.

4_If you are working from the figure, ask the model to take up five poses, turning through 180 degrees—looking left and turning through five poses from looking left in pose one to looking right in pose five.

5_Keep the size of the five drawings the same. If you are drawing a figure moving through 180 degrees, measure the size of the head, and divide the body by the number of heads. It will probably be six and a half to seven heads tall.

Assuming that the figure is seven heads tall. Draw a square seven heads tall, and seven heads wide. Draw a horizontal line across the square, one head down.

The distance from the top of the head to the pubis [just above the top of the crotch] will be approximately half the height of the figure. Draw a horizontal line across the square to mark this point. Draw horizontal lines for other crucial measurements—knees, breasts, elbows, etc.. It is very important to position your easel/drawing pad in the right place in relation to the figure to get a square on view, and you will have to move your position as the figure moves.

Start your drawing in the middle of the square with position three. Pose the figure for ten minute poses, and slightly overlap your drawings. Continue to draw the figure through three sets of five poses. Find routes for 'lines of looking' from head to toe, and across the form. Embrace the abstract, and allow yourself to make the interesting negative shapes positive.

Results

You should now be starting to understand the relationship between looking and responding with descriptive marks. Your drawings should reveal some sensitively felt linear mark-making and a searching attempt to realise in visual language what your object feels like to look at.

In abstract terms, the density of expressive uncoordinated marks on white paper might in themselves excite your eye.

This group of drawings should help you to begin to see your object in the round [three dimensions].

MICK MASLEN

in conversation with Jack Southern, Cirencester, March 2011

__JS__ Why these drawings, and not different drawings?

__MM__ These drawings are from a series I did about three or four
years ago. They seem appropriate and relevant in that they were
the last drawings I made. I will explain later. They have come from
a place deep within me, and in some ways they reveal something
of 'the eye of the brain', and illustrate to some extent the visual
intelligence of the unconscious mind. The problem is that as I have
become conscious of them, I have imbued them with meanings that
might be false. A bit like when the patient tells the psychotherapist
what happened in his dream—it becomes something else in the
telling, and the true moment of conception has been turned into a
once removed verbal description.

__JS__ These drawings are different to your usual work—how did they
come about?

__MM__ They probably go back to when I was a young art student,
17 or 18, in the mid-1960s. The words "abstract" and "abstraction"
seemed like new words to me at the time, and I was never really
sure what they meant. There were artists around—making
figurative work that had abstract qualities, whose work I quite
liked—De Kooning was one, Roger Hilton another, Bacon, etc..
Both Hilton and De Kooning said a couple of things that I found
really interesting and they have been stored in the back of my
brain ever since. Hilton said

> IT IS THE JOB OF EVERY GENERATION TO RE-INVENT
> THE FIGURE.

And De Kooning used the phrase

> SLIPPING GLIMPSE.

The idea of painters like Hilton inventing the figure, that interested
me, and what was meant by the phrase "slipping glimpse"? I have
thought about it a lot—maybe life is a slipping glimpse.

__JS__ The drawings belong to a series called _Psychobubble and the
Handless Maiden_. Can you say what they are about?

__MM__ Its difficult to be specific. I was doodling, in a state of half
consciousness whilst I was watching TV about five years ago and
what appeared were a series of single figures that I started to 'play'
around with visually, and more consciously invent.

 Our house is full of books on art and psychology, and over
the years I have become very interested in the veiled truth of the
unconscious mind, and what it might indirectly reveal. As often
happens when the time is right and one's mind is open to see,
things bump into each other, and as if by fate, combine to present
new insights. One wet Sunday, in April, four years ago I think it was,
I remember because it was raining like I have never seen before. I
was browsing through a book on mythology and came across the
myth of _The Handless Maiden_ and as I was reading, it occurred to
me that I was having difficulty with the hands in the drawings I had
started making—they never seemed to work. Thinking about them

OPPOSITE *Psychobubble 17, The Handless Maiden*, pencil. Courtesy the artist.

TOP *Psychobubble 19, The Handless Maiden*, pencil and acrylic paint. Courtesy the artist.

BOTTOM *Psychobubble 13, The Handless Maiden*, pencil and acrylic paint. Courtesy the artist.

now, they were either fists or feathers, and neither seemed right at the time. I read the myth, and felt a profound empathy towards it. This is where I am turning what the drawings are as a product of the unconscious mind, into a consciously projected idea. It is like the dreamer turning his dream into words.

But like in a dream, I realised that the drawing is all me and of my making. I was the drawing and I was also the handless maiden. This meant that I had to look closely at both the drawings and myself and ask some interesting and personal questions. It was like I was being offered a chance to take a 'slipping glimpse'.

The drawings seemed to be full of sensual lumps and bumps and nervy tactile 'hot spots', and as I played about with both the drawings and the myth, I started to become more conscious of what they might be about, and what I wanted them to look like. I started to make drawings of the drawings—perhaps not a good thing to do sometimes, in that you lose the spontaneous flush of innocence that the first marks carry, but, whatever.

JS Tell me what the myth is about?

MM The myth tells the story of an innocent maiden living under the roof of her father, the miller, in a world dominated by masculine formal reasoning. In order to obtain greater wealth, the miller sells his daughters hands to the devil and tries to persuade her that with his newfound riches, she will be able to have silver hands and servants to do everything for her. She will not need hands.

In the drawings, I have tried to portray the maiden as a lump of sensuality with no metaphorical hands with which to creatively get in touch with her feelings. I see the maiden as an aspect of my feminine self that was being suppressed, perhaps by the more formal reasoning of, well, institutional life. I suppose in some ways they are an attempt on a personal level to describe something of our masculine/feminine split, and the dilemma we all face in trying to reconcile these aspects within ourselves, and within society as a whole.

JS Why 'Psychobubble'?

MM Well, I suppose it is about being stuck inside a bubble—maybe my head, or a bubble of thoughts. Someone once told me that I often started a sentence with the words "I think..." She went on to say, "Don't you ever feel?" I understood what she was saying, and I now have choice. I can say "I think...", or I can say, "I feel...".

So without thinking too much about the maidens hands being cut off, I began to cut some of the drawings up, and arrange the pieces in a way that 'boxed' them into what I saw as a formal masculine structure. As I cut them up and re-positioned the parts they began to fragment and sit on the edge of 'making sense', which is a risky but interesting place to be.

I do not see all of them as being resolved—some of them I will leave, and some I will keep cutting up and re-arranging until I feel they are right.

JS Unfortunately you now have Parkinson's Disease. It seems strange that the last drawings you made were about having no hands—and now you have a tremor that effectively means that you

have no hands, and are therefore unable to draw in the way you could before. And as we are talking about feelings, how does that make you feel?"

MM As you can image I am really pissed off. Looking back at my difficulty with drawing the hands—feathers were probably right then, and fists would be right now.

My hands shake as soon as I pick up a pencil and direct it with any purpose—and you are right—it is strange, but like Bruce Mau says

THE WRONG ANSWER IS THE RIGHT ANSWER IN SEARCH OF A DIFFERENT QUESTION, COLLECT WRONG ANSWERS AS PART OF THE PROCESS. ASK DIFFERENT QUESTIONS.

I will make it fun, and start again, but with a new vocabulary and new questions. You will be pleased to know that the maiden discovers herself with new hands in her own creative world.

ABOVE *Psychobubble 33,*
The Handless Maiden, pencil and oilpaint.
Courtesy the artist.

OPPOSITE *Psychobubble 7,*
The Handless Maiden, pencil and oilpaint.
Courtesy the artist.

bridging the memory gap
PROJECT 3

MULTIPLE LINES/
MARKS
searching for form

DRAWING 19

Duration
15–20 min.

Subject
A single object of your choice.

Technique
Orthodox hand, continuous contact, synchronicity, multiple lines. Looking at the drawing.
Your drawing should be no larger than 30 cm.

Materials
Use a 2B, 3B, or 4B pencil, either singly or in combination on white cartridge paper.

Aims
To further develop the relationship between looking, feeling and drawing by creating continuity in the looking/drawing process, by having as small a gap as possible between looking at an object, making a decision and responding with a mark.

It is important to
LOOKDRAWLOOKDRAWLOOKDRAWLOOKDRAW
Try to keep the pencil in contact with the paper whilst looking. Think of the process as being continuous—like fast windscreen wipers.

TOP Alberto Giacometti, *Portrait of Annette (Buste d'Annette)*, oil on canvas, 29 x 22 cm, 1954. © Succession Giacometti/ADAGP, Paris and DACS, London 2011.

RIGHT Students drawing from the figure during a day long session taught by guest tutor Tom Lomax, during Workshop 2, July 2010.

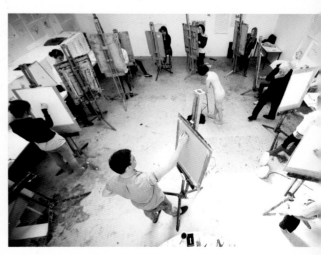

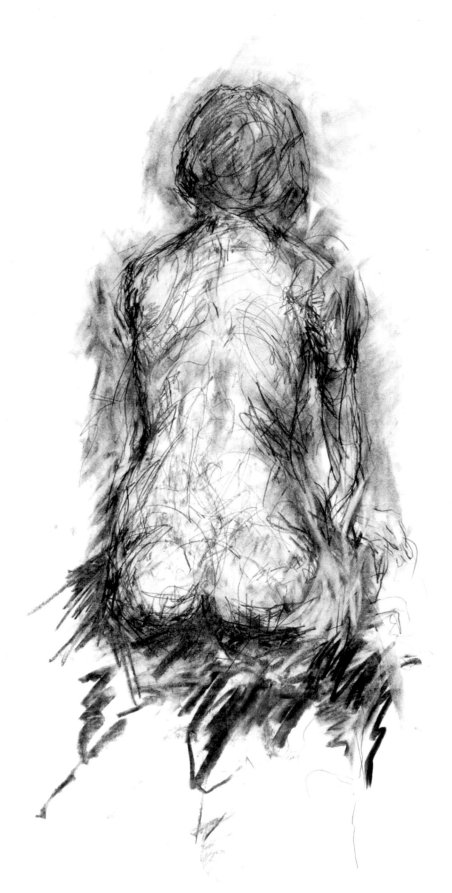

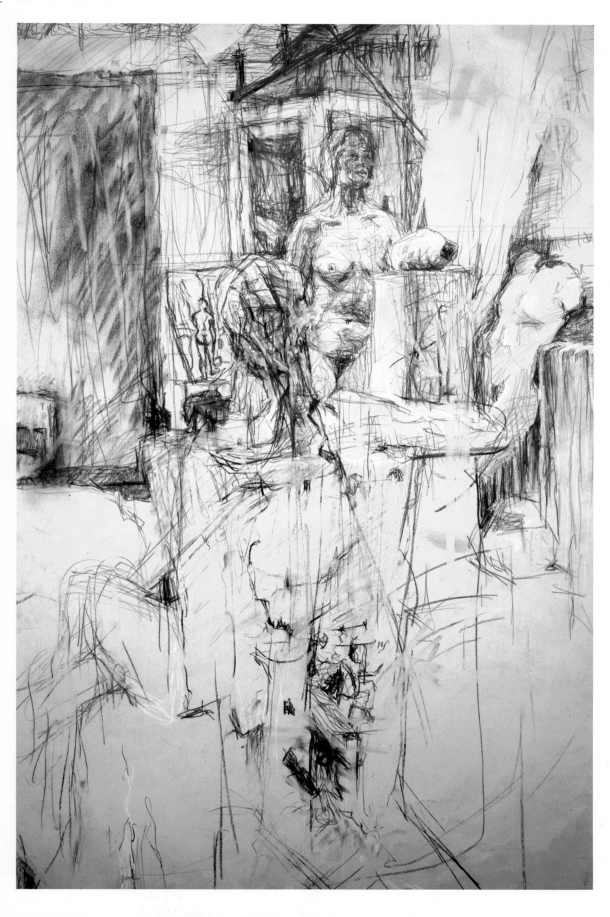

RUTH CHAMBERS IN CONVERSATION WITH JACK SOUTHERN, WORKSHOP 2, JULY 2010.

At the beginning of the workshops, I think my mark-making was very much bound up with ideas of 'likeness' and a photographic way of seeing the world. Going through each of the approaches to drawing over these two workshops has felt like a process of dissolving what I thought I knew about the visual world, and rebuilding it through looking and mark-making. It is like compiling a bank of marks that I can expand and draw upon. I can see more, and therefore draw more.

Throughout the workshops, and through practice, I have begun to realise that a mark does not necessarily have to be made on a flat surface. And the process of drawing does not have to involve looking at an object from a distance, in a way that feels removed from my whole process of responding to it. I can be more involved in the process, both physically and psychologically.

Thinking in this way seems to allow me to use marks that communicate meaning through their physical or material qualities, bridging a gap between what I feel and what I see.

Method

Have a look at some of the exciting marks you made in Drawing 6—the 'two pencil' project—and in this project, try and make as many similar marks, but with one pencil. Repeat Drawing 17, but allow your self to use more lines.

A multiple line drawing incorporates and displays the process and history of its own making, and something of the character of the artist who made it. The 'looseness' of all the lines make it easily accessible to the viewer, and it sits itself comfortably into the surface of the paper. It is made in a way that requires the viewer to look purposefully at a surface of loose lines, and decipher information, and select and make choices about which of the many lines drawn is the most appropriate to the artists intent.

When a contour is drawn with only one line, it has to be the 'right' line, drawn in the right place, with the right weight and tonal variation. It is fixed and non-flexible. The viewer does not participate in the same way—he has no choice but to accept it. In a multiple line drawing, the viewer has to make a decision about which of the many lines drawn works as 'the right one'.

It is important therefore, when making your drawing, that at any given edge, amongst the many lines you draw, there is one line that is there to be selected as being the 'right' one. This line might simply lift itself out of the drawing, and distinguish itself by being slightly darker.

In order to approach this drawing in a slightly different way to the previous contour drawings perhaps
1_Reconsider your habitual starting point, e.g.—you might always start a drawing at the top and work down. Make a deliberate attempt to start somewhere else, e.g.—the bottom and work up.
2_Try not to start with the exterior contour line that encloses the form, but try starting from a point within the form.

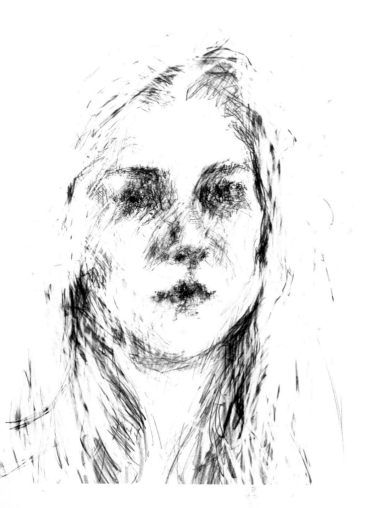

JEANETTE BARNES

Drawing is the beginning and the end of my practice. It is a thing in its own right and not a study for something else. I cannot imagine not drawing; it is something that is natural to me, like thought. Sometimes it might be as though it is a quick chat or it could be a long in depth conversation, but it is an ever-present thing in my life. I do not go to the studio everyday, but I do draw everyday, it might be an idea for a composition, or a quick sketch of someone on the tube. It is not a precious activity it is just an ever-present natural one. I have always drawn. My dad worked in a paper mill and he brought loads of paper home for us when we were children so we did not have to feel precious about using it. I am constantly putting thoughts, ideas and notations down on paper—it is a huge part of my life.

The large drawings are done over a long period of time, and exist in their own right. They evolve and change through months of work, and have all my ideas in them about living in an urban environment—I do not feel I could say any more or in a better way in a different medium. They are what they are. They evolve through a succession of phases and are created in a state of flux, constantly being re-made until something is revealed that portrays the atmosphere and activity of the space in a way that is new to me. I use charcoal and compressed charcoal as these are very flexible materials that allow for change and a build-up of ideas so the drawing has a visible history. Instinct, speculation and memory are key components in this process; hopefully taking my resulting drawings beyond mere topography towards something more personal.

I do a lot of sketches on location regularly returning to the same spot, these contain different ideas for the large drawings. I use an A2 board and work generally in soft pencil, but sometime in charcoal. I take the work back to the studio to inform my large compositions, together these sketches capture the changes that happen over a period of time.

I do not know exactly what my drawing will look like when it is finished. I have an idea where the main elements will go, and after initially drawing them out, I will begin to see what changes need to be made.

Often things that I thought would go together do not always work—the scale of objects is sometimes changed and the objects are often moved. What I thought would be a focal point, becomes less prominent and something that I had not thought about much, becomes more significant. If I am still gathering information I might be able to re-visit the place and look for something that would work in a particular area—or search through my sketches to see if I can use something else. I usually have a lot of sketches from a site, and will find something that will in the end prove to be an interesting alternative.

I enjoy having to reconsider a composition—I rub things out and move them around. Sometimes the decisions are major, sometimes minor. I think it makes the piece more interesting, building it up in layers. If I start to become too precious with something that is when it usually becomes less successful.

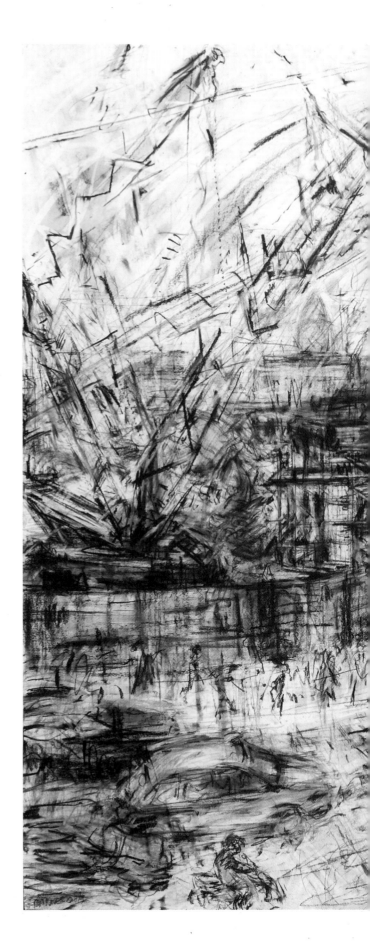

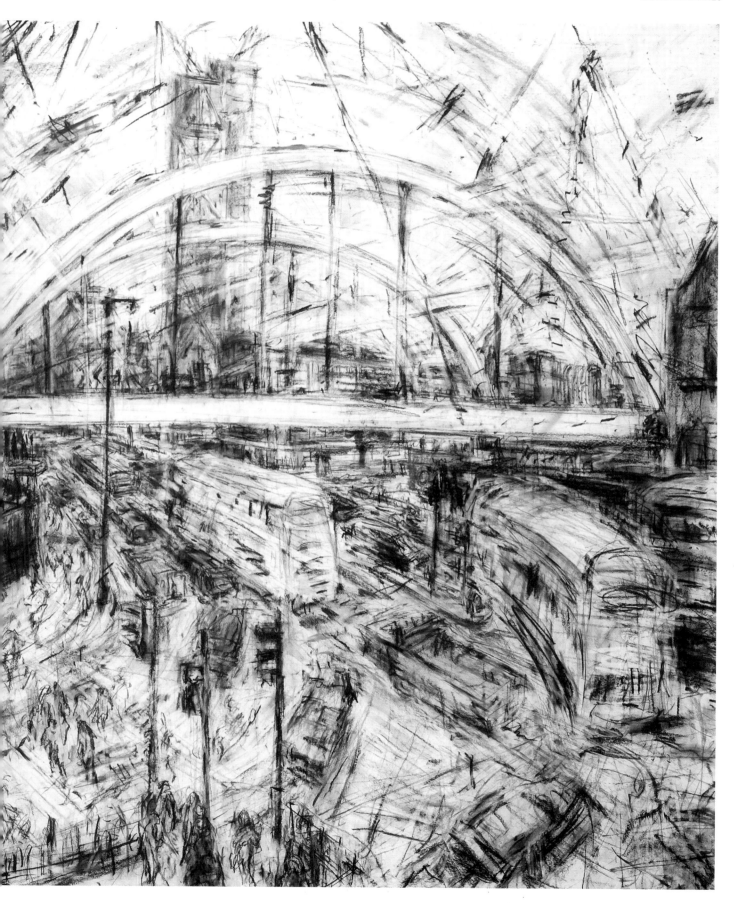

I think of the big drawings as being individual—they can stand up without having other work with them. But sometimes, although distinctive as separate pieces, they are part of a series, such as the *Olympic* drawings or my earlier *Docklands* work.

The *Docklands* series was about going to a place over a period of time from the 1990s and documenting the changes that happened there. Sometimes these works have been about new buildings being made, sometimes about commuters at a station—different things that have struck me at a particular time. I do like to ring the changes in my work. If I have done a couple of pieces that are predominantly about architecture, then the next one will be mainly about figures or *vice versa*.

With the *Docklands* work as it is over such a long period, I can see the difference in my own work, the change of scale and intensity, in the early ones scrabbling around finding a way of working.

I generally work very big or very small, not much in between. My large drawings are made on the wall of my studio, and are generally about 150 x 200–230 cm. The roll of paper I use is nearly as tall as me, but I would like to work a bit bigger, certainly wider. I like the feeling that they are on a human scale—I want to feel I can almost walk into one, to be at that place. I like to work on the drawings as a whole, and so it is important that I can reach all four corners easily. I use either compressed charcoal, Conté crayon or willow charcoal which is much softer. With Conté crayon, it is much harder to get rid of previous ideas, so the history in the drawing is much easier to see. Using willow charcoal is easier to get large areas down quickly and I can use my hand to smudge something down, to take out only a part of it, not the whole of it as with a rubber. I generally know which material will suit what kind of work. I have been working on these scales for a long time now and they seem to suit what I want to do.

On the big pieces I never know really when to stop, only if it has to be framed to go into an exhibition do I leave it alone. If it is on a roll in my studio I will generally have a go at it again, sometimes it is only one or two smaller things other times there are major decisions that have to be made. If I am getting bogged down in a piece or answering questions in the same way, I purposely stop and put it away for a while and then get it out after a number of weeks or months and see if I can do anything interesting to it. If they are framed and in my studio and I cannot get at them, it is like they are taunting me, I know the answer but I cannot change them, it is horrible. I have got a couple of framed drawings that need re-working at the moment, I am just waiting for the right time to ask my framer, ever so nicely, if he will take them out for me again.

Many things can make a drawing more or less successful. Sometimes it is my level of involvement in it—the journey and struggle I make whilst making the drawing—a desire to find something new or interesting about the subject, taking some creative risks. Occasionally a very fresh simple sketch can capture something about a place or thing that working hard at a theme for weeks in a tired way never will. It is often a surprising set of connections that I might not have thought about before that makes a drawing more interesting—and sometimes being too easily satisfied will, in the long run, make it less so.

I had several good tutors at the beginning of my career who encouraged me to find my own way of working and gave me the confidence to keep drawing. They encouraged me to think of a drawing as a whole, not to get sucked into small details and to be prepared to erase a part of it, in order to help the whole piece, even if it was the best bit of drawing.

My advice to anyone starting out would be to have a go, and do not think that you cannot draw if your drawing does not instantaneously turn out the way you want it to—or is unlike other peoples work. Drawing should always be a personal response. The more drawing you do, the more confident you will become. Experiment with different materials—one type might be more successful than another. Take creative risks.

Do not be afraid to dismiss your first ideas, and get rid of the notion that everything has to be right first time. Trial and error can help you grow as an artist.

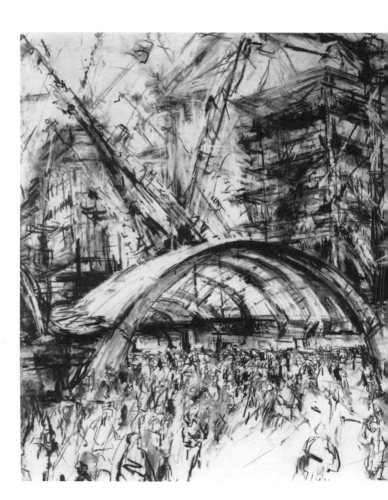

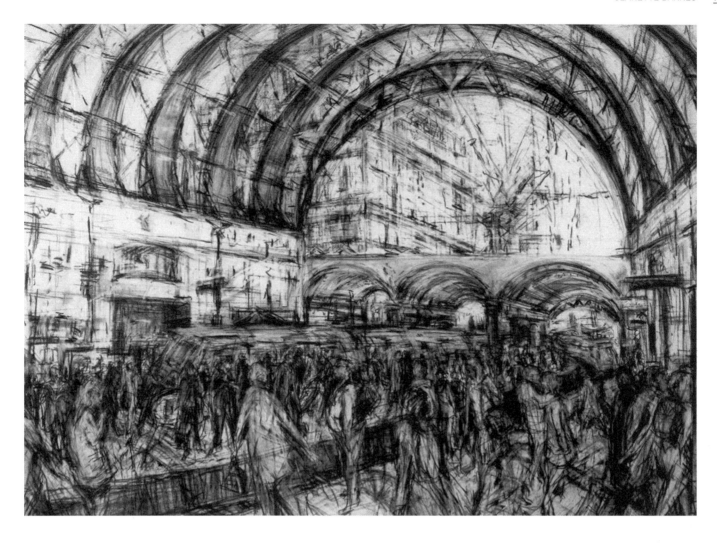

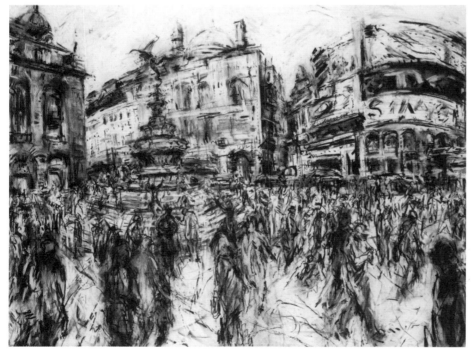

PREVIOUS PAGES *New Bridge Shoreditch High Street*, 2010, Conté crayon, 150 x 200 cm. Courtesy the artist.

OPPOSITE *Outside Canary Wharf DLR Station*, 2002, charcoal, 200 x 150 cm. Courtesy the artist.

TOP *Inside Canary Wharf DLR Station*, 2003, Conté crayon, 150 x 194 cm. Courtesy the artist.

BOTTOM *Piccadilly Circus*, 2008, charcoal, 140 x 186 cm. Courtesy the artist.

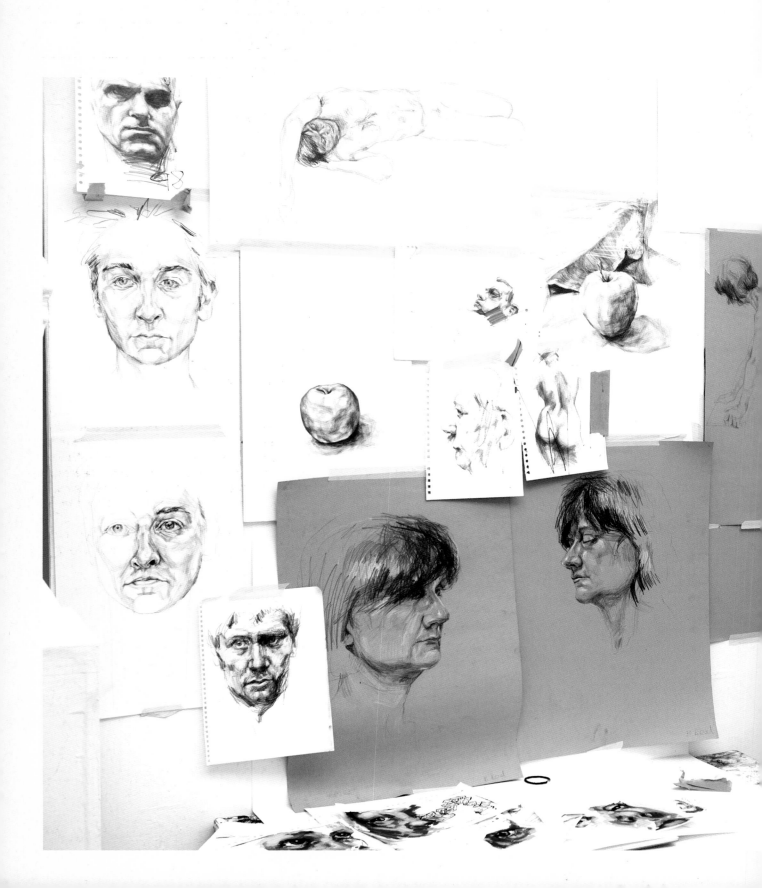

bridging the memory gap
PROJECT 3

SELECTED TONE
the arc of the mark

DRAWING 20

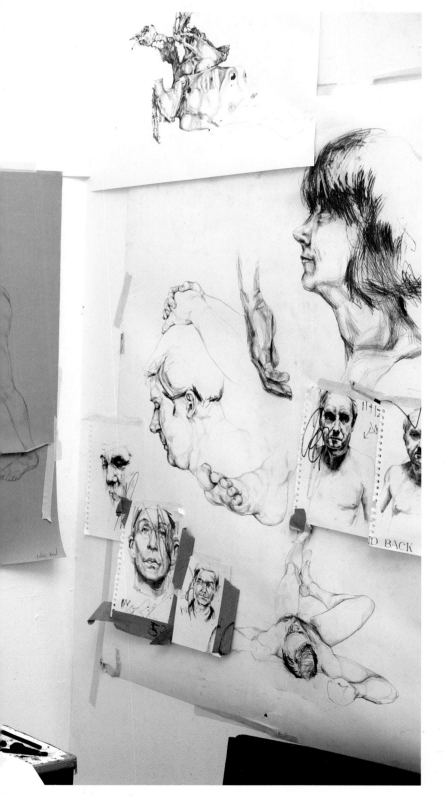

Duration
15–20 min.

Subject
A single object or portrait/self-portrait.

Technique
Orthodox hand, synchronicity.
Looking at the drawing.
Your drawing should be no larger than 30 cm.

Materials
Use any combination of 2B, 3B, and 4B pencils on white cartridge paper.

Aims
Use Drawings 15 and 16 as your guide, but in this drawing, use both line and selected blocks of tone. It is important that you do not put tone everywhere and that by being selective you are creating a balance of interest, between line and tone, busy detailed areas, loose empty areas, and the untouched white of the paper.

Depending on the amount of control needed, hold your pencil like a pen, or across your four fingers, between fore finger and thumb.

Method

1_Hatch [shade] the tone as a block of directional parallel marks that fill in the shadow shapes, or areas of darkness on your object.

2_Use the side of the pencil point, and hatch three or four tones. Knowing in which direction to make the marks comes with practice, and at this stage you should follow your intuition. In the smaller shapes of tone, try to contain the hatching within clearly defined shapes, but it doesn't need to be obsessively done. In the largest areas, try holding the pencil away from the point, and allow the generous nature of the arms arc to let the marks go over the contour lines you have already drawn.

You do not need to be too tidy. Your eye will recognise that the line is a boundary, and will 'read' the contained tone. The looseness of these hatched lines will help make your drawing accessible, and will signal to the viewer, that the drawer was relaxed enough not to worry about the edge, and that the generous 'ease' of the marks depicts an all over feel for the energy of light. Being able to use hatching in this selective way is a demonstration of a sophisticated drawing skill.

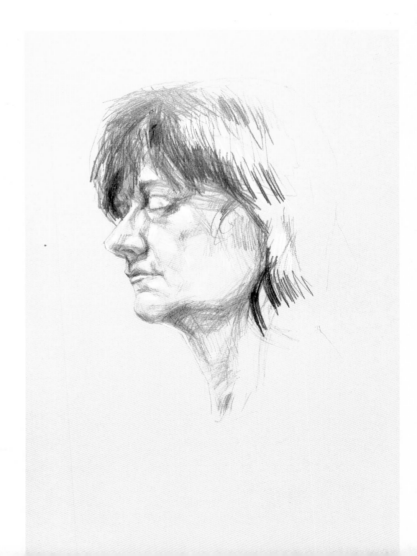

KATE ATKIN

in conversation with Jack Southern, London, December 2010

JS In the context of this book, you are one of the few artists who makes drawings directly from photographs; and interestingly in direct contrast to someone like Charles Avery, uses virtually no source material at all. I am really intrigued to discuss your process of sourcing, manipulating, and re-contextualising images through rendering them into drawings.

KA It is interesting; peoples' processes are so different. I do not feel I could just have an idea and reproduce it in the studio without any reference material. So yes, as you say I work from photographs, but I have to say, I very rarely find my photographs interesting. Generally I have a very ambiguous relationship to them. The majority are so banal and awful, just badly taken snapshots. But as they are my main source material for making drawings, I am both reliant on and repelled by my photographs.

JS Do you take many photographs?

KA No, very few. If you look at that collection on the wall up there, I have probably had that same set for about a year and a half now. I have not added a single image to them in that time. Occasionally one drops out of favour, and sometimes one re-emerges with a renewed significance to me.

JS So interesting to see such a sparse collection of photographs in a contemporary culture obsessed with capturing images. I find your attitude to being so visually selective with photography really refreshing.

KA Well, yes, digital photography is so effortless, limitlessly press a button and capture an image; my approach is the opposite. I think I only take one significant photograph every six months. I do not go round with a camera in my pocket. I sort of have the idea of what I want an image to portray, and go looking for it.

JS So you might have the characteristics of an image in mind that you want to capture, like the visual qualities, atmosphere, feeling and connotations?

KA Yes, exactly, and with those things in mind I go hunting for it with my camera, trying to fulfil the idea.

JS And in that process, do you find the image you might take is able to exemplify that intention or set of expectations and demands you place on it?

KA Rarely, hence my bad relationship with them. But in some ways the thing I took the photograph of in the first place does not interest me at all; it is the translation into a drawing, which is important. I suppose, that is why I do the drawing.

JS So the photograph serves a purpose in the process. In some ways it is a trigger or point of access to a long journey of contemplation, clarification, and then execution of a complex set of thoughts, feelings and visual relationships.

KA That is a very succinct way of saying it. I find this very hard to articulate. It is really plumbing the depths of why I find things interesting. But you are right because sometimes the photograph I take does not tell me that much about what I want to do in the drawing; it just reminds me what I was thinking in the moment. There is a tiny little glimmer there in the photograph, but it might fail.

JS And you started making drawings while doing an MA in photography at the Royal College. I can imagine you were unfulfilled by solely using photography as your creative output. It is like one half of the whole process was missing. What led you to the first drawing you made?

KA While at the RCA I was taking pictures of things that were almost interesting and all my tutors could see that I was floundering. I remember showing the photograph, which led to the first drawing I made, at a group critique. The subject of the photograph was a flowerbed in the middle of a park.

Showing the photograph to my peers, I explained how it looked like an island in a surreal sea of grass, but I could tell that they were not convinced; they were not able to see it. The college put me on report, and during the summer break I decided to try and draw it as if it was an island, so that I could at least show the tutors what I was alluding to.

In making the drawing the most incredible thing happened, like an epiphany. I literally felt drawn into this kind of magic, and had discovered how to express myself, it was incredible. I could barely talk about it without welling up. I still feel a bit like that; I get strangely weepy about it if people really get me going, it is like a tap straight into all my most excited feelings.

JS So making that first drawing confirmed there was something about working solely with photography that you felt limited your ability to create your own interpretations of things you found interesting? Is that right?

KA Yes, with that image for example, the drawing did something that the photograph could not. It could be interpreted in different ways as opposed to the single dimensionality of the photograph. Something to do with the way I could arrange and compose it in the drawing; lots of negative space, something you never get in photography, because it is so democratic, everything just floods in.

JS After that drawing and the revelation in the way you worked, what was the next set of drawings you made?

KA Well that led to a renewed confidence in my approach to taking pictures and more importantly, in how to develop them further, how they could go beyond that initial image. And a project for a friend of mine, who was also a tutor at the Royal

College, called John Strutton spurred the first photograph I took which I was genuinely excited by. It was something he and Alan Miller did at 39 where they got lots of people to do a project with the same rules.

In this project each artist was given a cartridge of ten Polaroids in the camera, which they had to return developed within an hour. I had some extra ones, and on the way back to college I took a couple of extra shots to just to use them up. One of them was an image of this great big anthropomorphic looking, pollarded chestnut tree. I did not even think of it as a particularly interesting thing at the time.

I kept that one. I did not know what I was going to do with it, but felt it was like this precious object I was carrying around with me, like I would got something but I did not know what it was yet. I started drawing it and it grew from the central point, and it went from there.

That photograph spurred the whole body of work during and post-college. Working on the drawing of it was when I had the realisation of exactly what I was going to do. I think that was October 2004, the most exciting month of my entire life. I was going round as if I would have fallen in love, lurching stomach, just amazing feeling.

JS And that realisation was how to translate something as incidental and accidental as a snapshot Polaroid into something profound and permanent; make that huge leap, using a new visual language of drawing?

KS Yes, and it is a huge leap because the drawings are so labour intensive.

JS And in that labour, it seems you need to go through a process of concentration and quietness in order to understand how the photograph becomes something that is relevant to you and able to express your interest in it? But the photograph's significance becomes more and more distant a reference point as the process goes on?

KA Yes, exactly, because I think of ideas, as being really quiet and tiny. You could miss them but if you are concentrating hard enough, certain things in the world start flagging you down. The way I have developed making drawings allows those quiet moments, thoughts or seemingly insignificant things come to the surface for the next one then.

JS And considering the first drawing we were referring to was done from a Polaroid, and the photographs on the wall over there are all A4 or smaller, I guess scale is a very important aspect of that translation and 'elevation' of the object, and therefore the subject matter. It allows the object you draw to transcend its clichéd associations, because they become these very powerful, heavy, weighted forces?

KA Absolutely, and very important you mention that because the transformation of the subject matter is so crucial. Because a lot of my work is basically pictures of natural forms like wood, bark and twigs. But I hope the way I frame or arranged those forms on the page are satisfying enough to be suggestive of other things. That is the whole point for me, to try to recast this rather user-friendly material that everybody is familiar with. But I do not know whether that comes across in all of them?

JS Yes I think it does, I have always felt that when I have looked at your drawings, that there is a set of inherent, very powerful visual devices used that allows the subject to transcend its meaning, the sum of its parts if you like?

KA I am comforted to hear that. Because it is a really fine line I walk. And yes, to go back to your original example of scale; the change of scale is really important, and I decide what size the drawing is going to be by thinking about what order of magnitude seems to make the most sense in relation to the subject. And like you suggest, it is often about being quite a lot different than the original thing.

JS That is really interesting though because, if the photography you work from is true to the size of the actual object, in the process of enlarging, surely there is not enough information in the image? So it resembles the original form but a lot of the actual visual information that you draw is purely made up?

KA Exactly, it is about making marks that relate to the marks next to them, which relate to the next marks next to that. So that it makes a sort of logic. And that is the interesting thing about it, because it is like the generating of matter where there is not enough to copy. So my process of building the drawing has a relationship to generating matter, similar to the natural growing process of the matter itself.

So in making the drawing, I usually just start in the middle or on the far right side and just work across and avoid going back over it at all. I just kind of generate and go along, fully finishing each section. I start and finish a section every day. Maybe a square foot.

As the drawing progresses, I have a vague idea about how it is going to develop, but it is interesting that you can see in the marks how my feelings about it change as the days go on. Like on this drawing, this bit here is really fine and overworked, but this part of it here is very rough.

JS And as well as scale, you use other key visual devices in the compositions, specifically the framing and angle of the subject?

KS Yes they are all tools I use. I think of them as 'actions', which I can use to 'activate' the subject I am drawing. Like taking the subject and planting it on its own page, forcing it to be of interest. Or reversing the image before I print it. Or turning it 90 degrees left or right suddenly makes it work. I use the quarter turn in a lot of my drawings, which somehow brings the subject into this amazing sharp focus that I could not see in it before. These tools have the potential to recast what I'm doing in a different light.

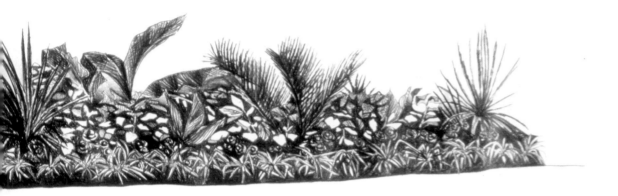

TOP *Study: Island*, pencil on paper, 2004,
42 x 119 cm. Courtesy the artist.

OPPOSITE *Study: Horse Chestnut
(Aesculus Hippocastanum)*, 2004, pencil
on paper, 59 x 42 cm. Courtesy the artist.

LEFT *Lines & Sections: Line I*, 2005, pencil
on paper, 153 x 157 cm. Courtesy the artist.

RIGHT *Head*, 2010, pencil on paper
120 x 189 cm. Courtesy the artist.

OVERLEAF *Maw [Replica]*, 2008, pencil on
paper, 107 x 168 cm. Courtesy the artist.

JS Do you think any of those visual devices you use in the drawings come from studying photography? Many of the strategies you use have associations with the fundamental elements of a camera, such as the mirror and lens, and therefore reflection and symmetry, and the position of the subject in relation to the picture frame.

KA Yes, I think you are right; my process of enlargement and the 'tools' I use; it is like printing from a negative.

JS And in that context, it is interesting to think about how bombarded by images we are in contemporary society, and obviously photography plays a big part in that. I wonder how much compositional value of photography is rattling around in our heads. And particularly with you having studied photography, how much resonates and kind of seeps into the work when you make drawings.

KA Yes, I think so, I do not think I will ever escape it. I think it is a really well learned set of rules; it is a kind of trap in a way. And with my work, I think what you were saying about the subject in relation to the picture frame is particularly relevant, no one's ever said that before. It made me think that I very rarely do a drawing where the subject enters the frame from the side. And if I do, I tend to draw right to the edge and then crop it like a photograph. I am interested in making the whole subject central and appearing prominent and intentional, like there is not an unworked bit on that paper. And now that you have made that reference, I can see that it is an aesthetic you get in a photograph.

JS All of these activating devices are ways of asking an interesting visual question about your subjects, you know, what happens if I turn it to this angle? Or enlarge this part? Bring this into focus and defuse this bit of the drawing? What if the subject was leaning? And so on.

KA Yes and about matter as well. How is that supported now? Where is the shadow now? Which obviously is questioned more by some of the sculptural works I have made.

JS I was going to ask you about that because looking around the studio, it appears like that is the direction your work is going?

KA: Yes, I am interested more in actual forms now, because I think there are infinite possibilities to make natural forms look like other things, and I feel like I have explored that now. You could just do that forever, because it just works, but as an experiment I feel like it is finished. It seems very natural to make them really three-dimensional now. But most of my drawings have been very sculptural. I feel there are similar methods in the processes of making both drawings and sculpture.

I also feel I am moving towards a slightly more verbal associations in the works too. As opposed to the anthropomorphic non-verbal sort of sensations of indefinable matter, central to lot of the drawings. My interests seem to be moving towards

things, which are definitely representational in some way. Like this *Leaning Figure* for example, having a person in it feels like a very interesting new territory for me.

JS And this is a good example of both of the aspects of your new interests because of its representational nature in being figurative, and also being a three-dimensional form.

KA Yes, this piece feels very important, *Leaning Figure* is the biggest thing I have ever done in a way but, it is only about 35.5 or 38 cm tall.

JS And when you just mentioned the cross-over or parallels in process between the drawings and sculptural works, the explicit things here seem to be the detail, the labour, and of course the process of construction, in the way that your drawings also feel like they have been 'built'.

KA I agree and making this piece was very labour intensive, it took three weeks, working every day. But a departure in method in the sense that I was not studio bound and I only used found materials. I made it while living by the sea in France in the middle of winter; I collected materials, which were washed up on the beach, like cardboard, polystyrene, bits of rags, and seashells. The seashells were washed up in drifts as if the sea sorted all of them into little veins all along the beach. And I went along the beach every morning and collected all the ones where the little hole was right in the middle of the shell, dead centre, so if I stitched it on it would hang symmetrically. After making the body structure, I spent every morning collecting more off the beach and every afternoon sewing them all on by hand in sets of about four.

JS And that process of making a three-dimensional object has obviously led to thinking more instinctively and playfully in three-dimensional form.

KA Yes, I think it has, but it is quite a big change, and the evidence is in front of us on the table with these wire structures. This week I have had this idea to grab some wire, a pair of pliers, and a gardening glove and work really instinctively. Working with shapes, I have been deciding as the day goes on what it might turn into, and at some point I will decide, right it is going to be a... OK it is going to be a prawn, for example. It is like allowing really important things to bubble up, without thinking about it too much. I mean it might just be meaningless image grabbing, but I sort of feel like there might be something there that is important. So my process is changing, and I feel like I am right at that point; in fact I am prepared to say today is the turning point, there is everything I did before today, and everything I did after.

TOP *... a face like a French cheese, chalk and green, hollowed out and folded up like a mummy...*, 2009, pencil and watercolour on paper, birch ply-wood, 163 cm high. Courtesy the artist.

BOTTOM *Leaning Figure*, 2009, cardboard, paper, glue, string, foam, cloth, thread, pins, shells, nail varnish, 40.6 cm high. Courtesy the artist.

making light visible

PROJECT 4

GESTURAL TONE

footprints in the snow

DRAWING 21

Duration
25–45 min.

Subject
Two or three objects or portrait/self-portrait and background.

Technique
Orthodox hand, synchronicity.
Looking at the drawing.
Your drawing should be no larger than 30 cm.

Materials
Use any combination of B, 2B, and 3B pencils on white cartridge paper.

Aims
This drawing attempts to link two very important elements of drawing together into an integrated whole. You will see your object/context as an all over experience of light, and attempt to describe it through changes of tone and directional mark-making. The two elements are:

1_Negative space. Our perception of the object is greatly influenced by its context. The 'context' is the area and space around and in between objects, and is called the "negative space". Understanding negative space is vital, and our perception of the object is greatly influenced by what exists behind it. No object exists in isolation, and every object has a context. An object always is somewhere, and the 'somewhere' and the object are inseparably interdependent.

2_Tone. Tone is a quality of darkness and light. Light reveals form, and how we see form is dependent on how much light there is, and its directional origin. Shadows are caused by an absence of light, and less and less light will result in a darker shadow. A table top with objects on it is in effect a piece of 'still-life' theatre, and the objects are performers on a stage, each with a part to play. Where they are placed in relation to each other and the negative spaces that exist between them is very important. Some objects become leading actors, and take up primary positions, and others take up secondary supporting roles. The dramatic effect of the whole thing is made visually richer by the creative and considered use of lighting.

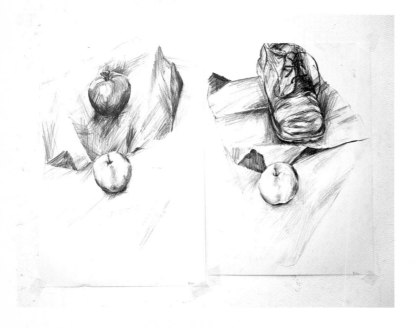

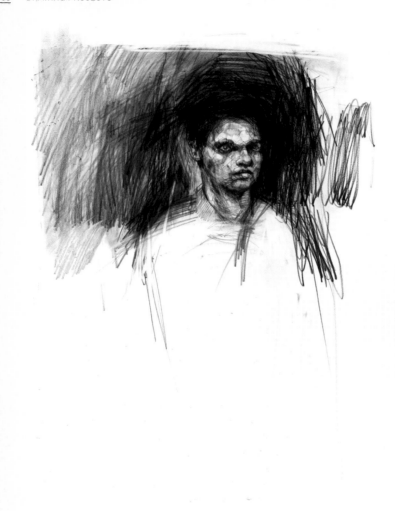

Method

For this drawing you might consider working under an artificial light in a slightly darkened room. The light from an Anglepoise or side lamp will provide a consistent more dramatic range of tones, and strong shadow shapes. Tone outside the figure/object is called "exotropic tone", and tone inside the figure/form is called "endotropic tone". Make both exotropic and endotropic tone.

1_Lay a piece of white cartridge paper on a flat surface, and place two or three white objects in an interesting composition on it.

2_Rule a rectangle on your drawing paper slightly larger than A4 in size. This is to contain the drawing.

3_Spend a few minutes looking at the visual experience, and to start with, only look at the tonal range within the negative space.

4_Observe where the darkest and lightest areas are. One of the things you will probably see is that the dark side/edge of the object will make the negative space immediately next to it look lighter, and the light side/ edge will make the negative space next to it appear darker. What is challenging about this exercise is that in our mind, the white paper passes under the objects, but in your sight it surrounds the objects. It may help to envisage your group of objects as being monumental in scale, and surrounded by a passage of sea.

Imagine that you are a camera taking a black and white photograph of your group of objects. In a fraction of a second you would record the picture in a range of tones—black, dark greys, mid greys, light greys, white.

Remember that when you make drawings, you must not only depict these 'measured' tones, but you are also drawing quantities of light. Light is invisible energy, and the marks you make should express this energy and make it visible.

5_Do not use line to draw the objects contour, but build the drawing out of 'all over' blocks of hatching/shading that describe the tone and direction of the surfaces.

6_Hold the pencil in a way you feel is appropriate, and start your drawing by using an HB pencil to draw the lightest tones. Gradually work towards the darker tones, and use HB, 2B, 3B, pencils in turn, as feels necessary. It is very important to 'feel' the direction of the surface plane as you hatch your marks.

7_You might start by discovering the boundaries of the object by putting tone in the negative space, and finding the edge of an object. Then work on the object and the negative space simultaneously, and work from larger shapes of tone, to smaller ones.

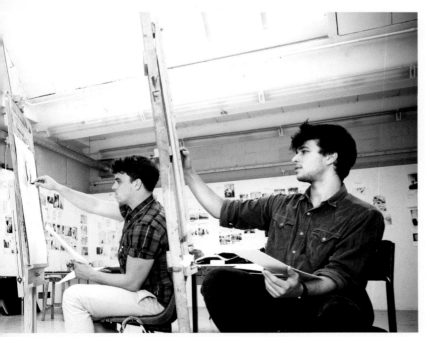

LEFT Theo Smith and Bartholomew Beale, drawing from the figure on a black background, as they start the first day of Workshop 2, July 2010.

Results

When finished, the drawing should have a feeling of integrated wholeness, where object and space have been given equal attention, and are mutually supportive. When you start drawing, being able to see and describe the direction of a surface plane can be challenging, and you may have to make several drawings before you start to fully understand their importance in the visual scheme of things.

Footprints in the snow—in the negative space

1_Start the drawing by sharpening a graphite pencil, and lightly sprinkle the dust onto your drawing paper.
2_Use your fingers or a tissue to lightly rub the dust into the surface of the paper—do not obliterate the surface, but create a lightly smudged, smeared effect all over, from edge to edge.
3_Make your drawing as above—Drawing 21—and whilst you are making it, use a putty rubber to gently 'dab out' the graphite dust from the negative space.
4_Pay particular attention to creating areas of most light [dab back to the white of the paper] and leaving, or putting more dust on for the darkest areas.
5_Dab right up to the sharp edges of your objects where necessary, or soften it into shadow.
6_Try not to obliterate the graphite completely, but see the dabbing out as leaving 'footprints in the snow'—a subtle record of you having been there.
7_The way your dabbing out surrounds the objects— like water flowing around a rock in a river—will hold the whole drawing together.

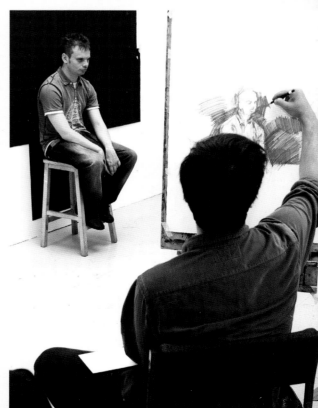

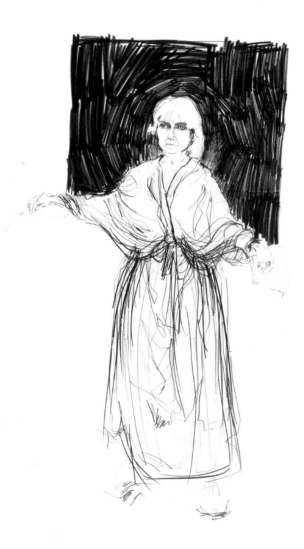

THEO SMITH

I am starting to understand how to be more selective by making some things more important—like if I get the face right—it does not matter what happens in the rest of the drawing. It can just be suggestive and at the same time, be exciting marks. The negative space works like a container, a sort of frame.

BENEDICT CARPENTER

I did not draw much until I was about 18 but from that point on I have drawn intensely in sporadic fits. I draw for lots of different reasons: to solve problems and to communicate information; to clarify things in my own mind about an object or method of production; to investigate an existing object; and finally for its own sake, as finished work. The drawings produced as 'art works' have the same status as my sculpture: once finished, they are intended to be complete and self-supporting.

Whether I am looking at my own drawings or other peoples', I feel that the difference between 'good' and 'bad' drawing is the same as the difference between being honest and showing off. Some good drawings demonstrate mimetic skill, manual dexterity, perhaps even a certain 'ease': but they will only be 'good' because they do something else as well. Glib precocity on its own is ugly and self-serving—skill should be used to do something other than display itself.

I once saw a drawing by the Austro-Hungarian war artist Kalman Kemeny that was made when he was 17 years old, from observation, of hunched troops running under fire between lines of trees. The drawing was made from an elevated vantage point, but close to what was being drawn. The charcoal marks were quick, spare and panicked, and the paper itself, which was a coarse brown wrapping type of paper, was torn at the edge and had been crudely folded. The terror that suffused the image left no room to admire, or for the artist, to practice, his 'skill'. The drawing would have taken only a few seconds to make, but the resulting image as a piece of primary evidence, as an accurate record of being under fire, had a tremendous and terrible charisma.

Even though this drawing was produced under peculiar circumstances, its qualities of economy and clarity of intention are shared by most of the drawings that I admire. If you think of the stillness and the ambiguity of a Morandi still life, and compare it with the confused terror of one of Kemeny's war drawings, it is surprising to realize that they both share these values. Both artists use their skill to communicate something specific, and in the process their skill becomes invisible, allowing the viewer of the drawing to concentrate on their subject, whether it is a metaphysical meditation or an explosion of existential anxiety. While neither artist uses their skill to show off, it is equally true that neither artist is impeded by a lack of skill. It is inevitable that at some stage in an artist's career, drawings will be made simply for the purpose of improving their ability. To this end, I offer the following advice: keep an open mind about what your drawings will look like. Most people have a visual notion of what good drawing is; often, this is a photographic look, and if the artist's early efforts fail to conform to this notion, as inevitably they will, it can be dispiriting. In any case, most often what an artist thinks is a 'good look' changes as their real ability begins to increase.

Secondly, the aim of producing a drawing should never be to make it 'good'. 80 per cent of the quality of a drawing is a measure of how successfully implicit criteria have been satisfied. If the purpose of a drawing is to describe a negative space, then the drawing will be successful if it achieves this end clearly. Having said that, I would like to contradict myself just a little and acknowledge that the other 20 per cent is probably just magic.

21 VI 07

TOP *Still Life 5*, 2007, Woolf's Carbon and Faber Castell polychromos pencil on Daler-Rowney heavy weight cartridge paper, 19.7 x 32.4 cm. Courtesy the artist.

OPPOSITE *Still Life 1*, 2007, Woolf's Carbon and Faber Castell polychromos pencil on Daler-Rowney heavy weight cartridge paper, 21.3 x 33.7 cm. Courtesy the artist.

BOTTOM *Still Life 6*, 2007, Woolf's Carbon and Faber Castell polychromos pencil on Daler-Rowney heavy weight cartridge paper, 19.4 x 35.6 cm. Courtesy the artist.

making light visible
PROJECT 4

ENERGISING TONE
dots and manic marks

MAKE CHANCE ESSENTIAL. <u>Paul Klee</u>

<u>ABOVE</u> Harold Gilman, *Mrs Mounter
at the breakfast Table*, 1917, pen and
black ink, partly scratched, squared in
red ink. Courtesy Ashmolean Museum,
University of Oxford.

<u>OPPOSITE</u> Lee Moss develops his self
portrait into a life-sized drawing of his
whole body by the end of the first week
of Workshop 2, July 2010.

DRAWING 22

<u>Duration</u>
30–40 min.

<u>Subject</u>
Black or white objects, other objects or
portrait/self-portrait.

<u>Technique</u>
Orthodox hand.
Looking at the drawing. No contour lines.
Your drawing should be no larger than 30 cm.

<u>Materials</u>
Use a combination of B, 2B, 3B, and 4B, or graphite
pencils on white cartridge paper. Charcoal if a larger
drawing is preferred on A1 white or mid-tone paper.

<u>Aims</u>
The same as Drawing 21—this drawing will help you
to see the object and negative space as an 'all over',
integrated whole, in which quantities of more and less
light create boundaries of definition and reveal form.
Your drawing should match the measured tones of a
pixelated black and white photograph, and use exciting
small gestural marks to make the energy of light visible.

<u>Method</u>
This drawing is a pencil drawing, but the process is the
same if you were to use charcoal.
1_Select two or three white objects and place them on
a sheet of white paper. [You could use black objects on
black paper, but the drawing will take much longer, and
have a denser tonal range].
2_Use light from an Anglepoise lamp (or similar) in a
darkened room to create a range of tonal contrast.
3_Rule a rectangle no bigger than A4 on your drawing
paper. This will become the containing space within
which your drawing is made.
4_Start the drawing by sharpening a graphite pencil,
and lightly sprinkle the dust onto your drawing paper.
5_Use your fingers or a tissue to lightly rub the dust into
the surface of the paper—do not obliterate the surface,
but create a lightly smudged, smeared effect all over,
from edge to edge.

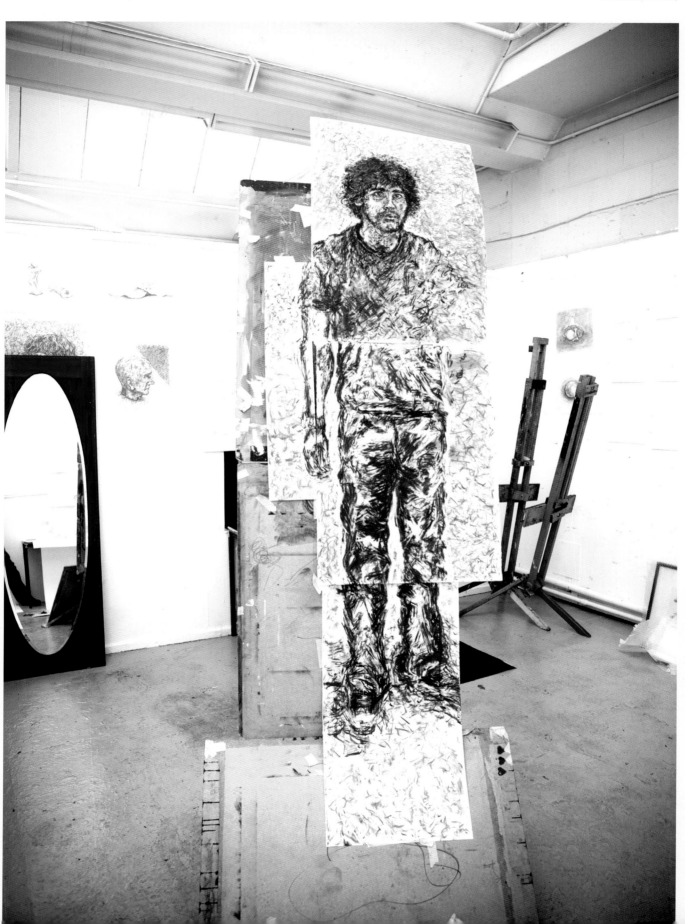

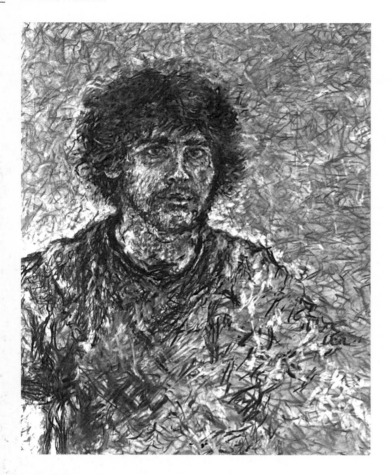

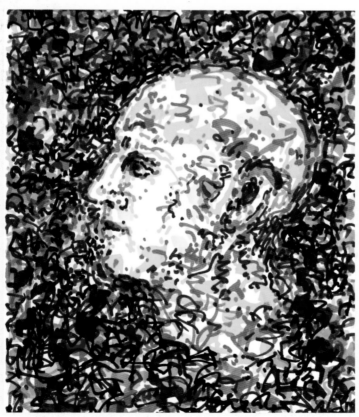

6_Spend some time looking at your set-up, and start wherever you like.

7_Use your range of pencils to cover the paper with a reasonably dense scattering of manic marks. Try and see the marks as manifestations of the energy it took to make them—alive and active.

8_Resist using outlines to define your objects, and make dots and small directional manic marks to build up areas of graded tone in seamless patches.

9_Use your rubber to rub back to the lightness of the white paper. Try to do this in an area of negative space that is light in your still life.

10_Form the image by accumulating densities of small marks. A denser group of marks will suggest a darker tone. Fewer marks, which leave the white of the paper exposed will define a lighter range of tones.

11_Continue to use the rubber to reveal quantities of light, and then re-introduce more dots, dashes, and manic marks, but nothing longer than three or four mm, and direct them—up, down and across the surface planes, 'feeling' the light as you make them. [Dots will flatten the image, and dashes will direct your eye across a surface—use both].

12_Use two or more pencils when drawing the darker areas.

13_Keep repeating the process until the marks collectively form to establish the required image.

Result

Your drawing should be an exciting 'all over' surface of small marks and have an integrated wholeness, where object and space meet without a linear boundary, and its 'all over' surface feels like energised light.

Supplementary Option

Consider using this option with Drawing 26.

1_Cover your rectangle with manic coloured felt pen marks.

2_Make a drawing as above on top of Instruction 1.

3_Use a small piece of mount card [about 5 x 5 cm] as a spatula, and scrape white oil paint over your drawing, pressing hard enough to let some of the earlier drawing show through. Allow the spatula to leave a record of it's straight edged shape, and show how you have pulled it across the surface of your drawing in blocks. Let any chance changes in the thickness of paint become part of the drawing.

4_Repeat Instruction 2.

5_Repeat the process until you are ready to stop.

6_Look at the quotes below, and if you feel that you have been a bit of a tame goose, "make chance essential" and get wild.

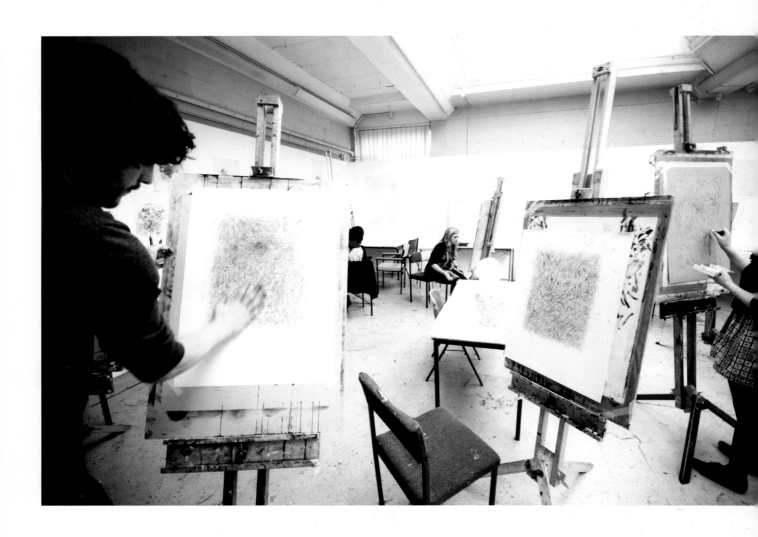

LEE MOSS
This is a new starting point for me—very exciting—it is flexible, adding and taking away—so open—a bit like painting.

ABOVE Lee Moss, Amy Smith and Melanie Chitty draw from a plaster cast head as they work on the dots and manic marks project on the last day of the first week of Workshop 2, July 2010.

YOU CAN MAKE A WILD GOOSE TAME, BUT YOU CANNOT MAKE A TAME GOOSE WILD. Robert Motherwell

DRYDEN GOODWIN

in conversation with Jack Southern, London, February 2011

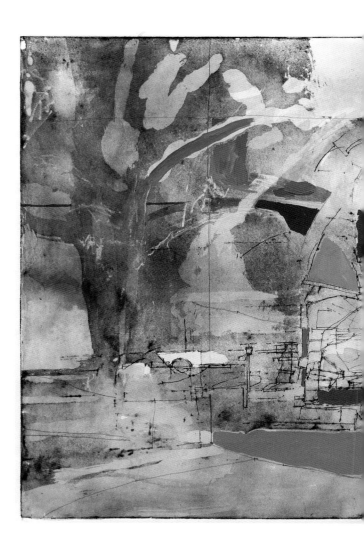

JS When we met up to discuss the potential of this interview, we talked a lot about the conversations I have had with other artists who have contributed to this book. I explained how those discussions had presented the opportunity to talk about works that are less commonly seen than those we might associate with them through exhibitions and publications. Works that are revealing and have a personal significance, perhaps anchor points in the process of developing ideas and ways of working.

I talked a lot about commonalities, threads and predominate thoughts in the work; when and how they may have been established, and how they re-occur. You seemed particularly excited about what could come out of such an investigative, open process, and mentioned that there were specific works and sketchbooks which came to mind as meaningful and important developmental points in your practice?

DG Yes, absolutely, and one of the first things I thought of was this framed drawing of etched head studies, so I brought it to the studio to show you. It was one of a body of dry point etchings I made during two terms at Wimbledon School of Art, before going to study at the Slade, so it is about 20 years old now. I remember I wanted to try and distil a whole host of feelings in an image, the re-working of the drawings has a lot to do with this.

I was using a steel etching needle onto a zinc surface and taking it through different stages. The process really felt like it was an attempt to grapple with the surface, because I could rub down the burr, burnish back into it, and build it up again. There is something about this drawing, which is really key to a lot of things I have done. It has visual qualities that express the singular moment, as well as something that is searched out over time. A thread or way of thinking that runs through many other works I have made.

I think there are similar visual qualities in these studies of Russell Square, which I did a few months later. I remember that I started this one on a really foggy night, and I kept on going back, re-working the drawing, which then led to a series of etchings. There was a distinctly linear approach to how I was constructing the compositions.

I think the significant thing about them is that I was developing this idea of mapping out an underlying structure, and the drawings became a visual manifestation of my attempt to express the facets and complexity of that structure. So as well as depicting a passage of time, they express something of a visual fragmentation and distortion beyond the surface. The idea of the schematic became very prominent in these drawings.

And the other thing I remember us talking about when we met was this sketchbook from my Foundation course in 1991, which I have also dug out to show you. I think some of the drawings in it are about working out certain compositions, or ideas that then informed paintings I went on to make.

But more importantly, I think they are about attempting to distil a feeling or emotional charge into an image. I was discovering how to translate and depict the intensity of something which I would have observed or experienced into the moment of a

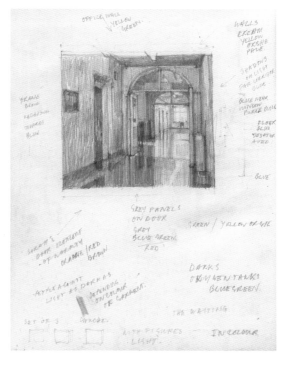

<u>TOP</u> *Russell Square, London*, 1992,
etching with gouache, 28 x 63 cm.
Courtesy the artist.

<u>OPPOSITE</u> *Hospital Corridor*, 1991,
pencil on sketchbook page, 23 x 19 cm.
Courtesy the artist.

<u>LEFT</u> *Sarah Asleep in Hospital*, 1991,
pencil on sketchbook page, 8 x 10 cm.
Courtesy the artist.

Head studies, 1991, dry point etching
from zinc plate, final state, 10 x 19.7 cm.
Courtesy the artist.

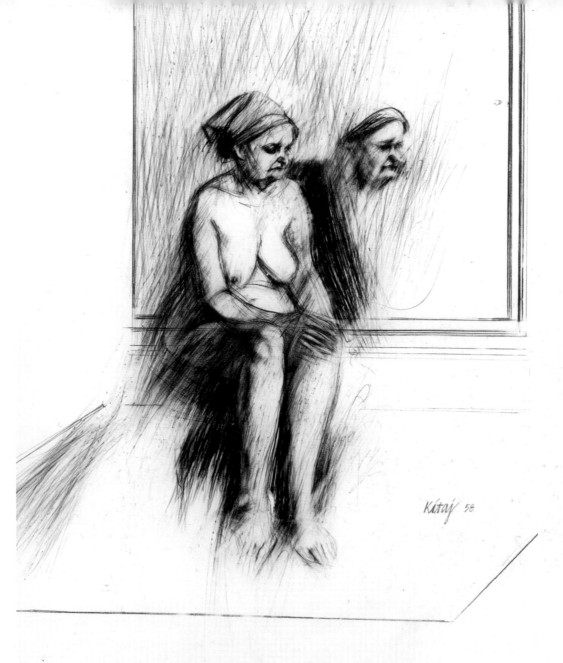

SHAHZIA SIKANDER

For me, drawing is a way of navigating the imagination and it remains the fundamental vehicle of my practice. Drawing allows me to be at my most inventive.

Monks and Novices is an ongoing series of work I started in 2005 in Laos. In the past, I have drawn on portraiture to initiate dialogue. But in the context of Laos, the complexity of the country was initially overwhelming. The gentleness of the people I met made it difficult to locate the country's underlying turbulent history.

In response to this paradox, I tried to project or imagine the 'invisible' layers within these people. Their composed faces belie the complexity of Laos. Their heads express a subtle tension between materiality and ethereality. They are both passive and aggressive. Each reveals a subtle exaggeration of a physical or psychological trait that I perceived.

My main aim was to highlight the uniqueness of each face, to create a homage to the personality of each individual, and to navigate a cultural terrain that is not accessible with a brief glance.

TOP *Monks and Novices Series, Novice Chanton*, 2006–2008, graphite on paper, 35.6 x 27.9 cm. Courtesy the artist and Sikkema Jenkins & Co, New York.

BOTTOM *Monks and Novices Series, Sathou Nyai One Keo Sitthivong*, 2006–2008, graphite on paper, 35.6 x 27.9 cm. Courtesy the artist and Sikkema Jenkins & Co, New York.

OPPOSITE *Monks and Novices Series, Novice Phouvanh*, 2006–2008, graphite on paper, 35.6 x 27.9 cm. Courtesy the artist and Sikkema Jenkins & Co, New York.

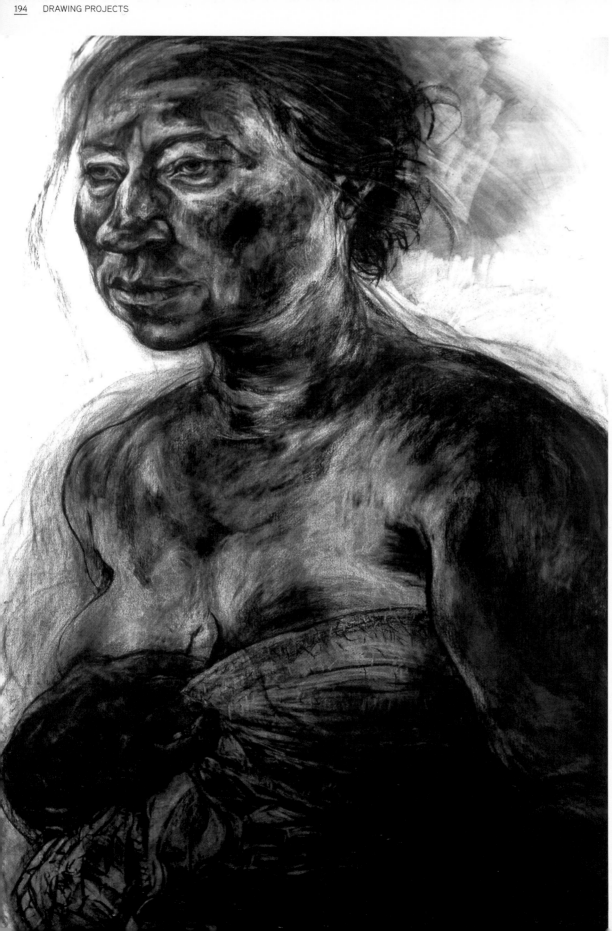

making light visible
PROJECT 4

SUBTRACTIVE TONE
an angel in the dark

DRAWING 24

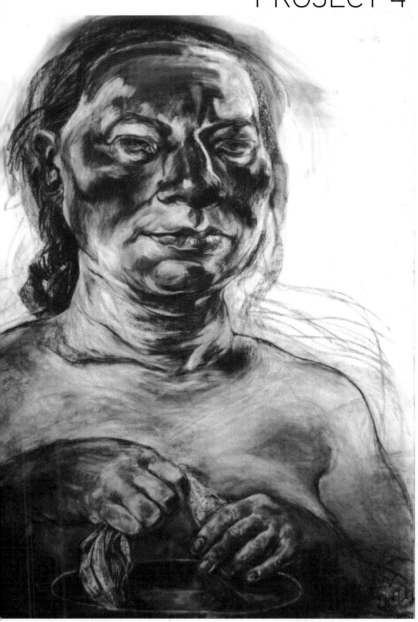

ABOVE Anita Taylor, *Cleanse*, 2003, charcoal on paper, 182 x 136 cm. Courtesy the artist.

OPPOSITE Anita Taylor, *Divulge—3*, 2004, charcoal on paper, 185 x 114 cm. Courtesy the artist.

OVERLEAF Barley Beal and Holly Ford lift charcoal off their drawing with a putty rubber as they attempt the subtractive tone project at the beginning of the second week of Workshop 2, July 2010.

Duration
40–60 min.

Subject
Several objects or self-portrait.

Technique
Orthodox hand.
Looking at the drawing.

Materials
Scenic charcoal, plastic eraser, putty rubber, soft cotton rag, soft paint brush, A3 white, mid-grey or light grey paper.

Aims
This drawing is primarily about the medium and method used to make it.

Charcoal has soft, tenuous qualities that make it the perfect medium for the depiction of light, and working with it offers an enormous amount of flexibility for adjusting and integrating any changes that need to be made.

This drawing is the opposite of other drawing methods, in which dark marks are added to white paper. A drawing can be made by covering a piece of white paper with charcoal, and then rubbing into it to reveal the paper. The white of the paper is revealed as a positive negative, and at its whitest, it reads as a highlight—the lightest tone. A range of mid-tones can be created by rubbing out more or less charcoal.

Use light from an Anglepoise in a darkened room to create a range of tonal contrast. Try to see your objects as being larger than life, and having 'monumental' qualities. Imagine them being as tall as the Eiffel Tower—a landscape to walk across—or an island in the sea, around which you could fly a helicopter. Visualise the spaces between them, as being alive—sea, sand or sky.

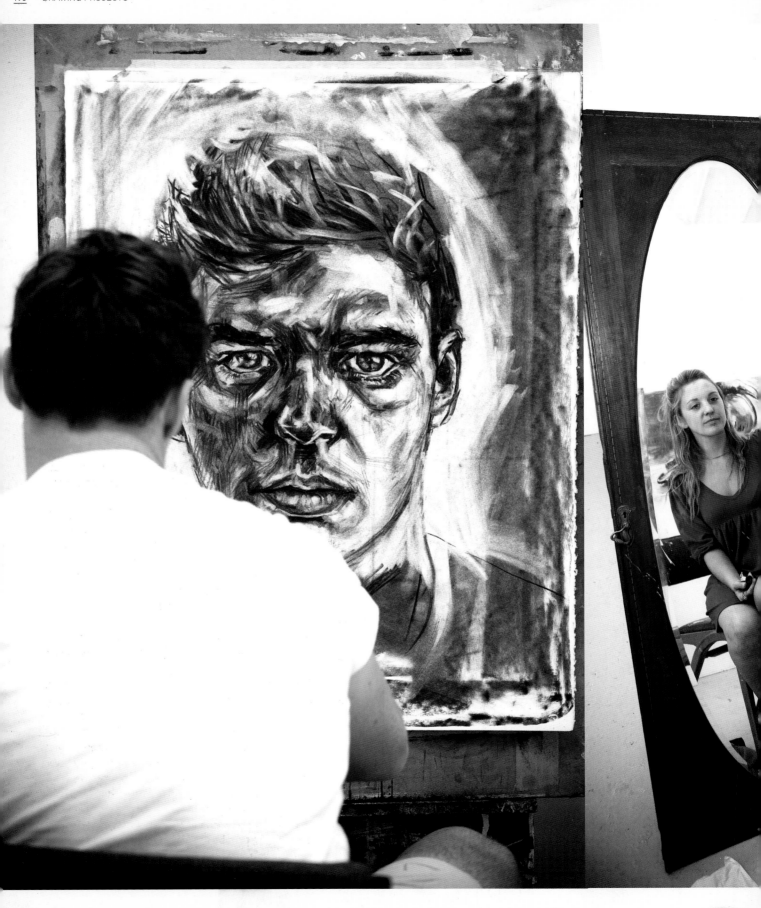

ABOVE Mick Maslen, *Reclining Woman*,
pen and ink.

slowing the looking down

SHORTHAND TONE
PROJECT 5

one decision—one mark

DRAWING 25

Duration
15–30 min.

Subject
A profile of a face, a white apple or a sliced apple, a peeled apple, a pepper or other objects.

Technique
Orthodox hand. Small sharp lines. Several studies. Looking at the drawing.
Your drawing should be no larger than 30 cm.
In this drawing, we are going to deal with two things,
1_One decision—one mark [straight lined curves] and
2_Shorthand tone.

Materials
Use a very sharp HB, B, 2B, or 3B pencil and hold it in a way that gives you maximum control. Use an eraser as required.

Aims
One decision—one mark [straight lined curves].
This way of seeing/drawing could radically change the way you draw. 'Slowing the looking down' requires you to make 'one decision—one mark', and is the opposite way of working to the 'continuous contact' line drawing of the earlier projects.

None of the marks made should be longer than a centimetre, and some may be as short as 2 mm. They should be drawn as sharp straight lines that are fast and tense. Feel them as you make them, and do not make them mechanical like stitching.

It sometimes helps to make a 'double' line—an 'echo line'—[one that runs parallel to the first line, about a millimetre away]. Let these 'echo lines' run into, and overlap each other. When drawing curves, draw round the curve with a series of small straight lines. Change direction with these short marks at every opportunity—2 mm one way 5 mm another—make a feature of any indentation or quirky detail. "God is in the detail", and your drawing will signal to the viewer that you have really looked at your objects by making detailed decisions.

SAM HIGLEY ON ONE DECISION—ONE MARK

This drawing has given me a chance to structure the circle—
it is like I am slightly exaggerating the formal properties, and
making it look more real.

EMILY MASON ON ONE DECISION—ONE MARK

I think that knocking it back and adjusting the drawing with
another set of marks seems to give it more body and character.

SOPHIE KEMP ON ONE DECISION—ONE MARK

It is great to have the rigour of looking and making one
decision at a time—it makes you look, but I find it a bit
restricting, and get stuck in the detail. I would like to combine
this with a more flowing feminine line.

ROB MORGAN ON ONE DECISION—ONE MARK

This asks you to look and really try to understand the form
with the gesture. You can see instantly where you have gone
wrong—a really good exercise.

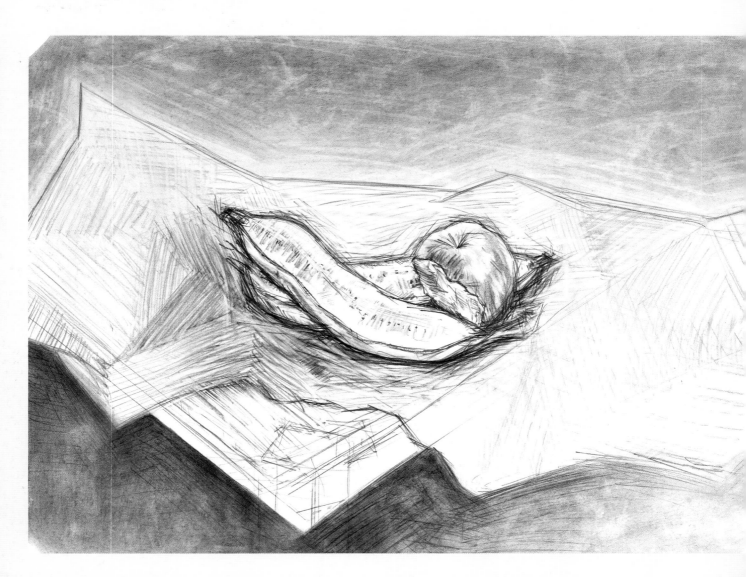

Shorthand Tone

It is important to be able to describe in marks how an object exists in three dimensions, and to be able to take the spectators eye on a descriptive journey across and around its form. Refer to Drawing 20.

Your aim is to use a 'shorthand' version of hatching to describe the changes of surface direction within the roundness of form on a curvilinear object.

Method

Start by drawing the profile of a friend. If you are left handed it will be easier if they are facing right, and if you are right handed have them facing left. Start by 'boxing in' the bigger shapes, [forget the labels]—the shape of the hair, the eye socket, the nose, the mouth, shadow shapes, etc., and then work towards the smaller shapes within the bigger shapes, and finally the details within the smaller shapes. Once the structure has been established, selectively incorporate some shorthand tone.

Supplementary Option

Although simple in appearance, the form and surface of apples is complex. Like a cylinder, their form originates from, and disappears back into the contour edge, but their complexity is in their multi-directional surface. Like a ball of string, it wraps around the form in every direction, having no beginning, and no end, and provides us with some of the complexities of the Figure—a combination of rounder planes, and subtle flatter planes.

1_Take a firm, well shaped apple, pear or banana, and paint it white. Matt white car spray primer is the most suitable, but if not available—two evenly applied coats of white emulsion paint will do. The apples pure white surface will focus your vision into seeing only quantities of light wrapping around its curvilinear form.

2_Relinquish your conceptual notion of an Apple as being 'spherical'. It is true to an extent, that they have spherical properties, but thinking that they are round will probably deceive you into drawing your generalised idea. If you were to slice a sphere into either vertical or horizontal sections, the result would be a set of circular sectioned pieces. If you were to slice an apple in the same way, then the result would be very particular apple-shaped sections. Try to see the shape of your apple as if you were seeing it for the first time.

3_Place the apple on an A3 sheet of white cartridge paper.

4_Spend some time turning it around, and looking at it from different angles, and try and see its angular properties.

5_Make several small studies of it from different positions, and use short straight lines only, to describe its contours—no curves for the moment. This should allow you to see the dynamic angular properties of the apple. It will almost need to be exaggerated to appear

more life-like. [At a later point in time, curves may be used to round off the straight lines if felt necessary.]

6_Make groups of two or three or four more, hatched lines that follow and illustrate the form and surface direction of light on the apple.

7_Integrate another object into the drawing, and tackle it in the same way.

Results

Your drawing should show the beginnings of an understanding of directional 'shorthand' hatching that describes surface direction and roundness of form. Drawing inside the contour edge, across, and around a surface can be daunting to begin with, but after a bit of practice, it becomes easier.

By slowing the looking down you will have made fewer 'not looked' at generalisations, and a more studious set of detailed observations.

Do not expect to be a master of this in your first drawing. You must practice and practice until you find yourself drawing in your minds eye, any curvilinear form that you look at.

KEITH TYSON

For me, creating art is a kind of opening to awareness: whether it is slowing down your vision to look at the detail in a surface, being open to serendipitous accident, or discerning the distinct flavours of your own internal states and emotions.

Sometimes, however, something just hits you with its poignancy. This was the case with *Tribute*, a drawing of a page from *The Financial Times* I read one morning while having breakfast. The image in the middle of the page (a sculpture by Sol LeWitt) looks so elegant in comparison to the chattering madness of human economics that surrounds it. It is even more telling how, with the passage of time, those stories become less accurate while the sculpture remains true.

I draw the vast majority of my studio wall drawings but, in this case, I asked an assistant to copy the page. It took him six weeks, but I still see myself as the author of this work and the assistant as an extension of my own process.

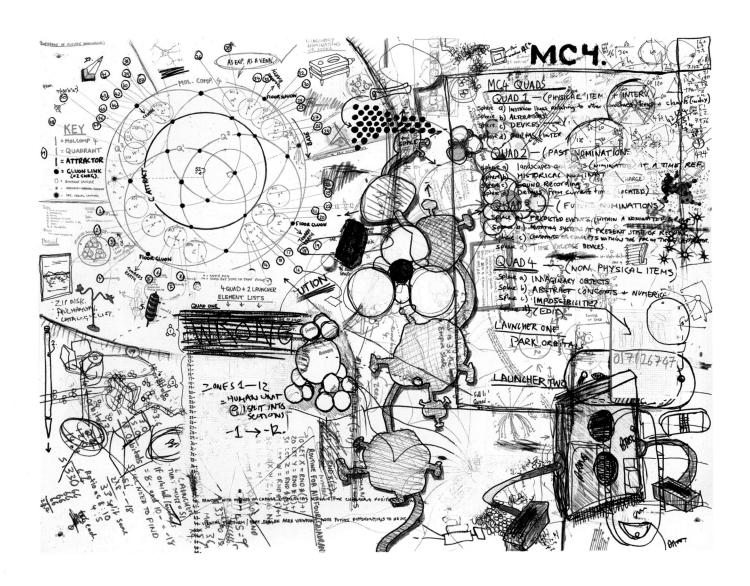

6 ★ FINANCIAL TIMES TUESDAY APRIL 10 2007

International News

Turkey's prime minister warned Iraqi Kurdish leaders against 'stirring up trouble' among Turkish Kurds
Page 9

Gas exporters launch pricing study

By Andrew England in Doha

Energy ministers from some of the world's leading gas producers agreed yesterday to set up a high-level committee to study pricing policies and other issues facing the gas sector.

Some delegates suggested it was a step towards an organisation of the petroleum Exporting Countries-style organisation. But others sought to play down the idea of a gas pricing cartel.

The decision to set up the committee was reached at a meeting in Doha of the Gas Exporting countries Forum (GECF), whose members, including Russia, Algeria and Qatar, are responsible for about 60 per cent of the world's gas exports.

Russia will lead the study into pricing, and the committee's findings will be presented at the GECF's next meeting, which is expected to be held in Moscow next year, said Viktor Khristenko, Russia's energy minister.

Concerns about the possible creation of a gas cartel have risen following statements by Vladimir Putin, Russia's president, and his Iranian and Venezuelan counterparts, who have all raised the notion. But Russia has appeared to backtrack, and other producers have dismissed the idea. Neither Iran nor Venezuela are net exporters of gas.

Mr Khristenko said: "There are a few issues (in head of discussion) – infrastructure, relations with customers and development of pricing policies."

Russia, which supplies its gas by pipeline but also has ambitions to create liquefied natural gas projects that would enable it to export via tankers, is concerned that the growing LNG trade outside its borders could impinge on its dominance of the European market.

Moscow also worries that Other gas suppliers could beat it to the Asian market. Both Russia's project to ship gas east via pipelines and its major Shtokman LNC project have suffered delays. Details on the composition of the new committee have yet to be worked out, said Mr Khristenko, adding that it would not take a decision that would lead to the establishment of a cartel.

However, Chakib Khalil, Algeria's energy minister, said that in the long term, gas producers were moving towards a "gas Opec", but stressed that it would take a long time. "The process up to now has been indexed to oil. The world has changed. Now we have lots of things people didn't talk about five years ago," he said.

Other delegates pointed Out that it was far harder to set up any form of pricing cartel for gas because it was traded in long-term contracts, was linked to oil and much of the world's gas was transported regionally by pipeline rather than tanker.

Lenny Saith, energy minister for Trinidad and Tobago, said the key issue was how gas producers and the GFCF adapted to a rising product costs and a changing energy market.

"The right context is as a group of producers faced with these challenges, how do we move forward? [A] cartel is the last thing," he told the Financial Times.

"How do you have a cartel [with] LNG contracts, long term contracts?" The whole structure of the industry is different. It's taxing oil out and selling it everywhere, so it's a different ball game."

GECF decisions will not have a significant impact on the US market, which produces about 80 per cent of its gas domestically. But Europe is dependent on Russia and Algeria for more than 60 per cent of its gas consumption.

Chinese police in ID swoop on cyber elves

By Mure Dickie in Tokyo

In China the authorities want to know who you are – even when you are an elf.

Under a "real name verification system" to tighten control over internet usage – and curb web addiction among the young – Chinese police are to check the identity card numbers of all would-be players of online games.

While it is unclear how rigorously it will be enforced, the move, announced yesterday, highlights Beijing's desire to strengthen controls over the net and reduce the potential for anonymity in cyberspace where, as a New Yorker cartoonist once put it, "nobody knows you are a dog".

Online role playing games are hugely popular in China, where millions regularly log on to play as elves, dwarves, magicians and martial artists in vast virtual worlds.

Chinese leaders recently announced a broad push to "purify" the internet of socially and politically suspect activity, and have been striving to press for the use of only true identities online.

Beijing is also looking at ways to implement a "real name" system for bloggers to curb "irresponsible" commentary and intellectual property abuse.

State media recently quoted Hu Qiheng of the China Internet Association as saying that bloggers' real names would be kept private "as long as they do no harm to the public interest".

Several online game operators already require players to supply identity card details, but the numbers submitted are often false.

China's 18 digit ID numbers are mainly based on place of birth, age and gender and are unique to each citizen, but widely available software can generate fake but plausible numbers.

Under the new system, police would check each number, a government official said yesterday. Players, whose IDs showed they were under 18, or who submitted incorrect numbers, would be forced to play versions of games featuring an anti-addiction system that encourages them to spend less time online.

Minors who stayed online for more than three hours a day would have half their game credits cancelled, those who played for more than five hours a day would lose all their credits.

The official gave no details of the likely cost of identity verification to online games operators, which include market leaders Netease.com, Theg and Shanda Interactive Entertainment. But Netease and Theg said it would not hurt their businesses.

Economies face less risk, says IMF

By Krishna Guha in Washington

The risks to the world economy today are less than they were six months ago, Rodrigo Rato international Monetary Fund managing director, said yesterday.

Mr Rato told the Peterson institute economic think tank that there was "greater consciousness of the uncertainties and paradoxes that lie behind our current prosperity" following the recent turbulence in global financial markets.

But he added that, overall, "I do not think that the risks are greater than they were six months ago. Actually, they are a little lower."

At the same time Mr Rato urged political leaders to take the tough steps needed

'It's no bad thing if there's more awareness of the dangers of playing with fire'

to make progress on global economic imbalances and financial market stability.

"We are living in a dry forest," he said. "If market developments have produced increased awareness of the dangers of playing with fire, that is no bad thing."

He pointed out that it was necessary to "translate that awareness into constructive action".

Mr Rato warned that "complacency" was also a threat to the IMF's agenda of institutional reform, which included proposals to shake up its shareholding structure and reform its finances.

Although each of the 185 members of the IMF had their own priorities and objectives, he warned it was "essential that members of groups of members do not treat this as an opportunity to press for their own preferred approaches at the expense of the consensus that is needed to make any changes at all".

The speech comes ahead of the spring meeting of the IMF's governing council of finance ministers and central bank governors in Washington this weekend – which will examine the state of the world economy and the IMF reform proposals.

Mr Rato said work on the IMF's multilateral consultation on global economic imbalances was "well advanced", although he played down any expectation that the report to be presented to finance ministers would propose radical new initiatives.

Instead, he said it would "solidify agreement on an approach that will tend to produce a gradual reduction of global imbalances".

Mr Rato said the IMF had "made some progress in agreeing on a set of underlying principles for the new quota formula" that defined each country's shareholding in the IMF.

Members agreed the formula should be "simple and transparent" and that it should result in changes "broadly acceptable to the membership" – in other words, giving developing countries a bigger say.

Mr Rato hailed the work he may not accept all the recommendations of the Malan report, which urged the IMF to pull back from several activities in lower-income countries, noting, for instance, that the balance of payments needs in many countries were "long-term and intractable".

Death of an artist Sol LeWitt succumbs to cancer in New York

Four-Sided Pyramid by Sol LeWitt, an artist known for his dynamic wall paintings and as a founder of minimal and conceptual art styles who died aged 78 in New York on Sunday of complications from cancer. Much of his art was based on variations of spheres, triangles and other geometric shapes. His sculptures commonly were based on cubes using precise, measured formats and carefully developed variations. His experiments with wall drawings were considered radical

Wolfowitz to co-operate in Riza inquiry

By Krishna Guha and Reuters in Washington

Paul Wolfowitz yesterday attempted to contain the growing row at the World Bank over a pay rise and promotion given to a colleague Shaha Riza, with whom he is romantically involved, by telling staff that he took "full responsibility for actions taken in this case"

The bank's staff association last week questioned Ms Riza's promotion and on Friday the bank's board called for a probe. The World Bank president told the bank's staff in an e-mail yesterday that he would co-operate fully with an investigation by the bank's board into the Riza move, which raised her salary to $193,000 free of tax.

The e-mail was passed to the FT by the Bank Information Centre, a non-governmental organisation.

In it, Mr Wolfowitz said he would ensure the board had access to the facts in the case "in a manner that also respects the bank's rules concerning the right of every staff member to the confidentiality of his or her records".

He could not immediately be reached for comment.

Ms Riza has been seconded from the bank to the State Department. The staff association said that before the secondment, she was promoted to a senior position which would normally be "competitive, vetted and approved by the relevant sector board". It also said she was given a pay raise that was more than double the amount allowed under staff rules.

Mr Wolfowitz said in the letter that he had sought the board's advice regarding Ms Riza soon after he arrived at the bank, where she was working. He was advised by the board's ethics committee that her presence presented a conflict of interest and that she should be seconded outside the bank.

"I subsequently acted on the advice of the board's ethics committee and its then general counsel have said they did not have anything to do with the negotiation or approval of specific terms and conditions in Ms Riza's transfer.

Mr Wolfowitz said in his e-mail: "I would like to assure the staff that I have always acted to uphold these rules to the best of my ability and I will continue to do so."

EUROZONE INTEREST RATES
ECB wonders how hard to apply brakes

India keeps tight control of rupee amid hot money surge

divine damage
PROJECT 6

RESURRECTING A DRAWING
evidence of passing time

DRAWING 26

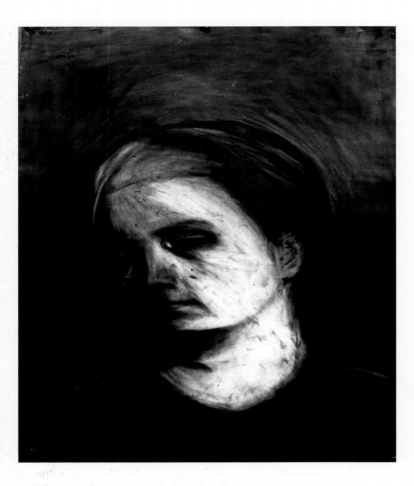

Frank Auerbach, *Head of E.O.W.*, 1957, charcoal and chalk in paper, 76.2 x 55.9 cm. © The artist. Courtesy Marlborough Fine Art, London.

Duration
15–30 min.

Subject
An existing pencil drawing that has been rejected and abandoned.

Technique
Orthodox hand. Working back into an old discarded drawing of your choice.

Materials
A combination of HB, 2B, and 3B pencils; a putty rubber and a plastic rubber.
Options—white stick of chalk, white oil paint.

Aims
It is important not to be over-precious about your drawings, and to realise that you can resurrect and re-establish the authority of a 'failed' drawing by re-working it.

This project requires you to adjust and re-work an existing 'failed' drawing. Find an old pencil drawing that you are not happy with, and the object you originally drew.

"Divine damage" is a term used to describe the evidence of struggle and endeavour that took place during the making of a drawing, and which remains in the drawing as part of its history. Our aim is to make a drawing that embodies these elements.

Every drawing should tell a story, the tale of the looking, the seeing, and the making. It should be the creation of a problem solved, whereby the viewer is offered a glimpse of the problem, and the journey and story of its solution.

DRAWINGS REVEAL THE PROCESS OF THEIR OWN MAKING—THEIR OWN LOOKING. John Berger

Method

1_Select a pencil drawing that you had made previously and abandoned, and the object you made the drawing from.

2_Smudge the drawing with your fingers or the ball of your hand, to create a grubby soiled effect.

3_Cut a large sharp edged piece of plastic rubber from your rubber, and lightly rub through carefully selected parts of the drawing.

4_Cut through some of the darker lines in the drawing with the rubber and turn them into broken stuttered lines. Do not obliterate the drawing, but create some soft graphite mid-tones, and let the carefully directed rubbing out reveal the white of the paper to give a feeling of directional light. Integrate these 'negative marks' into the drawing, and let them direct your eyes over and around the form.

5_Leave a 'ghost' of selected bits of drawing upon which you can build another layer of marks.

6_Make another, better drawing of the same object on top of the rubbed back drawing, adjusting, and leaving parts of the old drawing, and the history of changes made, to show through.

7_Keep repeating the process until you are happy with the history and character that the struggle has left evident.

Supplementary Options

An alternative to the above is to use a stick of white chalk to 'knock back' another existing drawing. Lay the chalk on its side and lightly rub it over the drawing to create a soft, misty effect. Use a putty rubber to gently dab out, as opposed to rub out most of the drawing, and re-draw and re-define your drawing on top. Pencils draw like silk on top of chalk. Repeat the process several times if necessary.

Refer to Drawing 22/Supplementary Option

White oil paint scraped across the drawing with a small piece of mounting card [5 x 5 cm] being used like a spatula, and leaving the drawing to show through, is another way of 'knocking back'. The drawing adjustments must be made while the paint is wet, and like graphite on chalk, it draws like silk.

Results

This drawing should have a hand-made, slightly scruffy feel and be as comfortable to look at, as your favourite jumper feels to wear. Inherent to the drawing will be the evidence of a struggle depicting the time, effort and energy spent making it, and you will realise that you have the ability to rescue a drawing that might have otherwise been disregarded, and turn it into a successful and perhaps more interesting drawing.

BETH KIRBY

This is a series of stages of development of the same drawing. I was unhappy with the first drawing; I felt it had no life, and decided to come back to it later in the workshops and try to re-work it. I erased the original drawing, leaving a trace of the integral lines and composition as reference.

I then changed the objects in an attempt to give the drawing a freshness, with a more dynamic composition. On reflection I felt the oval shape of the pot dominated the central space of the drawing and that there was too much negative space in the top half of the drawing. So I decided to take that object out of my still life, rub it back and add a vertical object that would encourage the eye to explore the top half of the drawing. I then added objects on the base line of the drawing, which seemed more interesting, they almost gave the drawing a series of diagonal line that lead the eye into the centre of the drawing.

More visual variation in the still life, meant more variation in the range of methods of drawing I used. So I drew my new objects with a greater mix of detail, for example, I drew the ice-cream cone with fastidious shading and detail, whereas the tiger and the dinosaur are drawn with more of a feel for lines and shapes, rather than shading and exact proportions. I also added more to the space around the objects, to create a new dimension of position and perspective.

I feel like the drawing has changed, and evolved for the better. It is a really interesting process to come back to a drawing that I had previously given up on, and grapple with what you feel does not work about the drawing. With suggestions from Mick and Jack, I think I have learnt a lot through the process of trying to resurrect the initial drawing.

FRANZISKA FURTER

In a process of copying, scanning, enlarging and drawing, my two dimensional works develop from appropriated references from science fiction books and illustrations as well as imagery taken from the Internet. The images often come from found visualisations of the 'invisible'; such as movements, sounds, dynamics or hallucinations.

Shifting between organic, mineral structures and cosmic representation; the three-dimensional drawings visual play with contrasting connotations of seemingly aggressive and fragile aesthetics.

The works vary from very small objects on the wall, to extensive installations proliferating into the room, as well as large scale ink-on-paper drawings. Often infused with a sense of ambiguity; scale shifts and time expands, causing a strange artificial illuminating light that implodes, casting deep black shadows.

Minimal and monochrome, the works evoke thoughts about material density eluding the eye's focus. They fluctuate between restrained unobtrusiveness, and penetrating imperiousness. The titles of the works are another element that counteracts the visible, and often distorts one's perception, shifting it into another direction, opening up new realms of association.

OPPOSITE *Draft VII*, 2009, pencil on
paper, 140 x 110 cm. Courtesy galerie
schleicher+lange, Paris.

ABOVE *Internal friction/neve*, 2009,
pencil and ink on paper, 33 x 48 cm.
Courtesy galerie schleicher+lange,
Paris.

Shades I, 2005/2006, enamel on paper,
100 x 140 cm. Courtesy Galerie Friedrich, Basel.
Photo: Jeannette Mehr.

<u>TOP</u> *Internal friction/erch*, 2009, pencil and ink on paper, 33 x 48 cm. Courtesy galerie schleicher+lange, Paris.

<u>BOTTOM</u> *Internal friction/erch*, 2009, pencil and ink on paper, 33 x 48 cm. Courtesy galerie schleicher+lange, Paris.

<u>OPPOSITE</u> *One more breath*, 2007, ink on paper, 350 x 206 cm. Photo schleicher+lange. Courtesy galerie schleicher+lange, Paris.

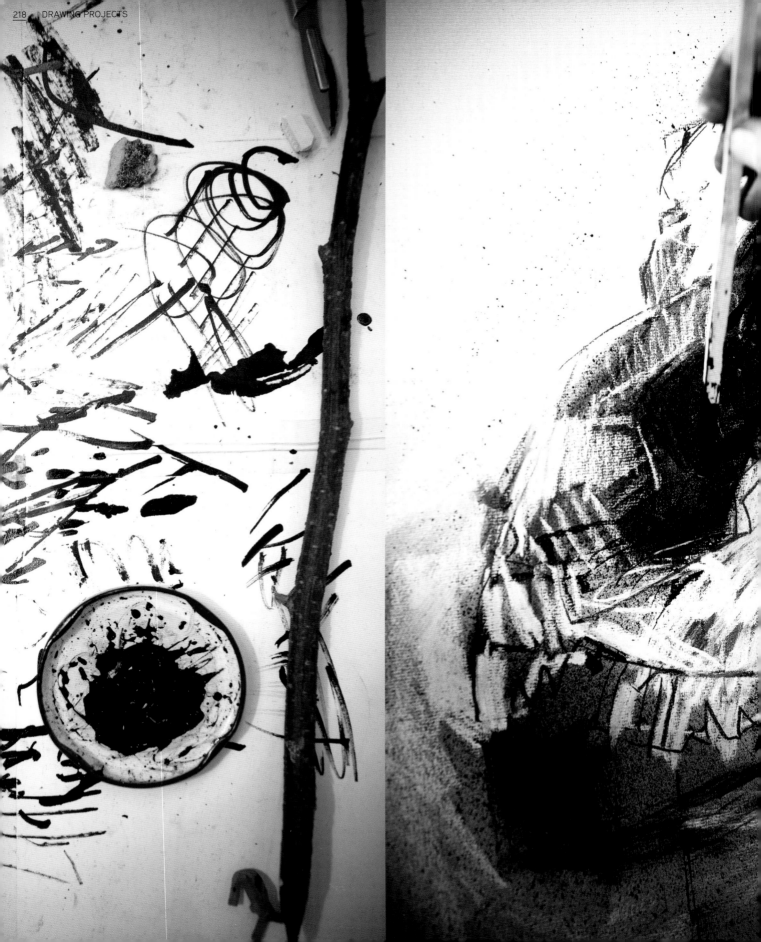

the thinking hand
PROJECT 7

AN EMOTIONAL RESPONSE
capturing character

DRAWINGS 27/28/29/30

Duration
15–30 min.

Subject
Chose a single object, which you feel emotional, drawn to. This could be with either positive or negative associations.

Technique
Orthodox hand. A4 in scale (Drawing 27), A2/A3 (Drawings 28, 29, 30).

Materials
Use a combination of B, 2B, 3B, and 4B pencils, and both a hard and putty rubber (Drawing 27). Charcoal, Conté, graphite dust, and both a hard and soft rubber (Drawing 28). Indian ink (3/4 different dilutions), a range of sticks, or the wrong end of your pencil, and a damp cloth (Drawing 29). Indian ink (3/4 different dilutions), a range of bits of ripped up sponges and fabrics, a range of sticks, or the wrong end of your pencil, and a damp cloth (Drawing 30).

DRAWING 27
Spiky and brittle.

Aims
To develop a tonal range, perhaps using a rubber to alter the intensity of the lines. Continue until you feel that the drawing has characteristics pertinent to your chosen object.

Method
1_Spend a few minutes looking at the object. Perhaps make a few notes on its characteristics.
2_Look at your sheet of paper. Imagine your object as a spiky line drawing placed on its surface space.
3_Make a few practice marks on other scraps. Use a ruler if it appeals. Make short sharp incised lines. It is important that the pencil is kept sharpened. Avoid its softer quality of line.
4_Begin the drawing by making an outline of your object using short straight lines.
5_Secure the edges of the drawing and gradually move across the form building up a surface description using spiky hard lines.

LAUREN WILSON

When making an emotional response to our objects the immediacy
of the ink seemed appropriate to the ambiguity of the little dress. A
series of quick, impulsive approximations of line seemed like the
most relevant way to explore the objects ambiguous and poetic
nature, as well as the indistinctness of its history.

6_Develop a tonal range, perhaps using a rubber to alter the intensity of the lines. Continue until you feel that the drawing has characteristics pertinent to your chosen object.

DRAWING 28
Soft and pliable.

Aims
Characteristically, charcoal marks are more generous, fluid and less restrictive than other drawing tools. Enjoy both these qualities of Charcoal, as well as working on a larger scale.

Method
Characteristically, charcoal marks are more generous, more fluid and less restrictive than other drawing tools. Working on a bigger scale gives more scope to enjoy this media.
1_Spend a few minutes looking at the object. Make a few notes on its characteristics.
2_Look at your sheet of paper. Imagine your object as a soft tonal drawing. Perhaps make a few practice charcoal marks on some scrap paper.
3_Use your fingers to smudge the line and your charcoal covered fingers to create broad lines or smudgy marks. You will find that fingers and hands will lift the charcoal from the surface of the paper creating subtle tones. Smudging with a cloth will leave more charcoal on the surface.
4_By employing both the soft woolly charcoal line and smudging marks make a drawing of your object. Enjoy the malleable qualities of the charcoal and match the marks to the intrinsic physical qualities and characteristics of your object.

DRAWING 29
Creepy and sinister.

Aims
Make a drawing that allows the messiness of the materials to communicate the sinister creepy nature of your object. Enjoy making tense scratchy marks. Let the ink splatter and using smudges partially submerge or obscure the identity of the subject.

Method
1_Spend a few minutes looking at the object perhaps make a few notes on its characteristics. Look at your sheet of paper and imagine your subject as a drawing that illustrates your emotional response.
2_Make some experiments with the materials. Indian ink is permanent when dry, which will enable you to work over the drawing with diluted ink as a thin wash or smudges. The combination of ink and scratchy marks made with the stick pen will give an unpredictable line, the ink with its fluid and

RUTH CHAMBERS

I was immediately drawn to the carved wooden figurine.
I like its contradictory and enigmatic qualities. It is now
worn, damaged and dull and bears the scars of its history.
I imagine it had been made to fulfil a deep human need and
had had huge significance in its initial context. It had a sense
of mystery, beauty, sadness, loss, silence and anonymity.
I like to think how it has changed physically from when it
was originally carved to now, where it has been and what it
has meant to the different people who have handled it. I was
drawn to it as a powerful depiction of the human form. I had
encountered similar objects during my childhood, which I
think was also why I felt a strong connection to the object.
The act of drawing the object was very intuitive and
physical. I initially began to use ink and Conté to draw
the figure. But these materials seemed alien and removed
from the nature of the object. Because the figure's original
significance was not known to me, I wanted to respond to
it in a physical way—its roughness, dryness, brittleness,
dustiness and damaged surface. Using the sandpaper was
a way for me to physically connect with the object.

I almost felt like I was grasping at something that I did
not understand about the object through the act of making
the marks. The gesture of carving, sanding or damaging the
drawing's surface seemed to reflect the way the object was
initially brought into being, and how it has changed over time.

unpredictable nature will give you dribbles and
splodges. With a damp cloth and watered down ink
you can make smudgy tones.
3_Make a drawing that allows the messiness of the
materials to communicate the sinister creepy nature
of your object. Enjoy making tense scratchy marks.
Let the ink splatter and using smudges partially
submerge or obscure the identity of the subject.

DRAWING 30
Dramatic and flamboyant.

Aims
Make a drawing that expresses the dramatic,
flamboyant qualities of your chosen object. Use
a range of marks. Use energetic and dynamic
movement, making use of multiple lines to underpin
the drawing with a sense of urgency.

Method
1_Spend a few minutes looking at the object—perhaps
make a few notes on its characteristics.
2_Look at your sheet of paper imagine your subject as
a drawing that illustrates your emotional response. This
drawing is to be full of energy and expressive marks.
By working on a bigger scale you will be able to make
confident gestural marks across the paper. This drawing
demands movement from the whole arm. It should be
freely composed with lots of sweeping dynamic lines.
3_Practice making fluid drawing lines, moving your arm
and hand almost as if conducting an orchestra.
4_Make a drawing that expresses the dramatic,
flamboyant qualities of your chosen object. Use a
range of marks, use energetic and dynamic movement,
making use of multiple lines to underpin the drawing
with a sense of urgency.

Results for all four drawings
The drawings should demonstrate that with a little
forward planning, and by choosing certain methods
and materials it is possible to capture both the physical
and emotional characteristic of your chosen subjects/
objects and in so doing use appropriate visual language
to communicate responses to the world around you.
Additionally, the drawings will illustrate a physical and
emotional understanding of the subjects/objects.

OPPOSITE Frank Auerbach, *Head of
E.O.W.*, 1956, charcoal and chalk on paper,
76.2 x 55.9 cm. © The artist. Courtesy
Marlborough Fine Art, London.

JAKE & DINOS CHAPMAN

ETCHING INCREASES UNCERTAINTY. IT IS BACK-TO-FRONT AND INSIDE OUT. BECAUSE OF THE CIRCUITOUS PROCESSES INVOLVED YOU OFTEN DRAW 'BLIND'. THIS IS AN ADVANTAGE IF YOU WANT DRAWING TO CONTRACT, EXPAND AND CASCADE TOWARDS COLLAPSE AND BACK AGAIN.

WE ARE GRIPPED BY THE IDEA THAT THE PRIMARY DRIVE TO MAKE ART IS DESTRUCTIVE. WE DO POSSESS VERY MATURE SECONDARY AMBITIONS WITH REGARDS TO OUR ENGAGEMENT WITH GOYA'S WORK, INCLUDING A DEADLY SERIOUS CRITIQUE OF THE CONCEPT OF ENLIGHTENMENT. HOWEVER, UNDERLYING ALL OF THIS IS A PRIMARY DRIVE TO OBLITERATE.

WE HAVE LONG SINCE PASSED THE THRESHOLD WHEREBY WE WERE UNDER THE IMPRESSION THAT WE WERE ENTIRELY IN CONTROL OF THE SUBSTANTIVE CONTENT OF OUR WORK. NOW THE WORK DECIDES UPON ITSELF AND SO WE MERELY SERVICE ITS REQUIREMENTS.

RIGHT *Drawing III from the Chapman Family Collection*, 2002, black and white etching, framed 148.6 x 128.6 cm. Courtesy the artists. Photo: Gareth Winters. Courtesy White Cube.

OPPOSITE *Drawing IV from the Chapman Family Collection*, 2002, black and white etching. Courtesy the artists. Photo: Gareth Winters. Courtesy White Cube.

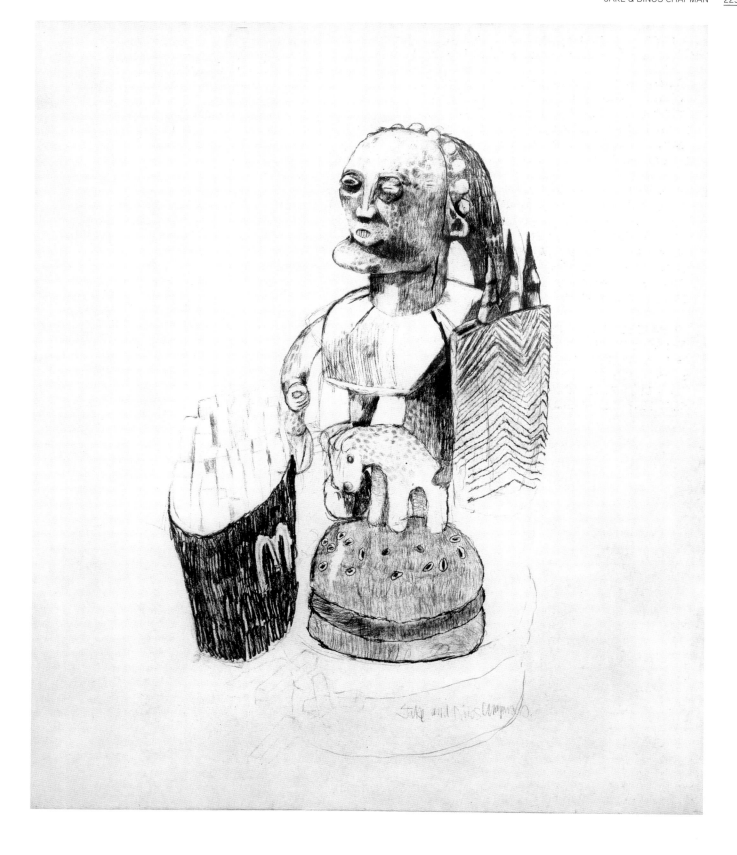

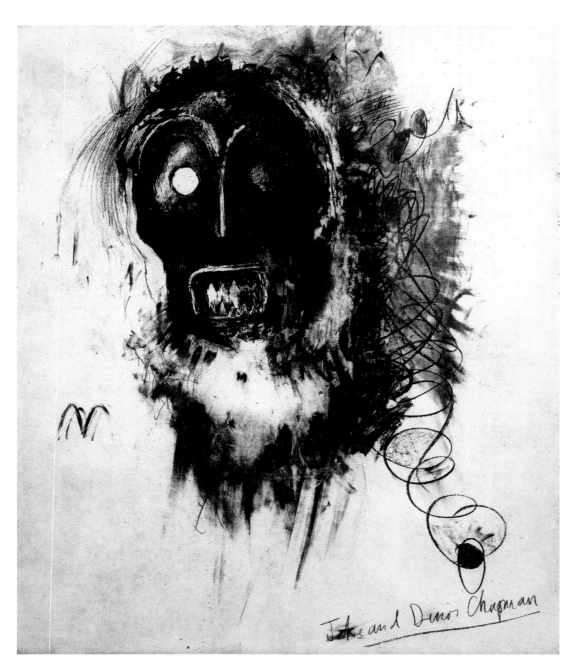

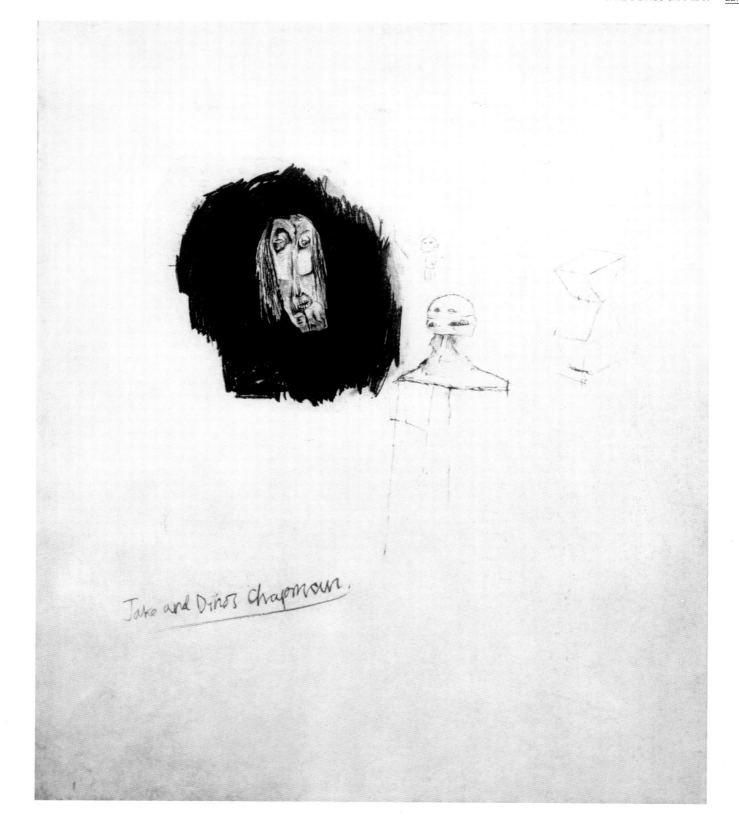

Jake and Dinos Chapman.

the thinking hand
PROJECT 7

COMMUNAL DRAWING
questioning authorship

Duration
Your choice.

Subject
An object of your choice from the domestic environment: you might choose an object which has distinct narrative content, for example, an object which is old, meaningful or precious to you. An interior domestic environment of your choice: somewhere in the domestic setting which has a relationship to the object; somewhere that reveals something about it history, use or meaning to you. For example, you might choose your favourite mug and you might place the mug in a specific place on the dinner table because you always have coffee in the morning sitting in that spot.

Method
1_Consider who and how many people might work on the drawing.
2_Think about what scale of paper you want to work on in relation to numbers. There is no limitation on this but if you intend to pass the drawing onto more than four people you might consider working larger than A4 for example.
3_Select an object and place it in a domestic setting which you find interesting to draw.
4_Draw your object in its context, use a lightness of touch when making your marks and leave large areas of the drawing empty or sparse. Remember that it will be drawn onto by a number of people and you do not want to dominate; imagine your drawing as a whisper, rather than a shout!
5_When you consider your section of the drawing 'finished', pass your drawing onto the next person.
6_The next person should now chose a new object, and setting in which to draw it.

From left to right; Sam Higley, Lilly Hawks, Melanie Chitty, Theo Smith, Lauren Wilson, Bartholomew Beale and Jack Park all work together on their part of the communal drawing, which all 30 participants contributed to, over the course of the final week of the workshops, July 2010.

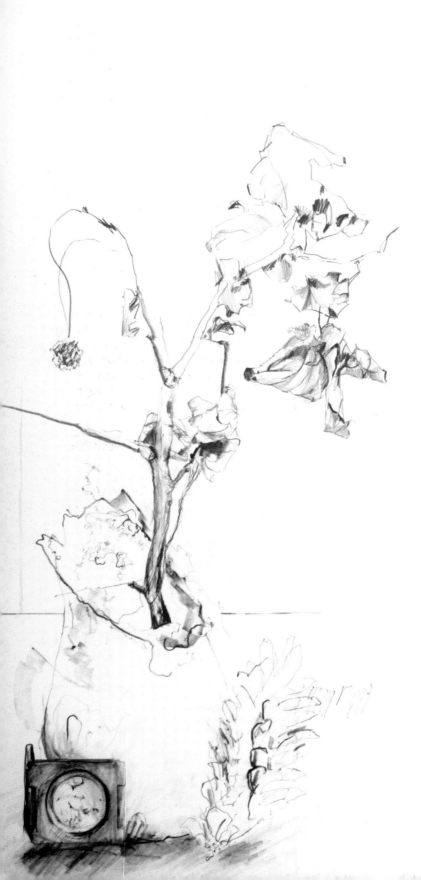

Guidance for the second person in the drawing chain

7_When choosing your subject and context in which to draw it, consider how it relates to the previous drawing. Have fun with objects and the construction of stories based on their connections and associations.

8_Begin by drawing your object and its immediate surroundings.

9_When you have drawn your object, draw its environment, your drawing will naturally overlap the pervious drawing. Lightly rub out sections of the pervious drawing if you feel necessary.

10_Repeat the process, the narrative will build up as more people add to the drawing.

Results

The resulting drawing will be both conceived and made by more than one person. The drawing will have been re-invented and re-interpreted, moving through different peoples possession and domestic environments.

As such the drawing will have a variety of objects, places, techniques of drawing and ideas in it. It will inevitably have built up its own history, its own story. This is not a necessarily a technical or analytical drawing, and you will find that proportion, perspective, scale, etc., can be 'inaccurate'. It will be full of charm, possibilities and narrative content.

LEFT Communal drawing made by Barley Beal, Andy Gomez, Lauren Wilson, Theo Smith, Kate Holford.

OVERLEAF The end of the final day of Workshop 2, an empty studio, and all of the drawing made over that last week, July 2010.

ANDY GOMEZ IN CONVERSATION WITH JACK SOUTHERN, WORKSHOP 2, JULY 2010

JS Have the workshops influenced your ongoing studio work?

AG In the time between this workshop and the previous one four months ago, I have consciously developed ideas and ways of working which the initial workshop introduced me to. I have noticed quite a change in the way I think about drawing. I am much more questioning, exploratory, and aware of the diversity, and possibilities of drawing.

JS Do you mean more exploratory in your general approach to the medium of drawing, or have you found that you have carried specific ideas and ways of working from the workshops forward?

AG Well, both really; I would say my whole approach to drawing is different in the sense that my current studio practice has become a playful revision of the fundamental components of drawing. Which is a method of investigation that is rooted in the breadth of discoveries I made during the first workshop. But I have specifically been thinking about the process involved in the creation of a drawing. And during the initial workshops, I was particularly interested in the projects we did which encouraged us to use different levels of control with the drawing implement. I also found drawing on other peoples drawings really interesting; how

it changed my feelings about the drawing I had made, and as a result, the sense of authorship being compromised. Back in the studio at college I was thinking about developing both aspects of those projects, and wondered what would happen if I could make a drawing with even less control than the ones I had made in the workshops. I began thinking about allowing the paper to move, as well as the drawing implement. I made a series of mechanised drawing boards, so the paper moved at random intervals. This level of disruption in the drawing allowed a huge variety of levels of control in the making. I often got a very unpredictable movement, and therefore a very awkward, erratic line. And then the next set of thoughts led me to relinquish control of one element of making the drawing, which is when I came up with the idea of involving someone else in the process.

JS So the initial ideas relating to the process of making a drawing with simple means, diversified to incorporate mechanical movement, sculptural aspects and in some ways performance?

AG Yes, I began using the moving drawing boards to make portraits of people, in which the person being drawn could have some influence on the outcome. I would draw the sitter, but allow them to control the movement of the paper around the board using a footswitch. In the process of making the drawing I would be attentively observing the sitter, and making marks in relation to my observation.

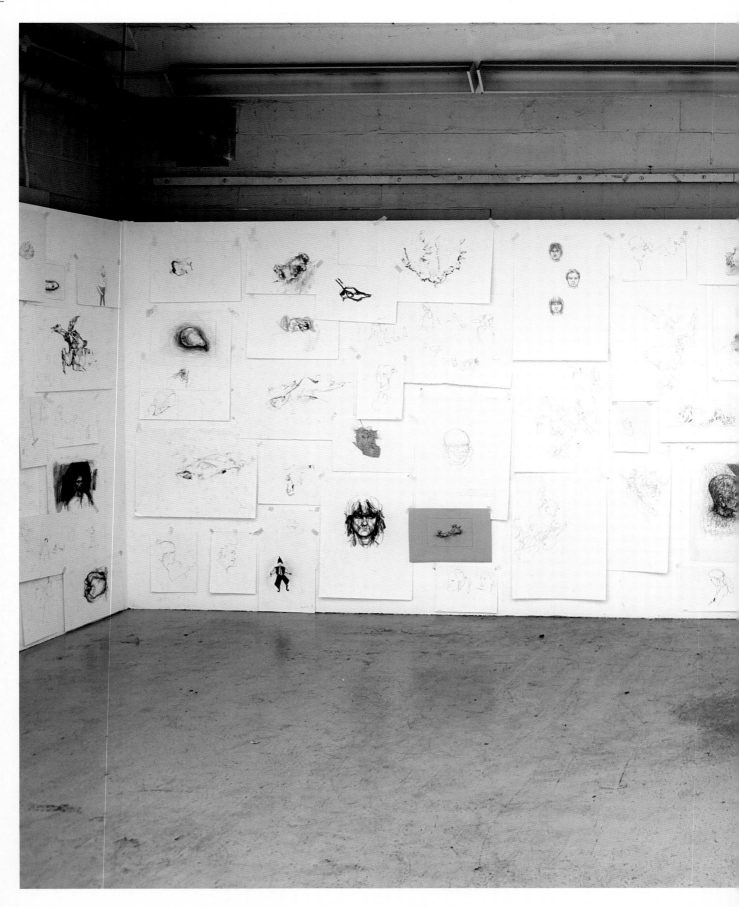

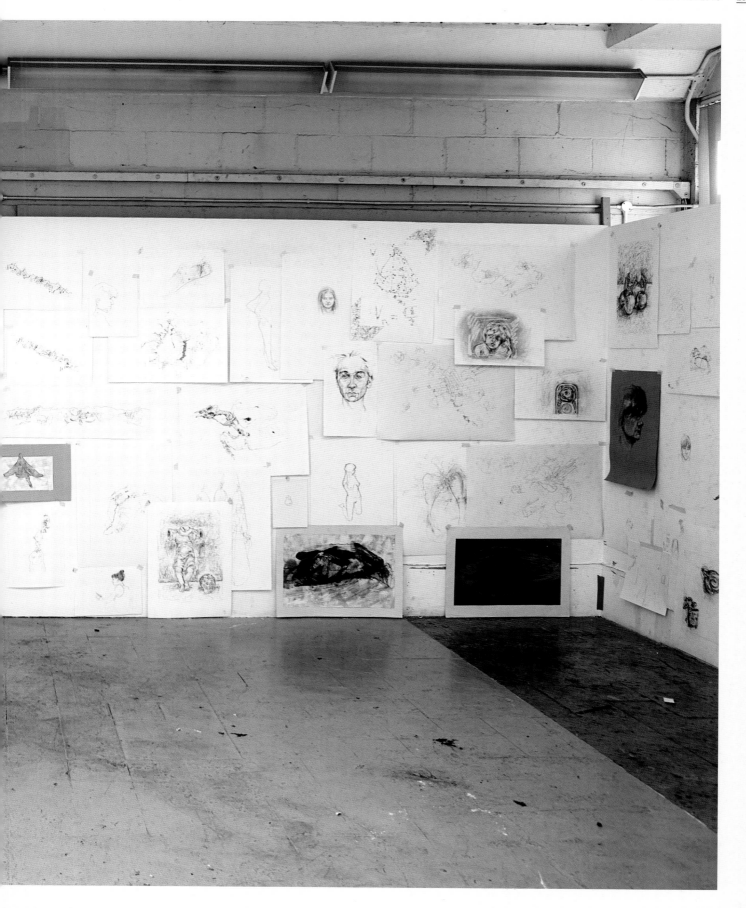

MATERIALS & EQUIPMENT

A well-stocked art shop is like an oasis in a desert to an artist. It is an art gallery for the imagination, where rows of rainbows, and reams of pure and empty white potential can be purchased—where the mouth waters with excitement at the possible outcome of a liaison with the creative self, and where time stands still in the presence of feeling at one with a world whose potential is infinite.

It is a place in which you can find a kind of spiritual nourishment, and meet, ponder and purchase the essence of life—a place full of seductive opportunities, where perhaps the thought of having a new tube of cadmium yellow, new brushes, a new drawing book, or a new box of pencils etc., will somehow provide the means by which a masterpiece might be created. It is difficult not to be seduced into thinking that by buying new and more expensive materials you might become a better artist, and it is true that the work is in part, the materials, and that one's choice of which to use is important.

Some will be preferred to others, and some will work better than others. The materials are the medium out of which the content is formed, and they are most often used as a means to an end. Finding the right ones for the right job is what is important, and what is learnt from failure in one instance can become success in another.

Enjoy the art shop, and be inspired, but do not feel that it can sell you the solution to your problem—it might, but there may be other, less familiar options that might suit your needs better. Try anything and everything, whether it be expensive or cheap, bought from an art shop or DIY supermarket. Surprise yourself. Make your own tools and try non art-materials. Become familiar with the unfamiliar. More expensive materials and equipment do not necessarily make better work.

MAKE YOUR OWN TOOLS: HYBRIDISE YOUR TOOLS IN ORDER TO BUILD UNIQUE THINGS. EVEN SIMPLE TOOLS THAT ARE YOUR OWN CAN YIELD ENTIRELY NEW AVENUES OF EXPLORATION. REMEMBER, TOOLS AMPLIFY YOUR CAPACITIES, SO EVEN A SMALL TOOL CAN MAKE A BIG DIFFERENCE. Bruce Mau

PAPER

Every drawing medium has the potential for its own language, and will behave differently when used on different surfaces [and of course by different artists]. Charcoal is a very different medium to ink, and will require that you recognise and consider its own particular qualities when using it. Your choice of paper will be an influencing factor in the quality of mark your drawing has. It has been said that

WHEN AN ARTIST DISCOVERS HIS PAPER,
HE LEARNS HOW TO DRAW.

The use of better quality paper does not necessarily result in better quality drawings. It is possible that it will, but more likely that it will not. It can, on the one hand inspire you to greater achievements, but on the other, it may also inhibit you, by making you timid in approach, and over conscious of its cost.

It is important to try out different makes of paper with different weights and surface qualities, in order to discover which paper you prefer to use with which medium. There are no rules to guide you with your choice, and at the end of the day, the results of your efforts will be evident in the drawings you make.

Some artists prefer a heavier weight—200 gms, hot pressed [smoother] cartridge paper to use pencil, graphite or, ink on, others prefer something with more 'tooth', [roughness of surface] or a lighter weight—perhaps 60 gms.

Some artists like a very white cartridge paper, others prefer something more off-white, creamer, and perhaps a little warmer. A paper with tooth is usually preferred when using softer mediums, such as charcoal, pastel or Conté. The tooth holds the medium, and has the effect of breaking it up by spreading it across the raised roughness of the surface.

Coloured pastels can be 'optically mixed' in this way, and charcoal and Conté tones can be more evenly graded/blended. Seurat's drawings made good use of the tooth of the paper, in that the majority of his best known were completely tonal on rough paper, and allowed the tooth to help carry and spread the tones into one another with soft seamless edges. Part of the resulting effect was that, as with his paintings, there was an optical mix/blending in the eye, and the shapes and forms became clearer when seen from a distance.

Your choice of paper is crucial to the quality of your finished drawing, and also to your choice of which drawing medium to use. Allow yourself to experiment with different types of paper, and to discover how various mediums work on them, in order to make your preferences.

CHARCOAL

Charcoal must be one of the oldest drawing materials of all, and It is not difficult to imagine our ancient ancestors making images on their cave walls with the burnt embers of twig, or soot, clay, chalk and earth. It has soft, fragile and tenuous qualities, and students of drawing quite often make decisions about their like or dislike for it after using it only once or twice. Its soft, smudgy properties can make it feel like a messy medium, and a student who likes strong clear definition will often assume that it is elusive and difficult to control. It might be initially, but after a little practice, it will become much easier.

Charcoal is definitely for people who do not mind getting their hands, and often their faces, dirty. Its use necessitates you to become involved in the drawing's surface, and it is almost always necessary to use your fingers in the erasing, softening, correcting, and drawing back. A student who likes to draw from flexible beginnings, and adjust, obliterate, re-adjust, etc., will love the flexible options available with charcoal.

It is available from most art shops in thick and thinner sticks, and small blocks, and in a 'hard' as well as 'soft' range, but soft 'scenic' or 'willow' is usually preferred. The resultant black is sooty, dense and matt, but varies depending on the type of wood used to make it from.

Charcoal is an expressive medium that speaks its own language. The overall weight and density of the black surface is

in itself seductively powerful, and offers a drawing a great deal of added quality. It is clearly attractive in its own right, and its range of soft, subtle, or bold blackness can help to divert one's attention away from what might otherwise be poor drawing.

It is used most successfully in larger drawings, and demands to be exploited in that it can be pushed around, and used in a bold and direct way. Its soft powdery characteristics make it very fragile, and it is necessary to 'fix' drawings immediately after they have been completed, otherwise the drawing will disappear very quickly. Always use a can of spray fixative to do this—do not try and economise by thinking that hair spray will work, it does not.

COMPRESSED CHARCOAL

Compressed charcoal is a denser medium than scenic or willow charcoal. It is harder, blacker, less flexible, and more difficult to erase, and is most often used as an addition to an already completed, or almost completed charcoal drawing, where the blacks need be a bit blacker or the whole drawing needs more weight or contrast. Although less fragile than stick charcoal, it too needs fixing as soon as the drawing is complete.

CONTÉ

Conté is available in either small square sticks, or wood-encased pencils. It can be purchased as individual sticks in black, white, red sanguine, sepia, and bistre, or as boxes of a basic range of mixed colours. In pencil form, it can be purchased in a much broader range of colours, either as individual pencils, or as boxed sets. The sticks are harder than compressed charcoal, as dense, if not denser, and slightly waxy. The pencil Conté is softer than the stick form and is used mainly for detail. Although less fragile than either charcoal or compressed charcoal, it too needs fixing immediately after the drawing is complete.

SOFT PASTELS

Soft pastels can be purchased in an extremely broad range of colours. They are pigment bound in gum or resin, rolled, dried, and wrapped in waxed paper. Soft pastels are effectively dry paints, and are very soft and disintegrate easily if not taken care of. When they are drawn with, the marks left on the surface remain as dry pigment, and are easily smudged. They can be purchased either individually, or in boxed sets, and are very dense, opaque, soft and malleable. Pastels work best on a paper with tooth, and Ingres Paper is regarded as the most suitable. It is available in many different colours, and the colour chosen is usually an influencing factor in the effect of the overall drawing. Their soft powdery properties make them very fragile, and drawings made in pastel should be fixed as soon as they have been completed.

OIL PASTELS

Oil pastels are available in a broad range of colours, and are loved by children as, immediate and spontaneous, fun colour. They are pigment bound in oil, and wrapped in waxed paper and available in stick form, usually in boxed sets—although good art shops will sell individual sticks of black or white. They are not very flexible in that they are difficult to adjust and erase, and if it is necessary to erase them, in order that new colour may be applied, then a knife blade will be needed to scrape the surface back to the paper. Turpentine or white spirit can be used as a solvent, and it is possible to dilute the pastel into a more liquid form, and by using a cloth or brush, blend the colours like paint whilst they are in the drawing. Their very bright colours give them an instant energy, and are favoured by artists who like to make a bold and direct statement.

CHALK

Chalk is best used as a highlight on a neutral mid- tone, [mid-grey] paper. Charcoal, or Conté can create the structure and shadow areas of your drawing—the grey of the paper, the mid-tones, and the white chalk, the highlight areas. It is necessary to fix a drawing in chalk as soon as it is completed.

PENCILS

People often associate the activity of drawing, with the use of pencils, and are deceived into thinking that to draw with a pencil is a fairly straightforward and easy matter. It is however a medium that, as well as offering the potential for wonderfully flexible sensual marks, can be very unforgiving, in that every mark made, openly reveals its makers hand.

As a medium, it offers little refuge to those of us who have limited skill or technique, and its fine sensitivity, exposes and puts on view, a whole array of problems that have to be faced, tackled and hopefully overcome.

An artist who draws well with a pencil, is a true draughtsman. There are a huge range of pencils available, and the best way of finding out about which to use, is to purchase a few, and try them. Buy them from the art shop, in preference to the stationers, and if in doubt, ask for advice about their differences. It is not necessary to buy a complete range, and the most useful will probably be in the softer range—HB, B, 2B, 3B, 4B, 5B, 6B. If a 6B is not soft or dark enough, then it may be better to use a graphite pencil, or woodless pencil. The harder the pencil, the lighter the potential mark, and the more difficult it is to erase.

Pencils are a very versatile medium, offering an enormous variety of mark-making possibilities. They can be used either sharper or blunter, darker or lighter, or—with the point, or side of the point. Some artists prefer to draw with a small stump of a pencil, while others like to hold a long pencil as far away from the point as possible.

It is very important to consider the scale of your drawing when using a pencil, and it should relate to the size and tone of the marks made. Anything from A5 to A3 paper is probably best suited to the size of mark a pencil makes. Either a very soft pencil, or graphite stick is suggested for any pencil drawing above A3 size. Pencils in the HB to 9B range are soft, and likely to smudge if not fixed. The type of paper chosen, and the quality of its surface will play a significant role in the sort

of mark the pencil makes, and a knowledge and understanding must develop in order to know which pencil will work best on which paper. Some papers will make an HB pencil draw like a 3B draws on another sort of paper.

CARBON PENCILS

Carbon pencils are available in a hard to soft range, and produce a waxier, denser black than graphite pencils.

GRAPHITE PENCILS/STICKS

Graphite pencils are available in a hard to soft range, and as a pencil-shaped stick—sometimes called a woodless pencil—and also as a chunkier thick stick. Graphite pencils were formerly known as lead pencils, when it was thought that graphite was primarily lead. They are available, depending on their make, in a range from 9H [very hard], to 9B [very soft]. A 2B graphite stick is as soft as some 6B pencils. It smudges very easily, and needs to be fixed.

GRAPHITE DUST

Graphite dust can be purchased as dust, or made by pencil sharpening a graphite pencil/stick into a container, or directly onto the drawing. It has a lead-like sheen to its blackness, and when used in large patches of tone, it may reflect the light, and can be awkward to see. It does, however, offer a wonderful range of rich soft tones that can be smudged into the drawing with fingers, or tissue, and carved back with an eraser if necessary. Like charcoal and soft pencil, it needs to be fixed.

BIRO

Biros are cheap, easily available, and excellent to draw with. Their 'rolled' mark offers lots of potential for consistent continuous line. A good quality rollerball pen is an excellent drawing implement. Some Biro inks are soluble in white spirit, or turpentine.

FIBRE PEN

Fibre pens offer all the advantages of the Biro, and perhaps with a more consistent flow to the ink.

ERASERS

An eraser is an essential item in an artist's equipment, and has been included in the materials section because of its variable use. They are most often associated with rubbing out mistakes, and in the main are used primarily for this purpose. Their other and perhaps more important use is as a creative tool for softening marks, or lifting tone. They are available in various forms, but the most useful, general purpose eraser is a plastic eraser, kneadable rubbers, or putty rubbers (as they are sometimes called) are essential for use with charcoal and the softer drawing mediums.

PEN AND INK

Inks are available in a wide range of colours, but the ink used most by artists is Indian ink. Ink is ideal for producing sharp black marks and lines, that are generally long and fluent, and which convey a feeling of purpose and deliberation. Marks made in ink cannot be erased, and are usually decisive in character. The blackness of Indian ink is opaque and solid, and dries with a slight sheen to its surface. It can be diluted with either tap or distilled water, and applied in a full range of tones as a brush-mark, or 'wash.'

Waterproof Indian ink does not re-dissolve when another wash is applied to an already dry wash, and because of its diluted, transparent qualities, this second coat will effectively double, or darken the tone of the first. Use non-waterproof ink if you wish to re-activate the line. It is possible to use any tool to convey a mark, and it is a good idea to experiment as much as possible. Try using, the wrong end of a paint brush, a match stick, a piece of sponge, a tissue, the edge of a small piece of cardboard, or corduroy, [to print tone]. The most familiar drawing tools for ink are dip pens, which hold a steel nib. The nib size will vary from thinner to thicker, and the nib holder will be flexible enough to allow you to take a nib out, and replace it with another. It is important to experiment with different nibs, in order to ascertain their different mark-making potential. Other types of pen can be used, ranging from bamboo, to the everyday fountain pen. If possible, try them all, although it is probably not a good idea to use Indian ink in a fountain pen. Your choice of paper will make a difference to the final result, and it is suggested that a light watercolour paper will be adequate, although once again it is important to try out as large a range as possible.

DRAWING BOARD

An artist's drawing board can seem like an expensive item to buy, but when used over a lifetime of drawing, it is clearly an excellent investment. If you are unable to afford a professional quality board, then a good DIY shop will probably stock a range of 15 mm MDF board that will be adequate. The board should of course have a completely flat and even surface, be as light as possible without being flimsy, and should be firm, rigid, and feel like a good solid support. Consider having two boards, one that is slightly larger than A1, and a half-size board, that is slightly larger than A2. The smaller board offers a flexible and more portable, alternative, and can be easily held, and supported on your lap. Wooden boards are preferable to plastic covered boards, in that they are easier to stretch paper on.

EASEL

Easels are almost always better to draw at than flat, table-top surfaces. Standing at an easel provides a more alert position from which to move towards, and step back from the drawing. Most importantly, it is a support for the vertical plane, which offers a truer image, and thereby helps to avoid possible distortion. When buying an easel, it is very important to purchase a good solid one that firmly supports an A1 drawing board, and although expensive, will probably last a lifetime.

Do not be tempted to buy an easel that is flimsy and insubstantial, even though it might be marketed as being usefully light and portable. It will probably be more trouble than it is worth. If you are unable to afford an easel, an alternative, might be to sit down, place your board on your knee, and prop the top of it up against the back of a high backed chair.

PORTFOLIO

It is a good idea to keep all of the drawings you make for a period of time, in order that a truer assessment of their success and failure can be made. I would suggest that all your drawings, even the very worst, should be kept for at least a year. What we might at one point regard as 'failure' has the potential to teach us something about what at a later date becomes success. When we 'finish' drawings, we are often unable to detach ourselves from the feelings present whilst making them, and we may make hasty judgments about them. Sometimes, a drawing does not seem to live up to our hopes and expectations, and our pre-conceptions cloud our view of its success and failure.

Our practical abilities are very often out of sync' with our critical faculties, and we discard the drawing because we are unable to accept aspects of it that are new to us, or remind us of the difficult feelings we experienced whilst making it. At a later date, this drawing may surprise us by revealing qualities that, up to that point we have been unable to recognise. The reverse may also be the case, and we are just as likely to think that a drawing is better than it actually is. A portfolio may hold a year's work, or a lifetime's, and as a protective, portable container its value is immense.

USING A VIEWFINDER

Its purpose is twofold—

1_To help us to isolate and select what to draw, and simultaneously what not to draw.

2_To help us to use the containing rectangle in a more interesting way. When making the viewfinder, it is important to—make the aperture in the same proportions as the paper you have selected to draw on [an A5 aperture is in proportion to an, A1, A2, A3, A4, drawing] Several different rectilinear viewfinders may be useful—perhaps one that is long and thin that can be used as either a vertical or horizontal window, and one that is more square.

1_Allow enough card/paper around the aperture to act as a border and thereby isolate the hole from the background at the outer edges of the viewfinder.

2_One of the purposes of the viewfinder is to make the selected area easily visible, and too narrow a border will not allow enough card/paper to comfortably block out what you do not want to see.

3_Make it from black, white or grey card, or rigid paper, and a suitable size would be approximately A4, with an A5 aperture. This would allow you to hold it at a comfortable distance from your eyes. An alternative method of making a viewfinder to the one described above, is to cut two L-shapes out of black, white, or grey card/paper, and tape them together as. This offers flexibility in changing the size of the aperture, and eliminates the need to make several viewfinders.

When using a viewfinder, it is important to relate to it from a fixed and constant position. Make sure that if you are standing at an easel, your feet are in the same position every time you look through the viewfinder. Some students like to attach their viewfinder to their easel in a convenient place on either the left or right vertical support, whilst others hold theirs at arms length away from their body. Mark your viewfinder into parts as shown in the diagram, and then similarly divide your drawing paper. If you feel that it is necessary, cotton may be taped across the hole to divide the viewfinder into sections, or alternatively, you could draw grid lines in fibre pen across a piece of acetate sheet, and tape it to the back of the viewfinder. Lightly drawn guidelines will need to be made to section your drawing paper into the same proportions, and it should then become clearer where objects exist in relation to each other, within the various grid sections.

It is essential to make very careful measurements, or if not, when you enlarge your grid, and register the drawing, any mistakes you have made on the grid, will be enlarged into the drawing. A viewfinder is only necessary for as long as it takes to position all the parts in relation to each other, and may be discarded once this has been done.

Use the viewfinder as if you were looking through a camera lens, searching for a point of view.

_look from the left/right
_look from above
_look from your eye-level
_look up
_move in closer
_step back
_re-arrange the objects and repeat the searching
_try the viewfinder in either landscape or portrait format/etc
_change the proportions of the viewfinder

1_Arrange your objects as if they were, leading actors, supporting actors, and props positioned on a well lit stage.

2_Create leading actors by making some objects more important than others.

3_Remember, the cherries, mixed fruit, and cake—have at least one 'focal point'.

4_Create a well-balanced mix of more and less interesting areas of 'negative space', and vary their size.

5_Make use of the whole rectangle and 'depth of field'.

6_Organise the rectangle to make maximum use of tone.

Less is sometimes more, so consider leaving out as much as you include. In other words, be selective. The relationship between two or three well placed objects, and the interesting spaces between them, may provide a tension that lots of objects complicate.

What you should be looking for is an underlying arrangement that uses the rectangle well. One that nourishes the eye, and offers an adventure and journey for the eye within the picture space, and leads it through interesting angles, lines, divisions, shapes, forms, tonal contrasts, and surface marks.

GLOSSARY

BLOCKING IN
Roughly 'filling in' broad areas of the drawing as shapes of tone.

CALLIGRAPHIC
A term characterised by linear flowing marks that might be analogous to handwriting.

COLOUR
Colour has three qualities; 1_Hue—the actual colour itself, e.g., red, yellow, blue, etc.. 2_Chroma—the relative brilliance or intensity of a colour, e.g., bright pink or dull crimson. 3_Value—the modification of a colour by light/air/distance.

COMPOSITION
The organisation of the physical elements of a work of art. The arrangement of shapes, forms, masses—usually within a rectangle.

CONTENT
The subject matter of a piece of work as distinct from the form in which it was expressed.

CONTOUR LINE
Contour lines offer the illusion of a line enclosing form. They attempt to inform the spectator about edges and boundaries of forms, and offer clues, by being thicker or thinner, lighter or darker, continuous or broken, that help create a three-dimensional illusion of an object/form in space.

ERASERS
A tool for removing marks from a drawing. Firm plastic, or soft putty rubbers are most commonly used.

ETCHING
A method of engraving a metal plate, such as zinc, copper or steel, by a process of biting the drawn lines with mordants. The design/drawing is first drawn into a wax ground with an etching needle, and then subjected to a series of acid bitings. Finally the plate is inked, wiped and printed.

EYE LEVEL
An imagined level plane projected out into the visible world at the height of the eyes from the ground. Everything visible is either above or below the level of the eyes.

FIXATIVE
A resin dissolved in solvent, which is sprayed onto a completed drawing to 'fix' the particles of graphite/charcoal to the paper, and prevent them from being smudged.

FORM
A three-dimensional object, or the illusion of one, on a two-dimensional surface

GRAPHITE PENCIL
A wood encased mixture of graphite and clay, formerly referred to as lead. The hardness and softness of the pencil depends on the proportion of graphite to clay.

GRAPHITE STICK
A solid stick of graphite without the wood encasing it, and chunkier than a graphite pencil.

HALF TONES
The range of tones that take up the mid values between the darkest and lightest tones.

HAPTIC
Relating to the sense of touch.

HATCHING
Hatching is a system of creating areas of tone by drawing close parallel lines next to each other. When seen from a short distance, they merge to read as a patch of darkness. The direction of the lines also informs the eye about the direction of the surface planes across and around an object.

HIGHLIGHT
The locality of any surface which catches most light. The lightest tone used in a drawing.

NATURE
The source of all inspiration.

LOCAL COLOUR
Theoretically the colour of an object that is seen to be unmodified by the proximity of other colours. The conceptual notion of that colour.

MEDIUM
The material means by which ideas and feelings are given visible form, the substance that the piece of work is made from—film, video, wood, bronze, oil paint, acrylic paint, graphite pencil, etc..

MONOCHROMATIC
Having only one colour.

NEGATIVE SPACE
The composer Debussy described music as 'the space between the sounds'—that is how important intervals of silence are to a musician. To an artist, the area and space around and in between objects is just as important, and is called the 'negative space'.

OPTICAL MIXING
The mixing of juxtaposed colours by the eye, thus when seen by the eye at a distance, e.g., yellow and blue merge to become green.

PICTURE PLANE
The vertical surface area of a piece of paper, upon which a drawing is made. The essence of the picture plane is flatness, and flatness is synonymous with two-dimensionality.

SCALE
The relative size of one part/measurement to another. [A5 is in proportion to, and half of A4, and A4 is half of A3].

SHAPE
A two-dimensional area, which does not possess a third dimension, and is perceived as being 'flat'.

SIGHT SIZE
A figure seen at distance might appear to be an inch tall. This is sight size, and when we draw an object as small as it appears, we are drawing it 'sight size'.

TONE
A quality of lightness and darkness that a colour may have, that fits into a modulated range of greys between white and black.

VIEWFINDER
A Viewfinder is a framing device that can be used to select a point of view. It is usually an aperture cut into a piece of card that acts as a 'window' through which to select what to draw, and at the same time, block out what not to draw.

ACKNOWLEDGEMENTS

We would like to acknowledge the invaluable support and advice from a range of individuals, galleries, museums and educational institutions that have been instrumental in the realisation of this book. Special thanks go to the following individuals; Kate Macfarlane who kindly agreed to write the foreword. Dr Bill Prosser for writing the section on "Doodles", which appears at the end of the core text. Professor Andrew Stonyer for his encouragement, and helpful comments on an early draft of the text. Danielle Olson, for her insight and advice on adjusting the text. Ruth Chambers for general research/administration, and amazing patience in transcribing all the artists' interviews. Jennifer Whiskerd for sharing her knowledge and inspirational outlook, as well as writing the project "An Emotional Response (Capturing Character)" which appears in "The Thinking Hand" section of this book. She also kindly presented this as a day-long taught session during the Workshop 1 in April 2010. Tom Lomax and Sam Belinfante for contributing a day's teaching during the second workshop in July 2010. Adele Underwood, who attended the first workshop, and made a drawing specifically for this publication which appears on pages on pages 26/27. Roger Coleman, for allowing us to use his drawings, which feature in the section on negative space. Diane Jones for proof reading and grammar correction, and helpful feedback throughout. Gill Maslen for both emotional and practical input, and also for cooking so many amazing dinners while we were hard at work in the studio. Gemma Anderson, for her ongoing emotional support and understanding. Dryden Goodwin, for his much valued advise and inspiration, in relation both to his own feature, and the publication as a whole. Dale Berning, for conducting the interviews with artists Jeff Koons and William Kentridge, which were originally published in the *Guardian Guide to Drawing* in September 2009, by the *Guardian* newspaper. We also thank the *Guardian* newspaper for allowing us to re-print these two interview in this publication. Ian Way, for sponsoring the workshops by providing precious materials from his business Artway, in Wiltshire. Artway is a supplier of quality art, craft and design materials, (artway.co.uk).

The following individuals, who assisted with essential contributions to the workshops held for this publication including, technical support from John Walters, Jack Park, Dan Young, Shaun KitKat and Elly Eagles. Mary Brazil, who was the life model for both workshops. The photographers, Dave Stokes and Matt Frederick, with a special thanks to Dave for all his hard work in doing the photographic post-production.

Artist features

We owe a debt of gratitude to the individual artists who have been extremely generous and accommodating with their time in working with us on their artist features. Many have involved multiple meeting and conversation in their studios, in what has proved to be a very involving process. So we thank you profoundly. Cornelia Parker, Jeff Koons, Julie Mehretu, Claude Heath, Martin Wilner, Charles Avery, Gemma Anderson, Tim Knowles, Jeanette Barnes, Kate Atkin, Benedict Carpenter, Dryden Goodwin, Shahzia Sikander, William Kentridge, Keith Tyson, Franziska Furter, Jake & Dinos Chapman.

Galleries/Museums/Artist Studios'

We would also like to thank a range of individuals, galleries and museums who have been vital in working with us in supplying and obtaining images, titles and credits in relation to the artist features in this book. These include the following: Emma Starkings; Frith Street Gallery, London; Lauran Rothstein; Jeff Koons LLC, New York; Sarah Rentz; Julie Mehretu Studio, New York; Catherine Belloy; Marian Goodman Gallery, New York; Michael Lewis; Charles Avery's studio, London; Rupert Gowar-Cliffe; ROSE Design, London; Scott Briscoe; Gallery Sikkema Jenkins & Co, New York; Shireen Painter; Keith Tyson Projects Ltd, West Sussex; Sara MacDonald, White Cube, London; Kate Austin, Marlborough Fine Art, London; Jodie Jacobson, The Horticultural Society of New York; Anne McIlleron, William Kentridge's studio, Johannesburg.

The University of Gloucestershire

The University of Gloucestershire generously allowed us to use their facilities, enabling us to run two workshops specifically for this publication in April and July 2010 at their Pittville Campus Studios, Cheltenham. We would also like to acknowledge the ongoing support from staff at the University throughout the project, and the Research Development Committee for crucial financial backing. A big thank-you to individuals who have played important roles, such as, Ben Calvert, Nick Sargeant, Nick Pride, Claire Nash, Chie Konishi and Mark Unsworth.

In some respects this publication celebrates the ongoing commitment the University of Gloucestershire has had, and continues to have, to developing and promoting the importance of drawing as a primary means by which greater visual awareness can develop. Past and present staff represented in this publication include, Professor Anita Taylor, former Deputy Head of Art, Media and Design and Co-founder and Director of the Jerwood Drawing Prize, former Professor at the University, Andrew Stonyer, Terry Murphy, Former foundation course leader, James Campbell, former Senior Lecture in ceramics and Jennifer Whiskerd, current Senior Lecture, BA (Hons) Illustration. Through the BA (Hons) in Fine Art, and other similar degree courses in the Department of Art and Design, The University of Gloucestershire will continue to place a significant importance on drawing and its relationship to the wider practises of visual art.

Students

Thank you to all the student who participated in the workshops for this publication, these include; Amy Smith, Andrew Gomez, Anna Geeson, Annabelle Craven-Jones, Anthony Banks, Aurelia Langue, Bartholomew Beale, Becky Turner, Beth Kirby, Bryony Lloyd, Christine Barnett, Cleo Price, David Parr, Emily Mason, Holly Ford, Jade Hughes, Kate Holford, Katie Dodsworth, Lauren Wilson, Laurie Plant, Lee Moss, Lilly Hawks, Lilly Musker, Lucy Evertts, Melanie Chitty, Nancy Trotter-Landry, Rebecca Ackroyd, Rob Morgan, Ruth Chambers, Sam Belinfante, Sam Higley, Simon Foxall, Steven Skinley, Sophie Kemp, Theo Smith, Toby Ursell.

Finally, thank you to every one at Black Dog Publishing, particularly the individuals with whom we have worked closely; Duncan McCorquodale, Anna Stratigakis, Libby Waite and Phoebe Adler.

COLOPHON

© 2011 Black Dog Publishing Limited, the artists and authors.
All rights reserved.

Black Dog Publishing Limited
10A Acton Street
London
WC1X 9NG

t. +44 (0)207 713 5097
f. +44 (0)207 713 8682
e. info@blackdogonline.com

All opinions expressed within this publication are those of the author and not necessarily of the publisher.

Designed by Anna Stratigakis at Black Dog Publishing.

British Library Cataloguing-in-Publication Data.
A CIP record for this book is available from the British Library.

ISBN 978 1 907317 25 5

Black Dog Publishing is an environmentally responsible company. *Drawing Projects: An Exploration of the Language of Drawing* is printed on FSC accredited paper.

reuse recycle reduce

art design fashion
history photography
theory and things

**black dog
publishing**

www.blackdogonline.com
london uk